RENAISSANCE AND BAROQUE MUSIC
A Comprehensive Survey

RENAISSANCE AND BAROQUE MUSIC

A Comprehensive Survey

FRIEDRICH BLUME

Translated by M.D. Herter Norton

W · W · NORTON & COMPANY · INC · NEW YORK

ISBN 0 393 09710 2

Contents

The translation of these richly informed and informative essays in music history could scarcely have emerged into the light of their author's approval but for the wise guidance, critical, editorial, and generous, of Nathan Broder.

M. D. H. N.

Preface

The history of music is a continuously flowing stream. Craftsmanship in the art passes from father to son, from teacher to pupil; the bearers of music, the religious and secular institutions, the classes of society, change their requirements at a slow tempo. What becomes apparent to the musicians of a generation (perhaps of every generation) is the gradual change of taste, which usually proceeds in small steps and seldom splits open deep chasms (as it did around 1910). Hardly any composer has been aware that he stood at the end of an era. Nor could he be, for every creative musician is rooted in tradition and alters it slowly according to the needs of a changing taste. Orlando Lasso's late motets and madrigals are a defense of tradition and yet at the same time lead far into new artistic territory. J. S. Bach's late work was an avowal of the past and yet at the same time opened the door leading to the Classic-Romantic era. Lasso, in the dedication to his *Cantiones* (1593), drew from his deep wisdom a comparison between young and old grapevines, and thus indicated how clearly he was aware of the change of taste that had taken place in his old age; but, historically minded as his period was, he says nothing about an end of his epoch in history. Bach writes in his *Entwurf einer wohlbestallten Kirchenmusik (Draft for a Well-Appointed Church Music,* 1730) that "our artistry has increased very much, and the *gusto* has changed astonishingly, and accordingly the former style of music no longer seems to please our ears," and J. J. Quantz describes in detail, in his *Versuch einer Anweisung* (1752), this "change of *gusto,*" but of a fundamental turn in the course of history, of the breaking off of one epoch and the beginning of another, there is no mention.

The history of music, however, requires organization if the contrasting phenomena of its changing phases are to be made intelligible. It is only looking back from a distance in history that the contrasts become clear, enabling us to characterize in their

light the phenomena that belong together and those that differ from one another. It is only in looking back from a distance that the eras and their boundaries can be determined. History does not organize itself; it is the historian who builds dams in the flowing stream.

In the attempt to organize the historical material into eras and describe the musical events with which they are filled, the historian faces a choice between at least two possible procedures. He can either treat music as a phenomenon *sui generis,* describe its events from the analytical and technical points of view, and in that way develop an organization and a terminology taken exclusively from music itself and possessing value for music alone. Or he can attempt to see the phenomena of music against a background of other occurrences and achievements, the background of the social structure, of poetry, of pictorial art—in short, against the background of the history of the human spirit. There is no doubt that both procedures have their advantages and disadvantages, their justifications and their weaknesses. The first procedure relieves the historian from the danger of forcing upon music standards taken from other fields of history, but it results in a historical picture that hovers alone in the empty space of a doubtful musical autonomy and that because of its method and terminology is accessible only to the expert in music history. The second procedure requires the historian to exercise careful restraint if he would avoid falling into the temptation of hastily setting up parallels between musical phenomena and those of other activities of the spirit; ideally, however, it can lead to perceiving music as a part of the whole spiritual activity of an age.

The present essays on music in the Renaissance and the Baroque attempt, on the basis of this second method, to distinguish the two eras from one another, to define their boundaries with the Middle Ages on the one side, with the Classic-Romantic era on the other, and to describe what is characteristic of their music. The essays seek to free themselves from the constraint of preconceived ideas of music history and to avoid the influence of older organizations of music history. They aim to examine the extent to which "Renaissance" and "Baroque" are justified as

concepts governing music-historical eras and to what degree musical events from about the middle of the 15th century to the middle of the 18th may be subsumed under them. They propose to avoid assuming for the musical events of these two eras a stylistic unity that does not correspond to historical fact, and to show instead the contradictions that each age bears in itself. But they hope to show, too, that each of these eras, despite all its inner contradictions, is marked by the unity of a higher artistic intent, which determines its individuality and sets it apart from other ages.

While each of the two methods of organizing music history has its advantages and its failings, if the results help to teach us to understand the music of an era, each will have fulfilled its task. It is hoped that the following contributions will be accepted as an introduction to the understanding of music in the Renaissance and the Baroque against the background of the cultural history of these periods.

FRIEDRICH BLUME

October 1966

RENAISSANCE AND BAROQUE MUSIC
A Comprehensive Survey

RENAISSANCE MUSIC

I

The Idea of "Renaissance"

The word "Renaissance" is current in this form in the German, English, and French languages; the corresponding Italian form is *rinascimento,* the Spanish *renacimiento.* The root is Latin, *renasci,* whence the Italian *rinascere, rinascenza, rinascita* meaning rebirth. In the sense of a historical event or period it came early into use. The idea gradually taking shape in the 14th century (and celebrated by Petrarch, Boccaccio, Cola di Rienzi, and many others) that Roman culture, language, literature, the plastic arts and painting "had been awakened to new life after a deathlike sleep of many centuries" became in the course of the 15th century already "a commonplace of humanistic thought on history," as August Buck puts it; and the feeling of living in a time of extensive renewal of the human spirit, of being "born again," was widespread. Matteo Palmieri (15th century) used both the concept and the word *rinascita* in the sense in which they are used today, and Vasari in his *Lives of the Painters* was the first to use *rinascita* to indicate a period in the history of art (Buck). Today the word "Renaissance" is generally accepted in the terminology of universal history as distinguishing a complex of intellectual and spiritual currents—scientific, artistic, religious, political, social— within a period the boundaries of which, while extremely flexible, embrace chiefly the 15th and 16th centuries. It is to be understood in this most general sense in what follows.

There is much argument, however, about whether all these currents may be traced to a single common impetus, wherein this impetus is to be perceived, whether all the tendencies and events comprehended under the label "Renaissance" correspond to a

definitely delimitable, more or less homogeneous period of history, and how such a period is to be marked off from others. Whether the revival of Antiquity in art and music, in language and literature is impetus or symptom, whether the ideas of religious reformation are fruits of humanism or were independent of the *rinascita,* whether the sense of new life welled forth from deep irrational springs or was a result of the new science and art, whether a new Messianism underlay all this or the rebirth was a reaction against the medieval monopoly of scholasticism and Thomism, now regarded as barbarism—all this is matter of violent controversy. The time limits vary widely. Many French and Italian historians look upon the 13th or the 14th century as the time of "rebirth"; others, failing to recognize the historical independence of the Enlightenment and the Baroque, seek to include the 17th century, even the 18th, in the "Renaissance" period. That the terminology of universal history has grown accustomed to equating the beginning of the Renaissance with the end of a "Middle Ages" and the beginning of a "New Era" (even the expression "medio evo" stems from the 15th century) makes the use of the word "Renaissance" to designate a particular historical period still more difficult. According to Trevelyan's *English Social History,* the Middle Ages lasted into the 18th century and the "New Era" only began with the Industrial Revolution; according to Georg Voigt (1859) the Renaissance begins with the humanism of Petrarch. Amalgamation with the religious reform movements of the 15th and 16th centuries, with the reforms of Luther, Zwingli, Calvin, Henry VIII, with the counter-reforms of Pope Paul IV, of Loyola, with the sectarian religious quarrels of the later 16th century, both burdens and considerably weakens the concept "Renaissance," while the frequent holding of this concept to be the same as that of "humanism" threatens to deprive the word "Renaissance" of all value for distinguishing a historical period.

In the pursuit of such thoughts it was inevitable that a more recent trend in historical research, characterized by Wallace K. Ferguson as "the revolt of the Medievalists," should have cast doubt upon the existence of any historical period one might call a "Renaissance." Besides, the established and still widely accepted

picture of the Renaissance, which goes back to Jacob Burckhardt (*The Civilization of the Renaissance in Italy*, first published in 1860), was drawn exclusively from the history, culture, science, and art of Italy. Michelet (*Histoire de France*, VII, first published in 1855) had been the first to formulate—in quite other contexts, to be sure—the idea of "la découverte du monde, la découverte de l'homme," which, according to Huizinga, Burckhardt then applied to the intellectual and political history of Italy. Thus Italy was elevated to the heartland of the Renaissance, "discovery of the world, discovery of man" to be her distinguishing task.

Even though Burckhardt's picture of the Renaissance is undoubtedly one-sided and has with justification called forth many criticisms and corrections,[1] for the periodization of history it has the great advantage of being conveyed by a word that stems from the terminology of the period in question and expresses that period's own view of itself, a corresponding concrete and definable historical reality, whatever the bearing of this reality on other simultaneous, preceding, or subsequent historical realities. If Burckhardt's view of the re-conquest of the world through newly awakened senses and ways of thinking is one-sided, certain more recent efforts that would make of the Italian Renaissance an era of coldly rational scientific and mathematical speculation or argue it out of existence altogether as a historical period, are not only no less one-sided but paler as well, less distinct, more alien to reality. The inclination to deal with reality *more mathematico,* as it is found among the painters and plastic artists throughout the 16th century from Leon Battista Alberti to Leonardo da Vinci and to Albrecht Dürer, and, notwithstanding all other currents of the time, among musicians from Prosdocimus de Beldemandis and Johannes Gallicus to Ramos, Salinas, Spataro, and onward to the countless theoretical schoolmen of the 16th century, is no peculiarity of the Renaissance but a continuing heritage from Antiquity and the Middle Ages. In music the writings of Johannes de Muris (first half of the 14th century) were for centuries regarded as the canon of all

1. Of which the most fundamental are by Karl Brandi, Konrad Burdach, Ernst Troeltsch, Karl Borinski, Johan Huizinga; cf. Huizinga's *The Problem of the Renaissance,* in his *Men and Ideas: History, the Middle Ages, the Renaissance,* p. 364, note 1.

knowledge, and at 16th-century German universities "reading Muris" amounted to lecturing on music.

The Renaissance is certainly the period of human history in the last two thousand years that has with the passage of time most deeply and lastingly shaped and guided the European spirit, and thus indirectly many peoples outside Europe. It laid the foundation of life—not only artistic but spiritual, intellectual, and moral—even into the early 20th century, and the efforts of the "new" art and music in our own time are in a certain sense a battling against the heritage of the Renaissance. To this extent a "new era" certainly began with it, much as this has lately been disputed. It is not surprising that the mistake most frequently made in attempting to characterize and delimit the Renaissance should be that of one-sidedness. The Renaissance is just as complex as the Middle Ages or the Baroque.

Remnants of scholastic and Thomist thinking lived on in it together with the remains of Greek, Roman, and patristic doctrines; in the 17th century Kepler's mathematical empiricism still carried on passionate polemics against the medieval number symbolism of Fludd, and Aristotelianism no less than Platonism again and again determined afresh the vision of poets and musicians. The countless *regolamenti* for the teaching of art, architecture and drawing, literature and music, do not only pulse with the life of the Renaissance: they are codifications, attempts to make comprehensible the invading fulness of sensual experience. There is often confusion here. The artists of the Renaissance felt the need to couch in rules their wealth of sensual experience; like the artists and musicians of the 20th century, they theorized because they felt the solid ground of tradition quaking beneath their feet, and they clung to what was logically and mathematically graspable to avoid drowning in the ocean of the senses. Hence their need for a norm, which is much more "medieval" than "modern" in effect and which makes itself especially strongly felt in music. To this should probably be added a further motive, the inclination to "Gelahrtheit" (*Gelehrtheit* = learnedness), music, for example, still being a *scientia*. Like the artists of the Baroque, those of the Renaissance liked to consider

themselves "scientific" and thus on the same level with the scholars. This motive behind their endless theoretical reasonings should not be overlooked. It is the same motive that led musicians around 1600 to the doctrine of rhetorical musical figures: they hung the mantle of *Gelahrtheit* about their shoulders, clothing in the terms of Quintilianic rhetoric what they had in practice long been doing.

To sustain the idea of "Renaissance" as designating an era in the history of culture and the human spirit remains, despite all hesitations and objections, a sound undertaking. Burckhardt's pithy phrase is still valid: "The 'Renaissance' would not have been the high necessity it was in the world's history if one could so lightly epitomize it." One would indeed be missing the point if one sought its origin only in the revival of Antiquity. For the history of music in particular the idea would lose much of its usefulness, because a definite turning in the practice of composition toward the fundamental principles (actual or imagined) of Greco-Roman Antiquity is only to be observed after the middle of the 16th century. Even Burckhardt (*Civilization of the Renaissance,* Part III, Introduction) saw that the Renaissance had "conquered the Western world" only through "its close alliance with the Italian national spirit already there beside it."

Whether it was through this alliance alone that reawakened Antiquity conquered the West has been a much disputed question, and from the point of view of music history it certainly calls for argument. The undeniable fact alone that in Renaissance times the high musical art of the Church, the courts, the nobility, the commercial cities was carried on for a century and a half principally by non-Italians—their composition, their performance, and largely also their theory—speaks against it. As in painting and plastic arts and in literature, so in music also "the Italian national spirit" took part in the cultivation of a new artistic ideal; how, in what manner and to what extent, is as yet in large measure unexplored, but surely to a far smaller degree than in sculpture, say, or painting. The musicians whose leadership and authority carried out this ideal, expressed, realized, developed it, worked in Italy, but they came from the northern countries of Europe. When, after the mid-

dle of the 16th century, Italy began with full strength and fresh-
ness to take a leading part in music history the spirit of the Ren-
aissance had already entered its old age and the hour of the
Baroque (or of "manneristic style," if one thinks it necessary to
introduce this concept into music history) had struck.

The Renaissance movement in music goes back exclusively to
neither the *renascentes bonae litterae* of Erasmus nor Burckhardt's
"Italian national spirit"; it even has little or nothing to do with the
processes of religious, social, or political history. If it is to be un-
derstood as a unit and a whole, it can only be grasped as a break-
ing out from irrational depths, as a spontaneous release of newly
awakened, autonomous musical forces, into which then in due
course influences from the humanistic, literary, religious, and social
currents of the time also mingled. There is therefore no point in
tracing back the changes in music of the Renaissance age only to
the sectarian religious movements of the North, to the "Modern
Devotion" (*devotio moderna*) of the Brothers of Common Life and
the Windesheim Congregation, as Herbert Birtner has attempted
to do, who says that "In contrast to the other arts, music lacks
the fully conscious joy in itself. It is a true child of Northern Hu-
manism." [2] One probably comes closest to its origin if one regards
it as the fruit of a happy moment in history: the musicians who
came to Italy from the North fertilized with their tradition of strict-
ness and abstraction the still virgin soil of the Italian people's
sensuous musical gift. The Renaissance *was* a "historical neces-
sity," and it burst forth from many sources simultaneously.

Greco-Roman Antiquity had never been forgotten even in the
Middle Ages, the writings of whose authors overflow with quota-
tions from Plato, Aristotle, Horace, Pliny, Boethius, and countless
others, as well as with excerpts from the Church Fathers. The
legends of Orpheus and Amphion, of Pythagoras and Olympos are
served up quite as tirelessly as those of Jubal and David. The
"pre-" and "proto-Renaissances" of the Carolingian, Ottonian, and
Hohenstaufen times (Panofsky's "renascences") are intermittently
recurring reflections of the heritage from Antiquity.

2. *Renaissance und Klassik in der Musik,* in *Festschrift Theodor
Kroyer,* Regensburg, 1933, p. 52.

The Carolingian Renaissance was recognized by the 15th-century humanist Gianozzo Manetti as a movement similar to that of his own time (Panofsky). With the same zeal with which the Carolingian writers handed on almost the entire mass of antique literature to posterity, those who came after—Petrarch, Boccaccio, Coluccio Salutati, Manuel Chrysoloras, and countless other humanists down to the Medicean circle around Lionardo Bruno, Manetti, Poggio Bracciolini, Francesco Filelfo, and all the minor Italian court humanists of the 16th century—kept up the endeavor to preserve and pass on the heritage of Antiquity. Einhard (c. 770–840) educated himself by means of Suetonius's *Lives of the Caesars* just as Vasari did 750 years later. The palace chapel at Aix was a copy of San Vitale in Ravenna, the basilicas of the Ottonian period leaned upon those of Rome and in turn became the model for 15th-century basilican structures in Florence, Rome, and elsewhere. The personifications of antique mythology reappear in the "pre-Renaissances" of the Middle Ages in the same shapes and forms they passed on to the Renaissance of the 15th–16th centuries. In the arts of design the models of Antiquity again and again freshly molded style and inspired imitation. The group of the *Visitation* in the Cathedral of Rheims was long held to be a work of the 16th century though it dates from 1227–30, and Nicola Pisano around 1260 was able to slip in a slightly reworked antique Dionysos among the witnesses to the *Presentation of Christ* in the Baptistery of Pisa (Panofsky). An antiquitarian undercurrent was at work in the plastic arts and in literature all through the Middle Ages and in countless "renaissances" it rose to the surface. The Gothic was not founded on the total decay of the Greco-Roman heritage, but was (as Panofsky has convincingly shown) a reaction to this heritage, still from time to time absorbing numerous stimuli from it.

This seems to have been least of all the case in music. In how far music of the Gothic period sprang from an independent development free of Greco-Roman influence and in how far "pre-" and "proto-Renaissances" made themselves felt here (most likely still in music theory) has heretofore not been investigated. Perhaps one may see the adoption of Roman choral forms and antiquitarian

hymn verses in Carolingian times as a parallel process. In one
thing, however, the self-understanding of musicians of the Ren-
aissance era obviously accords with that of the plastic artists:
they feel a deep spiritual relationship with the never quite ex-
tinguished heritage of Antiquity and, like them, they feel involved
in the dawn of a *new* age. "It is precisely this notion of a new
time which distinguishes the Italian Renaissance from all the
other so-called earlier Renaissances" (T. E. Mommsen). Whether
Filippo Villani or Leon Battista Alberti, Giorgio Vasari, Nicolò
Vicentino, or Gioseffo Zarlino—they all consider *maniera mo-
derna* and *maniera antica* as fundamentally one, a great spiri-
tual connection that stands in extremest contrast to the *maniera
vecchia* of the *medio evo,* to the *tenebre* of the "Dark Ages." Plas-
tic artists too understood the new period not only—not even prin-
cipally—as a return to Antiquity. Leonardo da Vinci held likeness
to nature and the laying of a new mathematical foundation for the
arts to be essential; they were principles by which he could of
course link up with Antiquity. To musicians the Greek calculation
of intervals gave the mathematical hold, the idea of imitation the
esthetic hold on this connection. Pythagoreans like Architas, Era-
tosthenes, Didymus, and Ptolemy had established the intervals on
the basis of exact mathematical relations. And Aristotle had
stated the formula: $\dot{\eta}$ $\tau \acute{\epsilon} \chi \nu \eta$ $\mu \iota \mu \epsilon \bar{\iota} \tau \alpha \iota$ $\tau \grave{\eta} \nu$ $\phi \acute{\upsilon} \sigma \iota \nu$ ("art imitates na-
ture"). In these axiomatic fundamentals Renaissance musicians,
disregarding their predecessors of the Middle Ages, entirely agreed
with those of Antiquity. Here elements of tradition are evident that
may well be comparable with the "renascences" of Antiquity in the
plastic arts and in literature.

In the musical creativity of the Middle Ages, however, in their
compositions, there is nothing to remind us of that undercurrent the
pulsing of which makes us feel Antiquity surviving in their litera-
ture and plastic arts. In any case, even in these areas the idea never
came up in the Middle Ages of conquering the present by a "re-
viving" of Antiquity, of liberating mankind from some "barbar-
ism" or other through the spirit of the classical age and leading it
to a new, ardently desired state of social and spiritual freedom.

This did not happen until the "real," the so-called "Italian" Renaissance of the 15th century. To this extent all pre- and proto-Renaissances in the long run remained fruitless, and if such movements were not apparent in music, or only faintly so, yet the musicians at the beginning of the 15th century had begun at the same point as the plastic artists and writers. The older "renascences" were (according to Panofsky) limited and transient, the 15th-16th-century *rinascimento dell' antichità* was comprehensive and lasting. But just as traces of the antique spirit live on under cover of scholasticism and of Thomism, now and then rising to the surface, so all through the Renaissance run undercurrents of medieval thought, bursting forth with grim violence in events and personalities—Savonarola's revolt or Loyola's institution of reforms—in the dark gloom of the Inquisition and the persecution of witches or in attempts at social revolution like the Peasants' Revolt in Germany. Protestantism is indeed hardly to be thought of without the breakthrough of humanism, but is itself anything but a manifestation of "Renaissance spirit." "The Renaissance in no way includes the entire culture of the 16th century, only one of its most important aspects" (Huizinga, after Troeltsch), and the contrast between Middle Ages and Renaissance is in no way so great as Burckhardt believed.

Fully aware of a dawning "golden age," as Marsilio Ficino called it, the artists, the poets, and the musicians began to see themselves as "creators," their art as a creative activity and no longer as a mere imitation of given models. This distinguished them from their fellows in all previous centuries: the Middle Ages had paid homage to the view that nothing new could be created. Now such an optimism about culture as has probably never been granted with such overwhelming force to any later age, seized hold of everyone. The creative artist formed the individual work of art and thus shaped his time. For Machiavelli it is the great men who determine the course of things, who "make history"; for those who wrote about art it is the great creators who give form to the works of their own mind and thus continue to shape the spirit of their time. Never before had the individual been looked upon to such an

extent as of historical significance, an individual creator, and never before had each separate discipline of the arts been looked upon to such an extent as something to be shaped *sui generis,* as now, from the beginning of the 15th century on, frequently happens. Alberti believed that the artists of his time, like Brunelleschi, Ghiberti, Masaccio, Luca della Robbia, were superior to Antiquity; they produced something not only new, but higher than that much-worshipped age. The human spirit, *virtù,* is stronger than fate, *fortuna.* Alberti coined the bold phrase: "Tiene giogo la fortuna solo a chi se gli sommette." [3]

With this the Renaissance stands in complete contrast to the Middle Ages as well as to the life-sense of the epoch that brought forth the Baroque, and this feeling created something fundamentally new in all realms of art, including music, something the after-effects of which have still not died out today. Even though the Renaissance was a Proteus, as Huizinga says, there is no occasion to disavow its existence as a historical epoch. In laying out the periods of music history one does well to take to heart Huizinga's wise advice:

> The only rescue from the dilemma of setting exact limits to periods in history lies in the abandoning of every demand of exactitude. One should use the expressions in a manner measured and discreet, as they occur in the customary language of the historian. One should handle them with leeway, and not build houses on them which they cannot bear. One should beware of compressing them, or treading them out thin, as has happened with "Renaissance." One should bear in mind that every term that purports to express the nature or the quality of a period is already prejudicial. In using such terms one does better to forget that "Middle Ages" speaks of an intermediate stage, "Renaissance" of a rebirth. One should be ever ready to re-

3. "Fate holds the yoke only of him who submits himself to it." Preface to *I primi tre libri della famiglia,* 1441; quoted by Buck.

ject a term as soon as it loses its value in the light
cast by the nature of the particular case.[4]

With these reservations the concept "Renaissance" can herein-
after be applied to that period, in the 15th and 16th centuries, for
which it has been adopted in the terminology of universal history.

4. *The Task of Cultural History;* a different translation in *Men and
Ideas,* p. 74.

II

Music as Understood
by the Renaissance

 The key to the question: "When did the Renaissance begin in the history of music?" is delivered to us by that period's own understanding of itself, which comes to light as a spontaneous reaction, indeed a violent opposition to a past it found "barbaric." In the 15th century musicians, like painters, sculptors, writers, begin to feel their age as a "new" one, themselves as representatives of a "new" art. Herewith there emerges more or less clearly the idea of a general rebirth after the "lacuna" of the 5th to 14th centuries, after the "medio evo," as it was expressed by Marsilio Ficino among others. Like the other arts, music is reborn. The chief witnesses to this attitude are Johannes Tinctoris and Franchino Gafori, the former from an emphatically critical historian's angle, the latter more as a fighter for new esthetic views in music.

For Tinctoris the music of his time is a "nova ars"; he examines into its origins:

> At this time, consequently, the possibilities of our music have been so marvelously increased that there appears to be a new art, if I may so call it, whose fount and origin is held to be among the English, of whom Dunstable stood forth as chief. Contemporary with him in France were Dufay and Binchoys, to whom directly succeeded the moderns Ockeghem, Busnoys, Regis and Caron, who are the most excellent of all the composers I have ever heard. Nor can

the English, who are popularly said to shout while
the French sing, stand comparison with them. For
the French contrive music in the newest manner for
the new times, while the English continue to use one
and the same style of composition, which shows a
wretched poverty of invention.[5]

"Fount and origin" of the new art is the English group around
Dunstable; if (as the close of the passage seems to say) this
group is no longer at the very top, the "Gallici" from Dufay to
Ockeghem have after all taken its place. They have led the "marvel-
ous increase" of music still higher. With many of them—with
Antoine Busnois, Ockeghem, Firmin Caron, Guillaume Faugues,
Jacques Carlier, Robert Morton, even with Jacob Obrecht—Tinc-
toris had personal relations. He dedicated his *De natura et propri-
etate tonorum* in 1476 to Ockeghem, *maître de chapelle* and com-
poser to the Kings of France, and Busnois, cantor to the Duke of
Burgundy, and his *Tractatus alterationum* to Guillaume Guingnant,
protho-capellanus to the Duke of Milan. In his *Proportionale* he
cites examples from the compositions of lesser masters like Guil-
laume Lerouge, Jehan Pyllois, Petrus de Domarto, Faugues, Bou-
bert, Courbert, Cousin. In his theory of counterpoint he most posi-
tively states his belief in the "new time":

Further, although it seems beyond belief, there does
not exist a single piece of music, not composed
within the last forty years, that is regarded by the
learned as worth hearing. Yet at this present time,
not to mention innumerable singers of the most
beautiful diction, there flourish, whether by the ef-
fect of some celestial influence or by the force of
assiduous practice, countless composers, among
them Jean Ockeghem, Jean Regis, Antoine Busnois,
Firmin Caron, and Guillaume Faugues, who glory
in having studied this divine art under John Duns-

5. Translation from Oliver Strunk, ed., *Source Readings in Music
History*, New York, 1950, p. 195 (or paperback ed., *Source Readings . . . :
The Renaissance*, New York, 1965, p. 5).

table, Gilles Binchois, and Guillaume Dufay, re-
cently deceased. Nearly all the works of these men
exhale such sweetness that in my opinion they are
to be considered most suitable, not only for men
and heroes, but even for the immortal gods. In-
deed, I never hear them, I never examine them,
without coming away happier and more enlight-
ened. As Virgil took Homer for his model in that
divine work the *Aeneid,* so I, by Hercules, have
used these composers as models for my modest
works, and especially in the arrangement of the
concords I have plainly imitated their admirable
style of composing.[6]

Music has reached an incredible height; it is scarcely to be
understood how it got there. What the masters write who surround
Ockeghem (to treat them summarily as pupils of the Dufay gen-
eration) radiates a sweetness, a *suavitas* (*suavitas* and *varietas* are
for Tinctoris the definitive qualities of good music) that is bound
to please men, heroes, and gods. But this music has only been in
existence for some forty years: everything that was composed be-
fore this boundary line is rejected by the *eruditi*—in this one sen-
tence all the self-awareness but also all the presumption of the Re-
naissance comes to light. As Virgil leaned on Homer, so Tinctoris
in this book of his leans on the masters of the Ockeghem-Busnois
group, following their most laudable style of composing.

Never before in the literature had music been so sharply defined
as an independent art, subject to its own necessities, obeying its
own forces, never before had one epoch in music been so succinctly
regarded as ended and another as begun, never before had a group
of composers been so cleanly divided from another, whether earlier
or later. Groupings of this sort were beloved of Renaissance litera-
ture. In the field of music they are repeated in the *Sängergebeten*
(singers' prayers) of the time, as in Loyset Compère's *Omnium bo-
norum plena* (c. 1470), in the French *Déploration* of Jean Molinet
on the death of Ockeghem (*Nymphes des bois*), which Josquin set

6. *De arti contrapuncti,* 1477, in C. E. H. de Coussemaker, *Scriptorum
de musica medii aevi nova series,* Paris, 1864–76, IV, 77.

to music (c. 1496). Alberti considers Brunelleschi, Donatello, Ghiberti, Luca della Robbia as the group of artists that led the new age to its heights (hence comparable to the Dufay group in music); it is this group that reawakened Antiquity, but also surpassed it by far. A century later Vasari sees an epoch, begun with the *rinascita,* brought to maturity in the *maniera perfetta* of Leonardo da Vinci, Raphael, and Michelangelo, as Zarlino sees it in the work of Willaert and his contemporaries.

Gafori was far less radical than Tinctoris, handed on far more medieval tradition, but he exercised a wide influence, particularly through his *Practica musicae* (1496), through his *De harmonia musicorum instrumentorum opus* (1500, printed in 1518), and through his personal contacts. Like Tinctoris, the Netherlander in Naples, Gafori, the Italian in Milan, stood at the center of a widely radiating circle. He quotes Alberti; he impressed Marsilio Ficino; he was a friend of Leonardo da Vinci (who painted his portrait or had a pupil paint it). As conductor of the Cathedral choir (1484–1522) he was in close contact with his Netherlands colleague, the court chapelmaster Gaspar van Weerbecke, who worked in the service of Galeazzo Maria Sforza and Ludovico Moro, and through him, with the whole circle of Netherlanders in Milan: Josquin, Compère, Baude Cordier, Johannes Martini, Jacotin, Alexander Agricola. His writings taken as a whole are a "systematic theory of composition" [7] and to this extent a direct parallel to those of Tinctoris; the rules of counterpoint in his *Practica musicae* are very like those in Tinctoris's *Ars contrapuncti.* His own compositions show that mingling of *varietas* and *suavitas* (freely interpreted: of Netherlands skill in setting and Italian beauty of sound) which formed the ideal of the period (Tinctoris appears to have been less important as a composer). His many-sided literary and poetical activity reveals Gafori as a genuine humanist, and his theoretical writings as well as his compositions closely resemble in their striving for tonal simplification and chordal sonority the work of Josquin and his circle.

Tinctoris and Gafori were no beginning. The consciousness of

7. According to Claudio Sartori, in *Die Musik in Geschichte und Gegenwart* (hereinafter referred to as MGG), article *Gaffurius.*

belonging to a new age penetrated but slowly among the writers of
the 15th century, yet it does appear in Ramos de Pareja when on
occasion he says that the music of his time has risen by its own
power far above that of the older masters (*Musica practica,* 1482).
In the *Ritus canendi vetustissimus et novus* (c. 1458–64) of the
Carthusian Johannes Gallicus of Namur, on the other hand, tra-
dition predominates by far, despite the title; to think of a school [8]
beginning with Vittorino da Feltre and later leading via Gallicus to
Nicolo Burzio, Gafori, and the rest seems hazardous. One may
rather find indications of the new self-understanding as far back as
the treatise on counterpoint of Prosdocimus de Beldemandis writ-
ten about 1412 or the same author's treatise on the monochord of
1413; [9] since he belonged to Johannes Ciconia's circle in Padua
and was the teacher of Nicolaus Cusanus, one may perhaps assume
that we have here a first theoretical crystallizing out of the new
consciousness.

The grouping of composers' names continues in the 16th cen-
tury. In 1523 Pietro Aron—who in 1516 entered into a contro-
versy with Gafori, in 1521 was taken under the wing of Giovanni
Spataro in combating the *Errori di Franchino Gafori,* had per-
sonal relations with Josquin, Obrecht, Isaac, and Agricola, for
many years corresponded with Giovanni del Lago, and in his *Luci-
dario* made an important contribution to the theory of composition
of his time—in his *Il Toscanello in musica* could look back on the
intermediary Renaissance generation as a closed chapter in his-
tory: to him Obrecht, La Rue, Isaac, Orto, and Compère already
belong to the "old ones." [10] Just as Lanfranco (*Scintille di musica,*
1533) now and then holds up the writers, sculptors, painters, and
musicians of his time to certain highly esteemed representatives of
classical Antiquity as their heirs and successors, so Glarean
(*Dodecachordon,* 1547) compares Josquin with Virgil, Obrecht
with Ovid, La Rue with Horace, Isaac with Lucan, etc., and
Cosimo Bartoli (in his much-quoted *Ragionamenti accademici,*
1567) sees in Ockeghem the reawakener of music, as Donatello
was of sculpture, and in Josquin the absolute pinnacle of the music

8. Leo Schrade, in *Utrecht Congress Report, 1952,* p. 26.
9. Heinrich Hüschen, in MGG, article *Beldemandis.*
10. Cf. Schrade, *op. cit.* p. 29.

of his age, comparable with Michelangelo, the unequalled master of architecture, sculpture, and painting. With Lodovico Zacconi (*Prattica di musica,* I, 1592), as Schrade has shown, this self-understanding that still feels itself heir to *rinascita* peters out; for him, Josquin's generation is not only the central but also the oldest generation of Renaissance musicians, that of the "antichi"; second comes that of Adrian Willaert, Cristóbal de Morales, Cipriano de Rore, Zarlino, and Palestrina; and finally, as the youngest stratum, that of his own contemporaries, the musicians born around 1550.[11] At about the same time, however, a new movement begins with Vincenzo Galilei and Girolamo Mei, which turns in new directions and to which the entire *rinascita* is but a historic memory.

Tinctoris is probably the first writer who understood music as an autonomous art and could look upon it with the eyes of a historian, the first to succeed in freeing himself from a tradition that had grown stale, the first of many followers consciously to cast off as superfluous ballast the speculative theorems inherited from the Middle Ages, replacing them with a quite sober and critical experience in keeping with the nature of musical practice in his time (hence, too, his frequent quotations from contemporary compositions). From such experience he precisely formulated the principles defining the new music. Consonance and dissonance are to be judged only by the ear *(Diffinitorium musices,* 1474?). If Marchetto of Padua in his *Lucidarium* (first half of the 14th century) still defined the concept of *harmonia* as "ratio numerorum in acuto et gravi" [12] ("a numerical ratio of high and low [tones]"), Tinctoris tersely sets down "harmonia" = "euphonia" and defines it as "any amenity in congruous sound": "est amoenitas quaedam ex convenienti sono causata" (*Diffinitorium*). Gafori (1496) gives the same explanation for writing in three voices: "Harmonia est extremarum contrariumque vocum communi medio consonantias complectentium suavis atque congrua sonoritas" ("Harmony is the sweet consonance and congruent sonority of extreme and contrary voices held together by a middle voice"); which means nothing

11. Schrade, *op. cit.,* p. 31 ff.
12. According to Hüschen, in MGG, article *Marchettus.*

but "harmonia" = the triad. Stephanus Vanneus goes further
(*Recanetum de musica aurea*, 1537): "est concinnitas quaedum vo-
cum non similum" ("any concinnity of dissimilar voices"), thus sur-
rendering the harmonic concept of free choice of consonant tones
that go well together.[13]

Then at the height of the Renaissance Nicolò Vicentino (1555)
sees harmony fulfilled in the piling up of consonances: a composi-
tion must be "full of harmony," "without poverty of consonances,"
else it "will remain insipid"; for "the ears will feed [elsewhere
"graze"] upon consonances" (*L'antica musica*, IV, Ch. XXI).
Agreeable sound and satisfaction of the ear have now become the
highest command, empiricism is the principle of the new theory.
"With experience the mistress of things," Vicentino (*Libro della
Teorica*, Ch. I) can do away with all the hallowed heirlooms of
medieval speculation: "we have omitted speaking of all these things
because they are of no use whatever to us in our practice" (*op.
cit.*, Ch. XVI). The whole of venerable *musica theorica* is dealt
with in twelve pages of his approximately three-hundred-page
treatise. All interest goes to the practice of his own time, which
has risen so far above the *vecchi,* and the title *L'antica musica ri-
dotta alla moderna prattica* loudly announces the awareness that
Antiquity and the present are one, bridging the *lacuna:* we stand on
the shoulders of the *antichi,* but we have far surpassed them "in
making music much richer and more abundant . . . so that we
might move the listeners more than did the ancients."

Even a relic from the ancestral household furnishings so satu-
rated with tradition as Boethius's classification of music,[14] which
had remained alive throughout all changes in its principles until
Ugolino of Orvieto (c. 1400), was now thrown overboard. Tinc-
toris says, in sober and practical terms: "modulandi peritia, cantu
sonoque consistens" ("skill in music-making, consisting in song
and sound"); "musica armonica est illa quae per vocem praticca-
tur humanam" ("harmonic music is that practiced by the human
voice"); "musica organica est illa quae fit in instrumtis flatu so-
num causantibus" ("organic music is that made by instruments

13. Cf. Hüschen, in MGG, article *Harmonie.*
14. Cf. Gerhard Pietzsch, *Die Klassifikation der Musik von Boethius
bis Ugolino von Orvieto,* Halle, 1929.

causing sound by breath"); "musica rithmica est illa quae fit per instrumenta tactu sonum reddentia" ("rhythmic music is that in which instruments produce sound by touch"—stringed instruments being here included). That is all: music consists of sounds produced by the singing voice, by wind or other instruments (plucked, bowed, percussion). Nothing more about harmony of the spheres or of body and soul, about mystic and speculative "theorica," but also nothing about traditional mathematical *practica*. New sorts of classification appear, joining the pragmatism of Tinctoris. A division social in nature reminds one of the distinction Johannes de Grocheo made in the 14th century between "musica simplex vel civilis vel vulgaris pro illiteratis" ("simple music either refined or popular for the illiterate") and "musica composita vel regularis vel canonica pro litteratis" ("music composed by rule or by canon for the literate"); but what seems isolated and without historical connection in its time is followed in the Renaissance by a widespread and generally valid distinction between music for the refined taste of gentlemen and princes, "connoisseurs" and "amateurs" on the one hand, and on the other music for the daily needs of the *misera plebs*. "Music for the chamber" expressively so-called, confronts the music used for the Church and for public festivities.[15] Vicentino says quite unmistakably (I, Ch. IV):

> Chromatic and Enharmonic Music were reserved to different use from Diatonic music, because this [latter] was sung in public festivities in public places for the use of vulgar ears: but those were performed for the private recreation of Gentlemen and Princes for the use of refined ears in praise of great personages and heroes. Hence because of its wonderful sweetness, and not to deviate in any part from the excellence of the ancient Principles,

gentlemen and princes learned this resurrected chromatic and enharmonic music, this true *musica rinata,* music reborn, that was created only for refined occasions, for "refined ears," while at

15. Cf. Hermann Zenck, *Nicola Vicentinos L'Antica Musica* (1555), in *Festschrift Theodor Kroyer*, p. 86, and Edward E. Lowinsky, *Secret Chromatic Art*, p. 87 ff.

public festivals diatonic music was played for "vulgar ears." (As early as 1527 Baldassare Castiglione, in his *Cortegiano,* calls for "orecchie esercitate," practiced ears, and "auditori disposti ad udire," listeners disposed to hear.) The resurrection of the antique genera, with which Vicentino is so passionately concerned (the chromatic and the enharmonic as he thought they had been constituted), is the true mark of *musica moderna,* which he here equates with *musica riserbata.*[16]

Whatever individual opinion may associate with the much-disputed term "musica reservata," [17] which after the 1550s became a catchword for music in polite society—whether one may link it particularly with chromaticism, whether it relates rather to practices of setting or performance, whether it stands for particular types of composition—certain it is that the musical claims and attitudes of the Renaissance found their focus in the concept of *musica reservata.* This irridescent term has as much to do with the musical refinements of chamber music, with retrospection upon Antiquity in any form (whether in the shape of revived genera, revived meters, or revived vocal practices), as with the priority given to the text and with enhanced expression. For Vicentino the "subject of the words" comes first and occupies the foreground of all composition. The composer receives his impetus from the "concetto" ("concept"), the "passione" of the "orazione." Monteverdi's famous formula is close at hand. More vigorously than Zarlino, Vicentino worked out the antiquitizing idea, which harks back to Plato, that music must derive its meaning from the word. For the "moderno," composition in the Italian language, "composizione volgare," is the fascinating task before which "cose Latine" ("things Latin") are visibly retreating; the composer solves the problem through "imitating the nature of the words." Great is the difference between a "composition for singing in church and one to be sung in the chamber," and "the compositions are different according to the subjects on which they are made." The execution too must correspond with such differences: "thus the singer must consider the mind of the tone-poet, and similarly that of the vernacular, or

16. Recognition of this point is to be credited to Edward E. Lowinsky; cf. Ludwig Finscher in *Musikforschung,* XV (1962), 54–77, esp. 65 ff.
17. See B. Meier in MGG, article *Musica reservata.*

Latin, poet and express the meaning of the words with his voice and use different ways of singing" (IV, Chs. XXI and XLII; the latter bears the title "Regola da concertare cantando ogni sorte di compositione," hence already uses the term "perform in concert" for the types of vocal execution). Chamber music is to be performed gently, quietly, with diminutions, enlivened, varied; church music, on the contrary, simply, strongly, solemnly. Thus to the social classifications at the height of the Renaissance there is added for the first time a clearly defined (though not yet so called in words) classification according to styles; Vicentino distinguishes strictly between music "da cantare in chiesa" and "da cantare in camera" and as a third style there are also the "cose basse" ("the humble things") of popular music that border on "cose buffoni" ("the comic"). In the description of styles identifying features emerge that already broadly anticipate the *stylus gravis* and *luxurians* of the 17th century.

Highly significant is the fact that in this connection a further distinction in styles now appears that was quite unknown to the Middle Ages and that, so far as we know, hardly played a noticeable role even in the 15th century: namely, that according to nationality. "Ogni natione ha gli suoi accenti" ("every nation has its own accents") says Vicentino right in the first chapter of Book I, and later (IV, Ch. XXIX) details follow on the handling of the Latin, Italian, French, Spanish, and German languages in music; even Hungarian, Turkish, and Hebrew are alluded to. Though Vicentino may only be complying with a long-standing situation in practical composition, yet it is significant for the period's beginning awareness of "natural rights" that these differences are recognized, albeit in no more than a cursory remark, as is still often the case with writers of the 17th century. Not until the 18th century were national musics thought of as fundamentally different and opposing forces.

Vicentino was the boldest, most progressive, most extreme advocate of the new in the music of the Renaissance; with him on the one hand, Zarlino on the other, the self-understanding of the period expressed itself in two figures very different in nature, complementary to each other, in effect almost like symbols of the

spirit of the time. Zarlino became the guardian of a renewed and
modified tradition; he was a point of departure for those who
carried on the *prima pratica* in subsequent years, and in a certain
sense his influence as bearer of the heritage has remained active,
passing on beyond the Baroque into most recent periods of music
history. With Vicentino, on the other hand, the *seconda pratica*
could connect directly, as well in its efforts at rendering tonality
more flexible, at chromaticism, effective representation, and so
forth as in its requirement that *orazione* be *padrona della musica*—
speech the mistress of music—and finally in its highly serious intent
of reconstructing Greek music.

In Vicentino's *Antica musica ridotta alla moderna prattica*
Vincenzo Galilei (*Dialogo della musica antica e della moderna,*
1581), Girolamo Mei (*Discorso sopra la musica antica e moderna,*
1602), Count Giovanni Bardi, Ottavio Rinuccini, Giulio Caccini,
Jacopo Peri, Monteverdi found their own ideas represented, while
similarly Giovanni Maria Artusi, Scipione Cerreto, Lodovico Zac-
coni, Adriano Banchieri, G. A. Bontempi, to say nothing of the
writers of other nations, could follow the paths laid out in Zarlino's
Istitutioni (1558). In historical reality these lines naturally often
cross. But this also means that both Vicentino and Zarlino already
stood at the end of the Renaissance in the narrower sense. Zarlino,
looking back, brings together the ideas he derived from the works
of the composer groups from Ockeghem via Josquin and Gombert
to Willaert; he stands "as lawgiver in the arts at the end of that
glorious tradition"—not, indeed, of the *prima pratica* Zenck meant,
but of the Netherlands-Italian Renaissance; Vicentino roots in the
same tradition and does not disavow it, but his "restlessly ex-
perimenting mind . . . presses for change; he is intent upon the
new and the not-yet-been." [18]

The 15th-century writers on music may have come but slowly
to recognize that a new age had dawned, but after Tinctoris they
reveal this self-understanding more emphatically and often more
temperamentally. Whatever has outlived its day is everywhere
rejected; what does not correspond to the purposes and principles
of the *aurea aetas,* the golden age, must fall. A strong, youthful

18. Zenck, *Vicentino,* p. 101.

self-awareness wafts through the literature; where old and new meet there are disputations and controversies, the most renowned among them being that between Nicolò Vicentino and Vicente Lusitano, on which at Rome in 1551 a court of arbitration presided over by Ghiselin Danckerts and Bartolomé Escobedo passed judgment. Tinctoris's late treatise *De inventione et usu* (c. 1484), only fragmentarily preserved, is a sheer compendium of the musical practice of his time and was frequently imitated, especially by the Italian theorists—by Pietro Aron (*Toscanello,* 1523; *Lucidario,* 1545), by Stefanus Vanneus (*Recanetum,* 1533), by Giovanni Maria Lanfranco (*Scintille,* 1533); these are the writers of Willaert's circle, of whom Vicentino and Zarlino are the last. Among them are Gafori, Ramos de Pareja, Giovanni Spataro, and Giovanni del Lago, authoritative men who discreetly sought to unite tradition with the new. Fundamentally they all looked on music in the same way; they are all filled with the optimism of the new age, they all keep their distance from a dark epoch belonging to the past, from which they still for the most part know only the names of a few outstanding theorists like Johannes de Muris and Guido d' Arezzo.

The Magna Carta of music in the Renaissance age, its conclusive, encyclopedic self-portrait, drawn up in the fullness of its lifetime and yet unmistakably announcing a turning-point, is Zarlino's *Istitutioni harmoniche* (1558). The book surpasses Vicentino through its sober moderation and its maturity of temper, in which it presents the real situation of music at the end of the era rather than propagating a wishful picture of how it ought to be composed. That Zarlino, compared with Vicentino, appears conservative, even retrospective, is explained, aside from his didactic way of expressing himself, by his leaving tradition more room than Vicentino does and not sharing Vicentino's extreme modernism. The *Istitutioni* stand at the end of an epoch as the breviary of its ideas on music and (particularly in connection with Zarlino's later writings) its musical practice. Zarlino too is an empiricist. For him as for Tinctoris and Gafori music is realized in its sonorous embodiment. The inherited notions of *musica mundana* and *humana* are dealt with indeed, but obviously only as subjects to be known; the material of *musica theorica* is condensed into the

least possible compass. More strictly than Tinctoris or any other of
the writers Zarlino decrees the autonomy of music, and more
definitely than anyone else he demands its freedom from set pur-
poses. Linking up with the Aristotelian διαγωγὴ ἐλευθέριος ("free
play of the spirit") and probably under the influence of Castiglione,
he fixes the meaning of music in a formula pertinent to and com-
pulsory for the whole Renaissance as "to pass the time and enter-
tain oneself with virtuosity." [19] This contrasts as clearly with the
patristic assignment of uses to music in medieval *musica theorica*
as with the declamations of the Baroque musical theorists con-
cerning its pathetic character. "The science of music had its origin
. . . in hearing" (p. 6); music consists of "harmony born of
sounds and voices" (p. 25). Further determinants of the musical
work of art are the "fixed and proportionate number" (p. 88),
i.e. rhythm, and the *narratione* or *oratione* which contributes what
can be grasped by the senses and the psyche. In the combining of
these elements the vocal work of art (and in contrast to Vicentino,
only this is decisive for Zarlino) becomes the bearer of definite
affective character. The composer must therefore see to it "in the
best way he is able" that tones, harmony, and rhythm with the help
of mimesis "express the words contained in the text." [20] What
Zarlino is defining is the *ars perfecta* (the term stems from Glarean
and refers to the work of Josquin), the *buona maniera* of the
Renaissance in its perfected state, not yet in its final Baroque-
minded form. The musical elements of tone and rhythm are in
equilibrium and through *imitar le parole* are brought on the way
to their highest objective: to represent the affects to which the
sensitive auditor (to whom Zarlino dedicates a detailed descrip-
tion) will respond with understanding. Through Zarlino the *imitatio
naturae* became a decisive requirement of the declining Renais-
sance in its music. Thus one may explain, for example, that it was
an outstanding distinction for Palestrina when Vincenzo Galilei
once called him "quel grande imitatore della natura."

 19. Cf. Zenck, *Zarlinos "Istitutioni harmoniche" als Quelle zur
Musikanschauung der italienischen Renaissance,* in *Zeitschrift für Musikwis-
senschaft,* XII (1930), 552.
 20. Zarlino, *Sopplimenti,* 1588, p. 315, quoted from Zenck, *Zarlino,* p.
569, note 1.

These demands in conjunction with those of Vicentino laid one of the foundation stones for the turn to the Baroque. The work of art is autonomous, like the "perfect musician" who brings it forth. Artistic skill is certainly necessary. The highly developed technique of counterpoint is not put in question. But it may not be exercised for its own sake and must subordinate itself to *bellezza*. For Zarlino as for Vicentino the consonant chord is the esthetic basis of beauty. The voices may launch forth upon the most complicated contrapuntal paths: what really matters is that they should combine in harmonious sonority. One further step, and the Baroque will make the fundamental bass and the chord resting upon it the cornerstone of all composition. To a work of art so made the *ben disposto* listener will respond who devotes himself to art in free leisure and is able to appreciate the "beautiful and elegant procedure, with a *je-ne-sais-quoi* touched with gravity." [21] To the ideal of beauty in the consonant setting of equal voices corresponds the ideal of the unified sound: the a-cappella sonority or that of a setting for instruments of the same family (viols, or flutes, etc.), the sound of the principal stop or the flute stop of the organ, or indeed a mixture of vocal and instrumental sounds that "blend" (Schering's word), in contrast to the "split" sonority of the Middle Ages and the Baroque. Music is held to be like fine discourse (the idea of discoursing in tones runs from Zarlino to C. P. E. Bach), but there is still lacking any closer tie with the theory of rhetorical disposition of *figurae* and *elegantiae*. The ancient modes were still taught but, as with Glarean (*Dodecachordon*, 1547), so also with Zarlino (1558) major and minor (the Ionian and the Aeolian) were in practice on the point of supplanting the old modes.

At the end of the Renaissance Zarlino and his contemporaries looked upon themselves as having brought to a close an age of "rebirth," an age still present to them, the gradual advance of which they could still survey, and which had reached its highest perfection in the group of Willaert and his pupils (to which Vicentino and Zarlino themselves of course belonged). On the very first page of his *Istitutioni* Zarlino says that Willaert "showed a rational order

21. Zarlino, *op. cit.*, p. 246 ff., quoted from Zenck, *Zarlino*, p. 557.

for composing any musical setting [*cantilena*] in an elegant manner, and has given clearest proof thereof in his composition." Barely a half-century later the Florentine monodists surrounding Bardi, Caccini, Peri, and Mei were to open the "battle against counterpoint." Barely a century after Zarlino the masters of the Renaissance were to be forgotten or, so far as they still lingered in memory, to survive, as we read in Giovanni Battista Doni (1594–1647), as an abomination from past times.

III

"Renaissance" as a Period
in Music History

After the 17th century the music of the Renaissance was increasingly forgotten. Only the memory of Lasso and Palestrina was from time to time reawakened through revivals of their works. Interest in the music of the 16th century (and later of the 15th) arose in the 19th entirely through performance and in connection with the efforts on behalf of "true church music" initiated by J. G. von Herder, K. A. von Mastiaux, E. T. A. Hoffmann, and others. In this, incipient research co-operated in the service of performance, as performance had previously stimulated and served research. Through A. F. J. Thibault, Giuseppe Baini, Carl von Winterfeld, through Karl Proske, C. K. G. von Tucher, R. G. Kiesewetter, F. J. Fétis, through E. A. Choron, J. A. L. de La Fage, Pietro Alfieri, C. F. Rimbault, William Horsley, and many others the music of the Renaisance was gradually moved back into the field of both performance and research, from which it had almost totally disappeared. This applied at first almost exclusively to church music. Only very gradually, in the second half of the 19th century, did interest in secular (vocal) music increase, more slowly still than in instrumental music. The reacquaintance with Renaissance music proceeded very much as did that with Greco-Roman Antiquity in the 18th and 19th centuries: as Greek art of classic and archaic times was first gradually mastered and understood through Roman copies and the late Hellenistic period, so the music of the Renaissance was made accessible through its late "manneristic" or late Baroque-minded stage, through Palestrina, Tomás Luis de Victoria, Giovanni Maria Nanino, Francesco

Soriano, in brief, through the Roman school, in which Lasso was more or less included.

If Forkel's and Winterfeld's historical picture was still altogether stamped by an idealized Palestrina cult that had found its focus in Baini, it was Kiesewetter and Fétis who first cleared the view over a "Netherlands period" in music history. The first historian who dared attempt to understand the "Renaissance" as a unified period in music was August Wilhelm Ambros of Prague. Volume III of his uncompleted presentation of music history as a whole, now almost a hundred years old (1868) and carried out with comprehensive knowledge and impartial clarity of judgment and to this extent still fundamental today, bears the title *Geschichte der Musik im Zeitalter der Renaissance bis zu Palestrina* (*History of Music in the Renaissance Period up to Palestrina*). The word "Renaissance" here naturally stands for the period, but his work shows at every turn how little Ambros himself took the unity of this period for granted. Whether his concept of the Renaissance would have been possible without Burckhardt's *Civilization of the Renaissance* (1860) may remain open; Burckhardt is occasionally mentioned,[22] but for his *Cicerone* (first published in 1855), not for his *Civilization*. For the rest, Ambros derives his views from Goethe's *Italienische Reise* (*Italian Journey*), Gregorovius's *History of the City of Rome,* and various art historians. In music history there was not much to draw on save such authors as Forkel, Baini, and Fétis. It is therefore the more remarkable that on the basis of so few preliminary studies Ambros could treat his subject with such completeness. He organized the whole period substantially as it is still understood in our time, introducing a structural arrangement that is on the whole (despite certain alterations) maintained in present-day writings. His greatest contribution is perhaps to have laid down the proportions and the highlights as they are still distributed today (always except for changes in detail). Predominant in the foreground he places the Netherlanders, primarily with the group around Ockeghem and Obrecht, then with Josquin des Prez as the central figure, and with a third group that he centers chiefly around Gombert. German

22. Ambros, III, 8; also IV, 50.

music of the 15th-16th centuries is dealt with in detail; of the French, English, and Spanish music of the time he knew comparatively little. The Venetians then constitute a second main group, headed by Willaert and Rore with whom Ambros links first their Italian followers, then the "German, Venetian-educated school of composers." A third section of the book begins with the Italians and Spaniards of the time of Leo X and was originally intended to lead up to Palestrina. The fact that Ambros could not bring this master in until Volume IV disturbs the balance, as does his having already dealt with the Dufay-Busnois group in his second volume.

Aside from much lack of material and from these particular shortcomings, Ambros was after all the first historian who succeeded in grasping the period as a whole, even if with much vacillation and effort. That a historical period complete in itself should reach from the "medieval remnants" in Dufay to the perfection of Palestrina was a view difficult to achieve. He first calls the 15th century "at once close of the Middle Ages and beginning of the new age" (p. 4). Then: "In Italy one can no longer count this 15th century in with the Middle Ages. It is otherwise in Germany" (p. 5). That there is no contradiction between the *Kunststück* (the artfully constructed piece—such as one in complex canon technique, etc.) and the *Kunstwerk* (the work of art), and that the music of the Netherlanders, even if it was rooted in "the soil of the Middle Ages," put forth "its leaves and blossoms in the mild sunlight of the Renaissance . . . which gave them cleaner forms and warmer colors" sounds easily said but was for Ambros the fruit of understanding won through much hard struggle.

Ambros laid the foundation in both universal history and music history upon which André Pirro was able to continue building some seventy years later with his *Histoire de la musique de la fin du XIVe siècle à la fin du XVIe* (1940), now including the Dufay group at the one end and the Palestrina circle at the other, and supplemented by countless further new sources and detailed information, but without questioning Ambros's conception of the "Renaissance." Heinrich Besseler (*Die Musik des Mittelalters und der Renaissance,* 1931), avoided drawing a sharp boundary line,

and attempted through inclusion of a "Burgundian epoch" to do justice to the special "late Gothic" developments of the northern countries, in which to be sure, he also included the specifically Italian beginnings of Renaissance music. When he then summarizes the Renaissance period in the narrower sense in a chapter entitled "Das niederländische Zeitalter" ("The Netherlandish Period"), a split results between North and South, between the 15th and the 16th centuries, between the early and the late Netherlands, putting the unity of the period more or less in question.

The concept of the Renaissance is dangerously diluted in the *Storia della Musica* (I, 1939) of Francesco Abbiati, for whom the era of *Bürgertum,* of guilds, the Hanseatic League, the culture of the Netherlands cities, of Pope John XXII and Jean de Muris, as well as that of Machaut, already count as parts of the Renaissance. Since the *trecento* is here organized by countries, the *quattrocento* partly by schools, partly by the invention of music printing, and partly as "L'Umanesimo nelle forme d'arte populari," but the *cinquecento* by persons and types of composition, the comparatively unified picture drawn by Ambros is completely lost.

In Curt Sachs's *Our Musical Heritage* (1948, 2nd ed. 1955) "Renaissance" oddly enough appears only as a subtitle to Chapter 8, "The Age of Dufay," and the 15th and 16th centuries are organized simply in groups of personalities. For him the Renaissance is to a much higher degree a rebirth of the Italian spirit after centuries of "barbaric," "Gothic" ways of thinking than a rebirth of Antiquity. "Boldly, it established the right of the senses against the spirit, the right of personal experience and judgment versus authority, the right of individual against collective mentality" (p. 100 ff.). There is an echo of Burckhardt's and Ambros's ideas when he says that the result of this process was the victory of the classical ideals of equilibrium, clarity, simplicity, and accuracy in structure, and the importation of Netherlands and Burgundian musicians led merely to the adaptation of their own native, Gothic style to the taste of the Italian Renaissance. Here a far too simplified view from the history of the plastic arts has been transferred to music. Yet Sachs did not overlook the strong contrasts and fluctuations between the styles of the various groups, and he sought

to explain them by a periodic pendulum motion. Thus he says of the composers around Ockeghem, Obrecht, and Finck: "The tidal law, manifest in aesthetic reversals from age to age . . . interrupted the classical trends of the Renaissance in the 1460s. The arts went back to picturesqueness, haste, and stress on action and feeling. And music went with them." Similarly with the two High Renaissance phases, 1500–1530 and 1530–1565, that Sachs sets up. Even though this is too much simplified, it is still an attempt to grasp the inherent contradictions of the period under the idea of a unified epoch.

Though from a quite independent angle, Hugo Riemann came close to the view of the French and Italian historians. After having permitted himself in Volume I, 2 of his *Handbuch der Musik-geschichte* (1905) to extend the Middle Ages into the 15th century, he felt obliged to offer a formal apology in the "Foreword" to II, 1 (1907): the discovery of the Florentine *trecento* compelled him to "close the musical Middle Ages as early as 1300 instead of with 1450." The discovery of "the secular art-song with instrumental accompaniment," the "flowering period" of which henceforth embraces the 14th and 15th centuries, obliged Riemann to recognize that the music of the 15th-16th centuries had been "a highly respectable flowering of a style that combined an artistic singing with instrumental accompaniment" and hence monody in the 17th century had been nothing new. He understands by the Renaissance period the centuries before *ars nova* up to Palestrina and the beginnings of instrumental music. Thus from his own point of view it is inconsistent of Riemann to cut off this period around 1600 and treat it in Volume II, 2 as the "Age of Thorough-bass."

Charles van den Borren (*Geschiedenis van de Muziek in de Nederlanden,* I, 1959), again organizes the period from a point of view entirely his own, including the whole history of Netherlands music in the 15th century from Dufay to La Rue, Isaac, Tinctoris, and the rest in "a century of Burgundian dukes," and has "The Renaissance" (Ch. 3, p. 230 ff.) begin only with the "triumph of the style of pervasive imitation" first achieved in 1520–1550 by Jean Mouton, Jean Richafort, Willaert, Gombert,

Clemens non Papa, Philippe Verdelot, Jacques Arcadelt, Cipriano de Rore, and many other Netherlanders in Italy; the Renaissance age then rounds off the second half of the century with the stage of "classical polyphony." Van den Borren's reasoning is as careful as it is characteristic (p. 230):

> The title of this chapter should cause no confusion. One must understand that it refers to the great 16th-century renaissance and not to the renaissance that took place during the *trecento* and the *quattrocento* chiefly in Italy . . . One cannot deny that this first, primitive renaissance was a prelude of inestimable importance to the second but it is equally certain that for the areas north of the [Italian] peninsula it was no more than a ferment that could work out its effect only after a long time, as it then actually did. Especially in art. In fact art in the Netherlands was dominated until the last years of the 15th century by the spirit of the Middle Ages . . .

A pertinent limitation from the Netherlands point of view but one in which the process that was probably decisive for the Renaissance as a whole—the blending of Italian temperament with northern tradition, the fertilizing of Italian music by Netherlands musicians—is pushed aside.

Van den Borren rightly observes that before the end of the 15th century none of the inherited forms freed themselves from the Gothic, though he himself on the other hand holds the "Gothic" overhang to be rather a question of technique, while the content increasingly filled the decorative-symbolic medieval element with human features. If, on the strength of van den Borren's argument, the spirit of the Renaissance took hold even of Netherlands music only after Charles V was crowned German Emperor (1520), and if in this way figures like Isaac, La Rue, and Josquin become "transitional masters" in whom the "inspired and arbitrary" dominates and "classical" traits appear only occasionally, it becomes clear that the model from which van den Borren drew his conclusions was not Glarean's ideal of *ars perfecta* as it applied

to Josquin but the late Renaissance music of Willaert and his school.

The most extensive and most exhaustively detailed specialized volume as yet published on the subject, Gustave Reese's *Music in the Renaissance* (1954), does not broach the question of the principles that underlie the dating and organization of the period and uses the term "Renaissance" without further discussion to mean the time from Dufay to Palestrina and the Gabrielis. This convention has meanwhile been adopted in less comprehensive publications. No attempt is made to differentiate between Middle Ages and Renaissance, whereas Manfred Bukofzer's *Music in the Baroque Era* (1947), on the other hand, in a brilliant introductory chapter, "Renaissance versus Baroque Music," has convincingly set forth the contrasts and the differences between the outgoing Renaissance and the beginnings of the Baroque.

The most recent comprehensive discussion, *Ars Nova and the Renaissance, 1300–1540* (*New Oxford History of Music,* III, 1960), gets around the problems both of dates and of inner unity by arranging the subject according to countries and species of composition and breaks up the history of the era (carried only to 1540) into a series of individual developments, occurring more or less independently of each other, so that, for example, English music of the 15th century appears in three separate and independent chapters, Netherlands music in two.

Widely divergent as are the consequences of all this for the writing of music history, it is not to be overlooked that the concept "Renaissance" has become firmly entrenched and that the principles on which it is based are in the main those stemming from the Burckhardt-Ambros tradition. Only with regard to geographical (and hence indirectly to chronological) extent and relationships are there profound differences, called forth by the fallacious implication that music in Northern Europe followed a course of development essentially divergent from that in the South. The fallacy rests on the fact that in the North (as van den Borren recognized) the "hangover" of the Middle Ages lasted longer than in the South (just as Gothic architecture lived for a century longer in the North than in the South) and the new species and

forms of the Netherlands-Italian Renaissance made their way much
more slowly there than in Italy or even Spain. Hangovers of this
sort are to be found in every style-period (cf. *Baroque Music,*
Chapters VIb and VII); they can obscure the picture, but they
change nothing in its basic features. Medieval survivals extend in
greater or less degree from Dufay to Palestrina. But the late
medieval species and techniques—like the isorhythmic motets, the
polyphonic French ballades, rondeaux, virelais, chaces, the cor-
responding older-style Italian madrigals, the ballate and cacce,
fauxbourdon, and so forth—disappear at about this time together
with the monophonic Latin song, the Minnelied, the rich literature
of monophonic lauds, carols, etc., or are transmuted into rigid
conventions; new species and techniques begin somewhere around
the middle of the 15th century to develop along their own lines,
remaining fruitful until, around 1570, they are replaced by the
new affective pathetic style of the early Baroque, when they them-
selves in turn become hangovers of style and rigid convention. By
convention the end of the Renaissance is still usually considered
to include the time of Luca Marenzio, the late Lasso, and the late
Palestrina, but this time should far rather be understood as an
early stage of the Baroque, (cf. *Baroque Music,* Chapters II, III,
and VII).

The question remains open whether an intermediary stage of
"mannerism" should be inserted in the writing of music history
as it is in the history of art and literature.[23] One will in any case do
well, if one does not wish to rob the concept "Renaissance" of all
pregnance, not to stretch its boundaries out beyond a period
reaching from approximately the middle of Dufay's lifetime to
the declining years of the Willaert school, to Zarlino and Rore, to
Vicentino and Gombert, to Clemens non Papa, and at most to
Andrea Gabrieli, and to see the core of the era in the merging of
Netherlands and Italian elements in the 15th-16th centuries. In
how far the special developments in the northern countries are
thus to be included under "Renaissance" or to remain isolated
is another question.

23. Cf. *Manierismo, Barocco, Rococò: concetti e termini* (Accademia
nazionale dei Lincei, CCCLIX, No. 52), Rome, 1962.

IV

South and North. The Nations and the Types of Composition

Tinctoris bore witness (in 1477) to the fact that not until "around the fourth decade" (1430–40) had anything been composed "held worth hearing by the learned"; the origin of such new-style music had lain with the Englishmen around Dunstable, whose place had then been taken by the "Gallici" around Dufay. This leaves no doubt when and with whom the new era had, in its own estimation, begun. The delimitation coincides with the recognizable features of inherited music and the beginning of "Netherlands" predominance in Europe. If French music had in the main held the field all through the 14th century (the North Italian *ars nova* had been able to gain only a limited currency in comparison, as the sources show), a shift took place around 1420–30 that unequivocally moved the "Netherlanders" into a position of leadership in European music that was to last a good century and a half. It is idle to argue about their "nationality," and special terms like "Franco-Flemish," "Burgundian," "Belgian," "Franco-Netherlandish," etc. serve no purpose because they always apply to only a part of the one and undisputed fact that by far the largest number of the leading musicians of the Renaissance period came from the narrow strip of country that today includes the Franco-Belgian region, Belgium, and the southern provinces of Holland— what in those days were the earldoms of Vermandois, Artois, Hainault, Flanders, the dukedom of Brabant, the bishoprics of Cambrai, Liège, and Utrecht, and so forth. For them the designation "Netherlanders," customary since Kiesewetter and Fétis and in its old sense implying no specific nationality, is still the most

fitting.

From about 1430 to 1570 these Netherlanders occupied the
leading positions not only in their homelands but also in the
Italian cities, residences, and cathedrals, at the Habsburg court
and in many German court households large and small, in
Habsburg Spain, and elsewhere. They were not only the *magistri
puerorum,* those Masters of the Children who trained the chapel
choirboys, conductors and composers, but also the performing
singers, even the instrumentalists and the copyists. Their music
had, as is shown by 15th-century manuscripts and after that by
the printed sources too, absolute and international validity. In
France and England their influence lay rather in the effect their
compositions exerted on the formation of style, their personal
activities receding into the background. The relationship between
this upper rank of Netherlanders and the ranks of national musi-
cians and types of composition varied from country to country. In
Burgundy the Netherlanders simply predominated. In France, after
the death of Ockeghem, the native musicians soon took the place
of the Netherlanders. England developed in its own way during
the Renaissance period, largely quite independently of the Con-
tinent. In Germany German music and German musicians still oc-
cupied the foreground through the 15th and early 16th centuries
and only during the course of the 16th did the Netherlanders take
over. In Italy there obviously took place a lasting and progressive
interpenetration between Netherlands and Italian music in which
the Italian musicians themselves stood in the shadow of the Nether-
landers throughout the entire period; not until the generation of Pal-
estrina did the Netherlanders withdraw, leaving open for the Italians
the way to the leading position they were to occupy in the Baroque
period. Spanish musicians, it is true, played an important part
in foreign countries (especially in the Papal Chapel) in the late
15th and early 16th centuries and were also doing not unimportant
work in Spain, but they too were driven into the background by
the pre-eminence of the Netherlanders and first began taking part
in the "European concert" perhaps with Cristóbal de Morales.

The years from the close of the 1300s to 1420, which, roughly
speaking, correspond to those of the Great Schism in the Western

Church (1378–1417), were a time of transition. Its musical heritage consists mainly of secular music, the French types of which, like ballade and virelai, together with the Italian ballata and (old-style) madrigal constitute a strong medieval hangover and but slowly undergo change. Pieces are still composed in often extremely complicated rhythm and are often extremely dissonant; three-voice writing is the rule, though two and four voices are not unusual. The strict isorhythmic motet, mostly of secular, festal or ferial, illustrative, and more rarely liturgical content, lives on in its various inherited forms. Masses are composed almost exclusively in individual sections and start out from the pattern of motet, conductus, ballade, etc. First attempts at the later parody Mass are evident here, especially with Ciconia. The foundation for the unified through-composed cyclic Mass seems to have been laid in the England of Dunstable, Leonel Power, and John Benet. Yet no new direction in style, to say nothing of any central tendency, is to be found in any type of composition. Composers functioning at the Burgundian court and in France during this transitional time were Pierre Fontayne, Nicolas Grenon, Guillaume Ruby, Richard de Bellengues (also called Cardot), Jean Tapissier, Johannes Carmen, Jean Césaris, Richard de Loqueville, Tailhandier, Guillaume Legrant, Simon Hasprois, Gilet Velut, Alain (Alanus, Aleyn), and others. In Rome, Baude Cordier of Rheims was active early, later also Guillaume Legrant, and after the reorganization of the Papal Chapel by Pope Martin V (whose election ended the schism), so were Grenon, Pyllois, G. Fontayne, and Arnold and Hugo de Lantins. Johannes de Limburgia and other Netherlanders working partly with Dufay in Rome and active through much of his lifetime, may have belonged temporarily to that institution also.

In Italy the practice of choral polyphony seems. to have come up at this time, judging by the introduction of choirbooks in large format; according to Bukofzer [24] this happened about the middle of the century, and already in antiphonal form. Among the Italian names we meet here—Antonio da Cividale, Cristòforo da Feltre, Gratiosus of Padua—the most important is that of Matteo

24. *Studies in Medieval and Renaissance Music,* p. 176 ff.

da Perugia in Milan. His successor at the Cathedral there was the
Provençal Beltrame Feraguti, who (according to Pirrotta) is iden-
tified with Bertrand of Avignon. Also active at this time was
Johannes Ciconia, probably the most important forerunner of the
coming Netherlands invasion of Italy. During the Great Schism
the Papal Chapel was made up preponderantly of Liègeois and
French musicians; with Pope Martin V's reform it became a center
for the cultivation of music in Italy and a magnet for musicians
from the North. In this general connection Ciconia too, who
worked for a while in Padua with Prosdocimus de Beldemandis
and Gratiosus of Padua, may have come to Italy from Liège.

England occupied a special position during the time of transi-
tion. Most of the masters of the Old Hall MS—the older ones like
Bittering, Fonteyns, Mayshuet (Mayhuet de Joan), Pycard, "Roy
Henry" (Henry V), but also the younger like Thomas Damett and
Nicolas Sturgeon—are still linked to the French tradition though
favoring English usages. Mass sections in the most various styles
are innumerable, like motets for festal and ferial days and partic-
ularly Marian antiphons; both groups still have in common with
continental music a wealth of dissonance and rhythmic complexity.
With Dunstable and his contemporaries—John Pyamour, Leonel
Power, Forest, John Benet, Bedingham, John Plummer, the very
group with which Martin le Franc and Tinctoris were linked—
something new appeared: the *contenance angloise*. It consisted
(says Bukofzer) mainly in a transition to euphony, a "pan-con-
sonant style" (Besseler's term) which further developed the old
English preference for the effects of thirds and sixths by sharply
restricting free syncopational dissonance to the prepared dissonance
of suspensions, hence to an emphatically more consonant style,
and led the rhythmically splintered, short melodic phrases of the
older music to unfold in a more singing melodiousness, thus laying
the groundwork for the *nouvelle pratique de faire frisque con-
sonance* of Binchois and Dufay.

In Dunstable's later works the lyricism of the song-like motet
in three-voice "cantilena setting," mostly on Marian texts, out-
weighs the stiffening isorhythmic festal or ferial motet; simultane-
ously there appears the beginning of cyclical composition of the

Mass (at first only partially cyclical, but then fully so) on common head-motifs or a common liturgical cantus firmus in the tenor. All these changes exerted a strong influence on the Continent: according to Bukofzer, the dividing line between Middle Ages and Renaissance is to be clearly drawn with Dunstable. Walter Frye and Robert Morton already belong to the age-group and the circle under Dufay's influence.

With Dufay the blending of the English tradition with the remnants of the French *ars nova* is consummated; with him and his contemporaries there follows also, after the Netherlands invasion of Italy had begun, the absorption of the older Italian music into the new "panconsonant" and fully harmonic structure. With him too begins the "new music" to which Tinctoris refers, marked by a flowing song-like quality and the desire for harmonic richness, gradually also by the prevalence of four-voice polyphony and (perhaps) by suppression of instrumental participation and increase in purely vocal performance. With him the preponderantly secular music of the transitional period gives way to sacred and liturgical church music. Fauxbourdon, modeled on the English discant and used in all purity by Dufay in his hymn-cycle (probably composed in Rome) as well as in his Magnificat verse settings, and first evident in his *Missa Sancti Jacobi* (says Besseler), penetrates with its chordal richness the other categories of music, especially those of church music. The demand for fullness of sonority everywhere increases. The harmonic foundation of composition becomes more and more tonal in the sense of later times. What Vicentino and Zarlino would be requiring of *armonia* at the end of the Renaissance period was now being realized for the first time.

After the example of the English, Dufay takes over the Mass-cycle, which at first he still links together by means of Proper sections, later developing it into the five-section Ordinary-cycle on a single tenor melody, at first liturgical, later as a rule secular. His *Missa Caput* perhaps follows an English model (Bukofzer). From mid-15th century on this type of Mass became an exercise for every composer; its construction upon a tenor cantus firmus in long note-values that is then mostly schematically shortened movement by movement remained exemplary into the early 16th century and

was still cultivated as an archaic show-piece up to Palestrina's time and later.

The motet too undergoes alteration, changing gradually, from the isorhythmic type with several texts to which it clung at first— a type written mainly for presentation at court or on state occasions —into the liturgical Latin tenor-motet. Beside it stands (probably intended for devotional purposes) the little three-voice song-like motet with lively figuration of the cantus firmus in the discant and two supporting instrumental voices, a species that reached its finest flowering with Dufay, distinguished by the melodious flow of the singing voice and the supporting harmonic function of the instruments as well as by its relatively rich sonority. The tenor-motet, finally represented by Johannes Regis, later becomes the "playground of the craftsman's clever tricks," [25] while the choral motet is gradually remodeled into the homogeneous piece of equal voices which then from Ockeghem's time on remained a basic form throughout the Renaissance (and beyond). At the same time the text repertory of the motet broadens out, absorbing, in addition to the previously popular Marian antiphons, cantica, sequences, and other elements of the liturgy. The secular song of Dufay and his contemporaries prefers the "cantilena setting" (Besseler) with leading superius and two supporting instrumental voices; in contrast to the preceding period the terseness, brevity, and simplicity of the forms—which in this area too are marked by melodiousness and relative fullness of sonority, by a wealth of thirds and sixths, and by clearly structural cadences—are striking.

The interrelationships of elements contributing to this development have heretofore been insufficiently studied in detail. This is especially true of the question to what extent and at what centers of activity the individual composers played a part in it. In Italy, Guillaume (Vincent?) Faugues, Beltrame Feraguti, Reginaldus Liebert, Johannes de Limburgia among others worked from time to time together with and after Dufay. Gilles Binchois was active exclusively in Paris and Burgundy. Presumably François de Gembloux, Hubert de Salinis, Jacobus Vide, and others lived mostly

25. Ludwig Finscher calls it the "Tummelplatz handwerklicher Kunststücke."

in the North. In Dufay's immediate surroundings one may prob-
ably include Johannes Regis, Jean Brassart, de Sarto, and Arnold
and Hugo de Lantins. The Englishmen active at the Burgundian
court, Walter Frye and Robert Morton, have already been mem-
tioned.

With Dufay's generation leadership of European music had
unquestionably passed to the Netherlanders. In the second half of
the 15th century English music went through a period of culti-
vating an insular self-reliance, capsuled off as it were, and in spite
of important achievements, especially by the masters of the Eton
MS 178 (among them Lambe, Richard Davy, Wylkinson, William
Cornysh, Robert Fayrfax, Gilbert Banister) contributed hardly
anything to the general European development (although shortly
after the middle of the century the first polyphonic compositions
—Passion sections, mystery plays, processional songs—made their
appearance in England). Italian and Spanish musicians begin to
count only toward the very end of the century, and then only in
special fields of composition. The first examples of German poly-
phonic music—like the *Lochamer* (*Locheimer*) *Liederbuch* (1452–
60), the *Hartmann Schedel Liederbuch* (c. 1460), the *Glogauer
Liederbuch* (after 1470), and other smaller sources—begin linked
to the masters of the Franco-Netherlands secular song, then with
the four-voice tenor song evolves an independent type that at first
remains outside the general European complex, but then in the
16th century is quite strongly influenced by the Netherlands-Italian
Renaissance. It is true for the whole period, however, that the
different nations did not, as in the Baroque, form national styles
in the various usual musical species, styles that in turn reacted on
the general European development. To the extent that the non-
Netherlands composers dip into the stream of Netherlands-Italian
development, they are completely assimilated and in many cases
then achieve European rank. Insofar as they do not do this, they
engender in separate, more or less marginal areas, national charac-
teristics that remain special cases without effect as a rule on the
general history of the period. The only special national species
that exerted any influence—in this case, a particularly deep in-
fluence—was the Italian frottola and its religious but non-liturgical

equivalent, the lauda.

Development remained at the beginning exclusively in the
hands of the leading Netherlands musicians, carried forward by
them with a certain consistency, even though a variety of medieval
remnants held out for a long time. Among these belong the much-
discussed arts of canon and mensuration, splendid exhibitions of
the composer's skill yet still limited in the main to Mass-
composition and not numerous enough to affect the picture. The
general development was much more concerned with casting off the
shackles of tradition. The remnants of isorhythm die off. The strict
forms of rondeau, ballade, and virelai give place to simpler and
more variable kinds of poetry, and in the art music other national
languages than French also appear, notably Italian and Flemish.
The dependence of motets and secular songs (except the German)
on a tenor is gradually abandoned. The differences in function of
the voices are leveled down in favor of increasing homogeneity.
The four registers of the human voice become the norms for the
vocal ranges in the artistic composition *a 4* that from now on is
itself the norm. With the increasing homogeneity, vocalization of
the parts also increases. In principle, from the generation of Oc-
keghem and Busnois on, every part is singable, even though practice
often deviates from this rule and expands far along instrumental
lines in treatment of the parts. One of the most remarkable proc-
esses is the reciprocal adaptation of the two species of composi-
tion, formerly so strictly differentiated, into the unified style of
ars perfecta, which towards 1500 develops more and more dis-
tinctly, itself the result of a fundamental upheaval in the practice
of composition: the old traditional technique of the successive
manner of composition is given up in favor of the simultaneous
conceiving and working out of the voices, as Johannes Cochlaeus
(1507), Pietro Aron (1516), and Auctor Lampadius (1537) al-
ready bear witness.[26] A couple of generations after Dufay the
esthetic and technical foundations of this new way of composing

26. Lowinsky, *On the Use of Scores by 16th Century Musicians,* in
Journal of the American Musicological Society, I (1948), 17; Suzanne
Clercx, *D'une ardoise aux partitions du XVIe siècle,* in *Melanges d'histoire
et d'esthetique musicales,* I (1955), 157; more recently Siegfried Hermelink,
Die Tabula compositoria, in *Festschrift Heinrich Besseler,* Leipzig, 1961,
p. 221.

were laid down; it became standard for the Renaissance period it-self and has remained so for all time since.

These changes went on over two generations, of which the first, the Ockeghem-Busnois group, was active from about the middle of the 15th century to around 1490 and the second, the Josquin-Obrecht-La Rue group, from about 1480 to 1520. The fact that in the works of the former (to which might further be added masters like Caron, Faugues, Hayne van Ghizeghem, and probably Johannes Martini, and among somewhat older composers also Johannes Regis and Jacobus Barbireau) antiquated traits are still often apparent and that this group's chief representatives worked continuously in the North, at the French and Burgundian courts, in Cambrai, Antwerp, and so forth (of those named only Caron and Martini seem to have been active at times in the South), has sometimes led to the erroneous idea that a "late Gothic-Burgundian" tendency in them had split them off from the Netherlands-Italian Renaissance represented by the second group. Such a view is in any case untenable because Ockeghem himself (even though Faugues in his Masses, Regis in his motets, Busnois or Barbireau in their chansons do occasionally produce an effect of archaic and artificial construction) was one of the most vigor-ous pathbreakers for the High-Renaissance style before mentioned and because, as we have seen, the greatest theorist of the century, Tinctoris, showed a preference for exemplifying the new style through the works of these very men, Ockeghem, Busnois, Caron, and the rest.

Tinctoris still belongs approximately to the same generation as Ockeghem's group. Born in 1436, he stood halfway between Ock-eghem and Obrecht in age and was only a few years older than Josquin; he spent the largest part of his life in Italy and was con-sequently there during almost the whole of Josquin's Italian work-ing period, but he demonstrates his points not by compositions of Josquin, La Rue, Compère, Weerbecke, or Isaac, but by those of the Ockeghem group, which for him brings to perfection the "musica auditu digna" ("music worthy to be heard") and in so doing proves that even a musician so steeped in Italian relation-ships regards this group as a member of the great complex that

reaches from Dufay into his own time.

Ockeghem himself was a highly independent individual. None of his Masses is worked out on the same scheme as the others: from the model of strictest double canon to entirely free forms, from the tenor-cantus-firmus Mass with parody insertions to cyclic construction through imitation of a head-motif, they are of every sort, and freedom of imagination is in no way restricted. His few motets stand on their own feet; his chansons show the masterful use of all the possibilities in techniques of setting, even pervading imitation in four-voices and canonic structure. His harmony, slightly harsh and full of dissonances, has at the same time nothing archaic about it, and the flow of his rhythmically uncommonly supple lines is immensely strong and vital. If such characteristic traits are lacking in the lesser masters of the group and if in consequence the structural skeleton of their compositions stands out more obviously, still they do not differ fundamentally from Ockeghem in their style. It is well, therefore, to include this group together with those composers born around 1440–50 in the first central Renaissance group.

How these composers are to be classified among themselves and how they belong together as schools is still for the most part unknown. In any case, to conclude from Guillaume Crétin's *Déploration* for Ockeghem that Josquin, La Rue, Weerbecke, and Compère were his pupils is hardly plausible. On the other hand, there is no doubt that these four masters, together with Isaac, Obrecht, Antoine Brumel, Alexander Agricola, Antoine and Robert de Févin, Marbriano de Orto, Antonius Divitis, Johannes Ghiselin (Verbonnet), Mattheus Pipelare, Elzéar Genet (Carpentras), Johannes Stokhem, Crispin van Stappen, and many other Netherlanders form a closed group, the centers of which lay not only in the Habsburg-Netherlands court households, especially the one in Milan, and in the Papal Chapel in Rome, but also in the ducal chapel of the Estes in Ferrara. Of these composers, so far as we know, only La Rue and Divitis were never in Italy (though both of them, like Agricola and de Orto, accompanied Philip the Handsome on his Spanish journeys); Brumel came there very late. Isaac, as musician to the Imperial chapel in Innsbruck and to the

Medici in Florence, stands somewhat outside the group, in which the famous composer and theorist Franchino Gafori, its only outstanding Italian member, is also to be included.

The Josquin group succeeded in developing a style as little imaginable without its heritage from the early Dufayan Renaissance as without the priority of Ockeghem and his contemporaries, a style that would also remain incomprehensible, however, if one did not take account of still another basic component, in the form of the Italian frottola and lauda music. If all other special national developments of the late 15th century are irrelevant to the central Netherlands-Italian Renaissance and without direct influence on it (and hence irrelevant to the whole progress of the Renaissance as an era in music), this one provides that element of youthful, fresh, half-popular, half-aristocratic national character which, fructified by the mature austerity of the Netherlands tradition, brought forth the central Renaissance style, that style which today may appear, as it appeared to Ambros, to be perhaps the purest expression of the Renaissance spirit in music.

Out of the purely Italian, half-popular heritage in the giustiniani (*arie veneziane*), the strambotti, canti carnascialeschi, frottole, canzoni for pageants (*trionfi*) and their decorated chariots (*carri*), and on the sacred side from the similarly half-popular tradition of the laude, there evolved soon after 1450 (and perhaps earlier) a polyphony—improvised at first, and rather simple, by about 1470–80 more artistic, then also fixed in written score—that obviously had no relation whatever to the high art of the Netherlanders, and obviously drew its nourishment from quite other sources. This polyphony rests at bottom on discant melody, the triad, and a clear major-minor harmony, and it only secondarily took up a rather more flexible semblance of polyphonic treatment of the voices. Its composers had from the very beginning been exclusively Italians and this continued to be the case later with few exceptions. In the hands of the ablest among them—Bartolomeo Tromboncino, Marco Cara, Giovanni Brocco, Michele Pesenti, Antonio Caprioli, J. B. Zesso, Sebastiano Festa, Giacomo Fogliano, and others, and for laude Pietro Capretto and Innocentius Dammonis as well—these species of composition emerged from semi-obscurity in the

late 15th century to become a recognized art for social occasions or for religious circles. The court of Isabella d'Este was the center of a highly literose composing of frottole. To the frottolists Petrucci devoted no less than eleven books (1504–14), to the laudists two (1508), of his many volumes of music. Fifteen other frottola books from the period 1510–31 (laude were not printed again till 1563) and countless manuscripts of both species speak for their extraordinary and widespread popularity, and so likewise does the guest-artist role that famous foreigners (like the Spaniard Juan Escribano, Isaac, Alexander Agricola, Johannes Japart, Compère, Genet, the most important being Josquin himself) played in the production of such compositions. The blending of this gay, light-hearted, and easily receptive popular art of the Italians (from about 1480 on) into the highly developed, firmly constructed, and tradition-based art the Netherlands masters brought with them from the North, must be looked upon as marking the birth-hour of the central Renaissance in music.

The name of Josquin des Prez stands for the Netherlands-Italian style of the central Renaissance. His work is an inclusive synthesis of all 15th-century tendencies and continued to influence the 16th century fundamentally. If the other great composers represent particular aspects of this style or particular types of composition in some ways more strongly than he, in versatility and effectiveness he overtops them all. No other member of this central group enjoyed such widespread and such lasting veneration. Ockeghem had laid down the outlines for the Mass cycle; neither Josquin himself nor any of his contemporaries overstepped them. From the traditional cantus-firmus Mass (on a secular or liturgical tenor), with or without schematic diminution, to imitation of or over the tenor material, to the parody Mass on a given model, or to quodlibet-like weaving of various *cantus prius facti,* also to the reworking of the different voices of pre-existent setting, and finally to the Mass in free imitation of chorale-motifs and to the quite freely invented Mass—all types are represented in Josquin's work. In the Mass as in motet and chanson his texture is perfectly homogeneous, save where some cantus firmus is emphasized or canons are built in. Pervading imitation has become a fun-

damental principle. Long-flowing, elegant, intricately woven lines alternate with chordal, homorhythmic declamation of text. Compact texture alternates with thinner use of voices, pairing of voices, a splitting up of texture, full polyphony with inserted duos or trios (often canonic).

The kind of setting he chooses depends a great deal on the text. With Josquin organization, construction, choice of motifs (insofar as this is free) for the first time manifestly serve interpretation of the word; a pregnant, grammatically correct textual declamation, in metrical texts often metered too, indicates the full breakthrough of humanism in music. The motets carry this further, to pictorial delineation and affective manner of expression. In this Josquin established the model for the intimate alliance of word and tone, so impressively advanced by the theorists at the close of the Renaissance, for deriving the music from the words of a language and for the pathos-laden blending of *orazione* and *armonia*. Herein too undoubtedly lies one of the reasons for his strong influence on contemporary musicians and those who were to follow, on theorists (from Gafori via Spataro and Glarean to Josquin's "prophet," Adriaen Petit Coclico, to Vicentino and Zarlino), and not least on laymen like Luther or Rabelais. Even Palestrina, Seth Calvisius, Thomas Morley, and not lastly Cesare Monteverdi still knew his works.

If Josquin found the Mass heavily burdened with traditional elements, he was freer to do as he pleased in the motet. Contributing to this was the basically important extension of the text repertory, which now took in the psalm, the Gospel, and even Old-Testament texts in addition to the customary antiphons, sequences, metrical poetry, etc. In Josquin's motets the cantus firmus took only a subordinate place, for the most part falling away altogether. Canon is comparatively rare. The greatest value is set on declamation, expression, and (on occasion) pictorial representation; texture extends from subtlest counterpoint to the pure homophony and homorhythm of the lauda (Josquin actually carries similarity to the point of complete identity: the same piece appears once with a Latin motet text, another time with an Italian lauda text).

Josquin's important secular compositions also make use of the

most varied techniques; in his chansons we see final rejection of
the forms of Busnois's time and the turning to a new manner of
treatment somewhat similar to the motet. In the greater part of his
works a state of equilibrium is achieved between soaring polyph-
ony and a vigorously penetrating basic feeling for harmony; it is
stamped with a highly impressive consciousness of form that unites
in itself exuberance and moderation. In comparison with Lasso or
Willaert, Josquin's style occasionally seemed to later times brittle
and dry. But one must not fail to realize that this judgment (Zar-
lino's, say) was pronounced by musicians of a later day who no
longer appreciated the clear stamp of the Renaissance feeling for
form in Josquin (much as the late 19th century frowned upon
Zelter's songs as brittle and dry in comparison with Schubert's),
no longer understanding that in just these songs the spirit of classi-
cism had left its purest imprint. Josquin was a contemporary of
Mantegna, Bramante, Botticelli, Ghirlandaio, and Leonardo da
Vinci; Willaert belongs to the age-level of Michelangelo and Titian.

What is evident in Josquin, especially in his "most mature"
works (the chronology is still not altogether clear: for example, it
is uncertain whether the six-voice motets are early works or a late
return to the subtle settings of his early period), is also to be found,
individually modified, but on the whole consistently in agreement,
among the other masters of the group. Isaac, in his Masses, per-
haps comes closest to him, but in his secular songs in various
languages stands out more sharply than Josquin through a sort of
cosmopolitan attitude (he is repeatedly said to have been of a
kindlier nature than the evidently proud, self-conscious Josquin)
and in his instrumental pieces he cultivated a type of composition
apparently otherwise neglected by his Netherlands contemporaries.
It was not by chance that his works received as wide or almost as
wide a circulation as Josquin's. La Rue too is especially closely re-
lated to Josquin in his Masses. Compère seems to equal him in
versatility, though his surviving compositions are far fewer. In
Obrecht, whose music had a particularly strong after-influence in
Germany, one already detects a slackening of Josquin's severe
economy of means and word-imposed declamation in favor of an
often fuller but less robust and far less smoothly woven texture;

one now and then has the impression of a certain semi-darkness in his works, almost a kind of *sfumato,* if that does not seem too venturesome for his time. Whether the southern Frenchman Genet is to be included in this generation or only in the next, still needs to be made clear; in what is known of his works, his style already deviates markedly.

While the Renaissance feeling for form was chiseling out its epochal style in this central Netherlands group working in Italy and mingling its art with that of frottola and lauda, and while France just at this period had come under the leadership of masters like Brumel, Antoine de Févin, Josquin himself, and Jean Mouton, compositions of special national character began to appear in Spain, England, and Germany. In Spain a distinctive type of polyphony first appeared with Juan Cornago in the second half of the 15th century; to what extent this had already been stimulated through the activity of the Netherlanders in Italy needs further investigation. Under the *reyes catolicos* Ferdinand and Isabella and their son the Infante Juan, whose *maestro de capilla* was Juan de Anchieta, it led to a wealth of production, as a considerable number of sources bear witness. Besides sacred music obviously influenced by the Netherlanders, polyphonic settings of vernacular texts are outstanding, especially those collected in the *Cancionero de Palacio* (end of the 15th century). Composers like Pedro Escobar, Francisco de Peñalosa, Juan del Encina (who was also active in Rome for a time), are represented mostly by villancicos *a 3,* offspring of the French virelai, usually in homophonic settings. Possible connections between this typically Spanish species and the Italian frottole are still unclear. One of the leaders, but in sacred music as well as in the secular music of the *Cancionero,* was a Netherlander, Johannes Urrede (Wreede, Vrede) of Bruges, in the service of the house of Alba. In Ferdinand's reign Ockeghem, Alexander Agricola, and Pierre de La Rue had been in Spain as guests. When Charles of Habsburg (later the emperor Charles V) took over the government in 1516 he brought along his *capilla flamenca* (Flemish performers); his empress, Isabella of Portugal, set up a Spanish musical establishment in 1526. The former took care of the church music for the court, the latter

mostly of secular and instrumental music. Under Charles V and
his son Philip II the Netherlanders and their music took prece-
dence; yet beside them a whole list of Spanish names is to be
noted. Numerous works of Josquin, Mouton, Gombert, Richafort,
Clemens non Papa, and other Netherlanders are preserved in
Spanish sources. Among the Spaniards themselves Antonio de
Ribera, Juan Escribano, Pedro Fernandez, and others stand out, and
in Cristóbal de Morales Spain finally produced a master ranking
with the other Europeans, on a level of style quite comparable to
Gombert, who often sojourned in Spain, or to Willaert in Italy. It
is to be assumed that Morales was also close to Gombert person-
ally. From time to time he was active in the Papal Chapel, first
together with Escribano, his senior, then with Bartolomé Escobedo,
Pedro Ordoñez, Melchior Robledo, Francisco Soto de Lanza,
and other Spaniards. If Morales was still entirely formed by Jos-
quin, Gombert, Mouton, Richafort, Verdelot, and the rest, the
Spanish school surrenders its special character completely with
later masters of the 16th century—like Francisco Guerrero, An-
drés Torrentes, the two Caballos—and blends in with the late
Netherlands-Italian Renaissance style of the Willaert group, while
at the same time new Netherlands composers, like Pierre de Man-
chicourt and Georges de la Hêle, keep going to work in Spain. The
period of characteristically Spanish production is therefore limited
in the main to the closing years of the 15th century, and only in
the instrumental field—with its important vihuelists, like Luis
Milán, Luis de Narváez, Alonzo de Mudarra, Enriquez de Val-
derrábano, Diego Pisador, Miguel de Fuenllana, Esteban Daza,
the viol-player Diego Ortiz, the organists and keyboard masters
Venegas de Henestrosa, Antonio de Cabezón, and others—did
Spain contribute significantly to the general history of music in
the Renaissance era, while leading its own national life. Essentially,
however, it kept out of the great current and exerted no notable
influence on the general development of music in that period.

In England Netherlands musicians of the closing 15th century
on through the 16th left no notable impression. After the Dun-
stable group had given a powerful impetus to the continental de-
velopment, English music relapsed into insular isolation. While

the fine arts of the Italian Renaissance began to penetrate into England in the early 16th century, mid-century music clung to a tradition more or less corresponding to that of the Ockeghem group on the Continent. The great manuscript collections of around 1500 still show the old repertory of Masses, Magnificats, and Marian antiphons, to which were added processional hymns, parts of the Passion, hymns, etc. Isorhythmic treatment was long preserved in the cyclic Mass, a Dufay-like treatment in song. The Eton Choirbook and several other collections are characterized by settings unusually strong as compared with continental custom (Eton, 5–9 voices). Marian antiphons keep the lively movement of outer voices over a tenor cantus firmus. Full sonority and density of texture combined with free imaginative treatment of the outer voices remains characteristic of English polyphony into the 1530s, quite contrary to Josquin's style or even Heinrich Finck's. The use of imitation penetrated the traditional forms of English church music only gradually toward mid-century, for example with John Taverner, John Redford, Richard Sampson, Thomas Tallis. It is significant that very few foreign musicians, like the Netherlander Benedikt de Opitiis, functioned in England. The old carol also, long become the song with most various content, sacred or secular, changes at about this time, in the hands of William Cornysh, Robert Fayrfax, and Taverner, under the influence of the French chanson. A particularly English species that came up around 1530 was the *In nomine,* set for an ensemble of three or four viols, first cultivated by Cornysh and Fayrfax; here one may possibly think of an influence from Isaac's instrumental pieces; the species lasted well into the 17th century. Keyboard music of mid-16th century transmitted in the *Mulliner Book* consists only of intabulations and adaptations of vocal music for viols.

Henry VIII's reforms (Supremacy Act, 1534) dealt the cultivation of English music a severe blow with the closing or destruction of many churches, monasteries, libraries, etc.; the foundations remained shattered until Elizabeth came to the throne (1558). With the masters who worked in this period of collapse and thereafter—John Merbecke (Marbeck), Christopher Tye, Robert White, John Shepherd, and Tallis—the tendency to full settings, rich so-

nority, and density of texture persisted, yet evidently some impetus from Netherlands-Italian music did reach England via the Netherlands. Besides church music on Latin texts, the setting of anthem, service, and psalm in English became a chief task of composers. Secular music took on continental traits more quickly and obviously than sacred music, as is shown by Thomas Whythorne's *Songes to three, fower and five voyces* (1571) on the pattern of the Neapolitan villanelle; yet the secular song of this period in England is represented in very few sources. The direction led in the 1560s and '70s to the English madrigal (first printing in Nicholas Yonge's *Musica Transalpina,* 1588), a highly original late-Renaissance flowering on the threshold of the Baroque period, which resulted from the intense absorption of the Italian model into English feeling. English musical practice throughout this whole time was far removed from that of the Continent and with all its high standing and all its originality remained an altogether and intrinsically English affair. Not until around 1600 did English music, above all through its viol and virginal players, begin once more to be fruitful for European music as a whole.

German music too, despite its own highly significant unfolding, remained apart from the general development until in the 16th century it fell more and more under the Netherlands influence, being obliged at times to leave leadership entirely to the Netherlanders. Practice in the main adhered to successive composition over a tenor cantus firmus (surely taken over from Busnois or Ockeghem or the late Dufay) in both sacred and secular production from the late 1400s into the 1530s, and in church music it makes no difference whether it was concerned with Latin or, after the Reformation, with German texts. Hymn, sequence, responsory, antiphon, or other Proper settings, and above all the secular song show preference for the embroidery (often without text) of the outer voices, twining happily about the tenor, independent and seldom bound by any imitative connection. Toward and around 1500 German polyphony came into vigorous bloom with masters like Adam of Fulda, Heinrich Finck, Paul Hofhaimer, Thomas Stoltzer, and Erasmus Lapicida, and radiated far into the East European countries (Poland, Bohemia, Hungary). Simultaneously

the works of the Netherlands composers of the Josquin group be-
gan to spread in Germany, with Obrecht, Alexander Agricola,
Compère, and Josquin in the foreground. The activity of Isaac on
German territory (Vienna, Innsbruck, Augsburg, Constance, per-
haps Torgau) may have contributed to bringing the special Ger-
man style closer to the central Netherlands-Italian Renaissance.
Yet composers like Stoltzer, Finck, and Hofhaimer cling tenaciously
to angular and "woodcut-like" leading of the outer voices and to
traditional forms; in this sense they continued to exert a profound
influence on later composers—Ludwig Senfl, Hans and Paul
Kugelmann, Johann Walter, Benedictus Ducis, Sixtus Dietrich,
Leonhard Paminger, Johannes Heugel. For this reason German
settings remained characteristically retrospective, for all the gradu-
ally increasing acceptance of Netherlands style elements. The set-
ting of Latin odes, of Horace and other antique or humanistic po-
ets, seems to have been a German specialty, even though this had
of course already been done by the Italian frottolists.

 In the 16th-century German *Liederbücher* from those of Arnt
von Aich (Aachen), Erhard Öglin, and Peter Schöffer (c. 1510–
13) to the great collection of Georg Forster (1539–56), not-
withstanding the constantly increasing headway made by Nether-
lands style elements, this conservative spirit predominates, as it
does in the polyphonic songbooks of the Lutheran Reformation
(Johann Walter, the collections of Georg Rhaw, Kugelmann, et al.).
So far as one can speak of a "German Renaissance," it centers
around Ludwig Senfl, and men of the same age, like Walter,
Arnold von Bruck, Sixtus Dietrich, Wilhelm Breitengraser, Lo-
renz Lemlin, Balthasar Resinarius, Stephen Mahu, and many oth-
ers. That their Latin church music, especially, closely approaches
the central Netherlands style is probably connected with the fact
that the works of Netherlanders like Josquin, Obrecht, Brumel,
Mouton, Isaac, Gombert, Willaert, Thomas Crecquillon, and oth-
ers up to Clemens non Papa quickly became known through the
music-publishing industry that flourished around 1530 in Nurem-
berg, Augsburg, Wittenberg, and elsewhere. Senfl himself, for ex-
ample, adapted Josquin's famous four-voice *Ave Maria . . .
virgo serena* for six voices; the funeral motet for Emperor Max-

imilian I, on the other hand, long attributed to him, was really the work of Costanzo Festa, its application to Maximilian being an adaptation.[27] It is to be noted, however, that around this same time and well into the 1550s, German music of the 15th century (Finck, Stoltzer, Hofhaimer) was still being published. Also to be noted perhaps is the obviously specially voluminous production in Germany of occasional compositions (epithalamia, symbola—i.e. musical settings of heraldic pieces, etc.). A younger generation of German composers, like Caspar Othmayr, Jobst vom Brandt, and others, cultivates older forms along with a newer, simpler, more popular type of lied, probably influenced by the French chanson, and with the sacred and secular bicinium and tricinium (two- and three-part piece), which catch up older style elements in a manner of their own and which persisted as a characteristically German type on into the 17th century. In Stoltzer it is already clear how the Netherlands model pervades his psalm compositions. As to Senfl, the influence of his teacher Isaac is often unmistakable.

Around 1530, too, the invasion began of those Netherlands musicians who were to occupy the leading positions at the German courts for half a century (Petrus Maessens and Jacob Vaet in Vienna, Mattheus LeMaistre in Dresden, Adriaen Petit Coclico in Königsberg, etc.) and with Lasso's moving to Munich (1556) the German musicians fell more and more under the spell of his powerful personality. His influence endured through those who were directly and indirectly his pupils: Germans like Johannes de Cleve, Jakob Reiner, Leonhard Lechner, Johann Eccard, Joachim a Burck, Netherlanders like Ivo de Vento and Anton Gosswin, Italians like Teodoro Riccio and Antonio Scandello, and so on to Gallus Dressler, Leonhart Schröter, Jacob Meiland, Georgius Otto, Hans Leo Hassler, Hieronymus Praetorius, Michael Praetorius, Philippus Dulichius, and so forth. How strongly a specifically German tradition persisted under these Netherlands overlayers Lasso's own German song settings show.

A scarcely less important influence spread at the same time

27. See Walter Gerstenberg, in his foreword to Ludwig Senfl: Zwei Marienmotetten (Das Chorwerk, LXII); also Alexander Main, Maximilian's Second-Hand Funeral Motet, in The Musical Quarterly, XLVIII (1962), 173.

from the Netherlands group in Prague—Philippe de Monte, Lambert de Sayve, Charles Luython, Jacques Regnart. Toward the end of the 16th century, when Netherlands predominance had come to an end in Italy and the *prima pratica* of the Roman and Venetian school had reached in its development to the threshold of the Baroque, this Italian music completely submerged German musical practice through the collections published by Friedrich Lindner (1558 ff.), Kaspar Hassler (1598 ff.) and others. In Germany, much as in Spain, freely composed instrumental music —here particularly for organ and keyboard (Leonhard Kleber, Hans Kotter, Elias Nicolaus Ammerbach) as well as for lute (Sebastian Ochsenkhun, the two Neusidlers, and others)—acquires characteristic form independent of vocal models. Yet seen as a whole, German music from the end of the 15th to the end of the 16th century, despite its high level and its originality, played only a receptive part in the "Renaissance"; like the architecture of its time, it had taken over forms but held fast to its own structures underneath these forms. The "Renaissance" in its full sense first came to Germany with the Netherlanders active there— that is, with the late stratum of Netherlands music that was itself already strongly Italianized.

While the nations were thus proceeding in their own directions as these were dictated by changing needs and changing taste, and participating in the central evolution but without influencing it, there had been forming among younger Netherlanders the second central Renaissance group, to which by this time Italian composers also belonged in increasing numbers and importance and which itself increasingly took on Italian traits. Its centers were the Papal Chapel in Rome, St. Mark's in Venice, cities and cathedrals like Florence, Bologna, Treviso, Padua, together with occasional princely courts like those of Ferrara, Mantua, Urbino, and others. Since its days of glory under Julius II and Leo X, the Papal Chapel had continued all through the 16th century and beyond to bring together the most important musicians, chiefly Netherlanders, Spaniards, Italians, and Frenchmen. In it one can see the process of amalgamation between the nations and the gradual development of that unified musical style which then in Palestrina's time

led to the blending of all differences in the style of the "Roman
School," to *prima pratica* in the strictest sense. The Chapel in Leo
X's day included, all at the same time, Andreas de Silva, Costanzo
Festa, Elzéar Genet, Francisco de Peñalosa, Gaspar van Weer-
becke, and numerous other natives of the four countries. In
Venice a group perhaps even more important for the general
development gathered around Adrian Willaert, who came from the
school of Josquin and Mouton and to whose own school (in both
the narrower and the broader sense) one may count as adherents
Girolamo Cavazzoni, Jacques Buus, Cipriano de Rore, Zarlino,
Maître Jean (perhaps identical with Giovanni Nasco), Vincenzo
Ruffo, Jhan Gero, Jachet of Mantua, Hubert Naich, and finally
Hubert Waelrant too, Claude Le Jeune, and Andrea Gabrieli. The
Willaert group connects directly in time with the Josquin group and
may be looked upon as *the* second central Netherlands-Italian
group.

Willaert had come to Italy in 1522 and became chapel
master at St. Mark's in 1527, in which post he remained until
his death in 1562. In this period too Netherlanders still frequently
occupied the leading positions in Italy, working in various places:
Jacques Arcadelt in Florence and Rome, Jean Richafort in Rome,
Dominique Phinot in Pesaro, Ghiselin Danckerts in the Sistine
Chapel, which he served under five popes (from Paul III to Pius
VI; in 1551 he acted together with Escobedo as judge in the
quarrel between Lusitano and Vicentino), Philippe Verdelot in
Florence, and so forth. While the Netherlanders penetrated into
England almost not at all, and into Germany not till the 1530s,
in Italy a new Netherlands generation, already the fourth in line,
were carrying on an old tradition. Towards the end of the century
they were even followed by another, a smaller group, also with
important names: Hermann Matthias Werrecore, Giaches de Wert,
Giovanni de Macque, and others. At the same time, however,
evidently in connection with the frottolists and laudists of the
early century, Italian musicians made their way into the fore-
ground, at first mainly in secular areas and in instrumental music,
then increasingly in church music as well: Costanzo Festa, Fran-
cesco Corteccia, Girolamo Parabosco, Nicolò Vicentino, Andrea

Gabrieli, Alessandro Striggio the elder, Luzzasco Luzzaschi, Costanzo Porta, the Roman group from Giovanni Animuccia to Luca Marenzio, Palestrina, the two Nanini (Giovanni Bernardino and Giovanni Maria), and in instrumental music such men as Girolamo Cavazzoni, Annibale Padovano, Parabosco, Claudio Merulo, Andrea Gabrieli. Toward the end of the century the number of Italians active is beyond counting: it is the generation that achieves the transition to the Baroque period. Other Netherlanders—Gombert, Jacques Champion, Manchicourt, Crecquillon—belonged to the chapel of Emperor Charles V, working sometimes in Spain, otherwise in the Netherlands, as did also Andries Pevernage, Benedictus Appenzeller, Lupus Hellinck, and, most important of the Netherlanders in the Netherlands, Clemens non Papa. A great number were active in Germany. The picture of the whole period remains that of a continuous Netherlands hegemony in Europe, at least into the 1560s or '70s—that is, to the end of the era that in the narrower sense can count as "Renaissance."

For the musicians of this time the Mass still remains the representative species, even though its finest flowering was over and style and form developed no more beyond the Josquin tradition. Willaert himself still clung quite closely to the model of Josquin and his contemporaries. By and large, however, a motet-like style, with pervading imitation, takes root, often with, more often without cantus firmus. The use of secular tenor melodies received a severe setback from the decisions regarding church music taken at the Council of Trent (1562–63). The general standardization of the Mass is characteristic for this Netherlands-Italian region (in contrast to France, say, or Germany), the differences that may still have existed between Josquin, La Rue, and Isaac being progressively evened out, whether by Morales or Guerrero, by Animuccia or Palestrina, by Gombert or Clemens non Papa. This is especially true of the parody Mass, which is now favored over free Mass composition. The great majority of the Masses of Lasso, Palestrina, Monte, and most other masters consists of "parodies," i.e. resettings of motets, chansons, madrigals, or songs of their own or others' composition. The flowering of

original polyphonic Mass composition came to an end with the
Renaissance, but the species called forth a centuries-long more or
less epigonal second blooming in the "Palestrina style," and from
the beginning of the 17th century on there arose a sometimes
dangerous competitor to it in the concertante Mass (the Mass
with soloistic sections, instruments, and thoroughbass).

The composers appear to have bestowed far more interest
upon the motet than upon the Mass; from Willaert to Palestrina
the mature late style of *ars perfecta* was much more strongly
developed in the former than in the latter. If Gombert, Clemens
non Papa, Cornelius Canis, Crecquillon, Hellinck, Manchicourt,
and many others still adhere more closely to the heritage from
Josquin's time, Festa, Danckerts, Arcadelt, Morales, Willaert
himself, among others, obviously prefer a texture with emphatically
tonal base, strongly homophonic in effect, though rendered flexible
by polyphony. Willaert's Vesper Psalms (1550) are merely a
link in the chain of development in writing for responsorial choirs
that had begun in the 15th century, in mid-16th found parallels
in Manchicourt, Crecquillon, Phinot, and others, and at the end
of the 16th led everywhere in Italy and Germany (from Leonhart
Schröter and Michael Praetorius to Andrea Gabrieli and Palestrina)
to widespread practice of a simpler, more homophonic polychoral
music.

Common to the polyphonic or rather the pseudo-polyphonic
motet style of all these masters is the perfect parity of the voices,
the growing preference for using five, six, eight, and more voices
(from eight voices up either polychoral or also undivided), the
simple delineation of form according to divisions in the text, by
which form can be strengthened through refrain-like repetition
of sections, fully developed pervading imitation of sometimes one,
sometimes several motifs, declamation more or less generated by
the words, and the key-based harmonic texture that takes on an
increasingly major-minor character. The principles Glarean derived
from examples of the Josquin period prove applicable to his own
time. The old modes recede more and more. Tonal answers in
the imitative play of the voices are no longer rare. Cadences more
or less definitely mark dominant-subdominant-tonic relationships.

With all this the treating of liturgical melodies in one technique or another remains possible and customary—as wandering cantus firmus, in quodlibet manner, less often in canons or in sustained-tone tenors, preferably by means of motif-like breaking-up of the borrowed melody and reworking it in the vocal fabric.

The introduction of contrasting, troping, or interpretive quotations in the form of ostinato text and melody formulas into the otherwise homogeneous motet structure seems at times to have been almost a fashion. The text repertory broadens greatly through frequent composition of metrical poetry (sacred and secular, creating a whole literature of "secular motets") and through the rising custom of setting to music any sort of biblical or liturgical text. Rhythm still soars, often refined by intricate criss-crossing of the voices; but on the other hand passages carry through in a measured manner that may spring from the influence of the half-popular villote and villanelle or from the countless regular-metered dances of the time. The inclination of Josquin's day to clear-cut cadences is softened by a preference for veiling the structure; also in contrast to Josquin's time the vocal fabric is often so densely woven that is scarcely admits of pauses. The increase in feeling for tonality leads to harmonic enrichment, to the inclusion of rarer tones and tonalities, to wider use of *musica ficta,* and finally in the 1550s to an occasionally extravagant chromaticism, used (in motet and madrigal) experimentally by Willaert, Vicentino, Lasso, and others, and later with expressive effect by Rore, Francesco Orso, Marenzio, and many more.[28] The relationship of consonance and dissonance is increasingly directed toward absolute euphony, finally reaching in Palestrina's counterpoint that "definitive" norm which has come down through the centuries to the present, firmly established in the history of music as *prima pratica,* later to be

28. Cf. the writings of Edward E. Lowinsky, e.g. *Adrian Willaert's Chromatic "Duo" Re-examined,* in *Tidjschrift voor Muziekwetenschap,* XVIII (1956), 1; *The Goddess Fortuna in Music,* in *The Musical Quarterly,* XXIX (1943), 45; *Matthaeus Greiter's Fortuna,* in *ibid.,* XLII (1956), 500, and XLIII (1957), 68. Countless questions having to do with experimental chromaticism as found in Lasso's *Prophetiae Sybillarum,* for example, or Vicentino's experiments, with the humanistic affective chromatics of Rore and Marenzio, with wider use of *musica ficta* and a "secret chromatic art" assumed by Lowinsky, are still under dispute.

called *stile antico, stile osservato,* or *stilus gravis.* Certain other
types of sacred composition, cultivated by the Netherlanders in
Italy as well as by the Italians themselves, like Passion, hymn,
litany, etc., obey their own laws and at least in part do not submit
to these changes in style.

The progress of motet composition in the last Renaissance
generation (Rore, Lasso, Palestrina, Marenzio) is particularly
linked to Willaert, whose profound influence on the 16th century
can scarcely be overestimated. It consists especially in the intensive
pervasion of invention and texture by the idea of *imitar la natura,
imitar le parole.* A thoroughly detailed understanding of this transi-
tion to the late stage is still lacking. Here—together with the
general tendency among the composers to chordal texture, beauty
of sound, understanding of the words, and together with the de-
mands put forth by the Council of Trent and with other external
circumstances calling for affective and pictorial expression—here
too and above all the mutual interpenetration of types so entirely
typical of the Renaissance played a great role. The Venetian school
of Willaert and the motet composition of Lasso already announced
in many ways the pathos of the Baroque, while Palestrina and the
Roman school, simultaneously at considerable pains to be more
restrained in favor of a more absolute ideal of beauty, still no less
frequently show traces of luxuriating in utter surrender to all their
devotional fervor. The motet took up countless stimuli from the
chanson and the madrigal, just as these two forms in turn are in
the last third of the 16th century (especially with Lasso) abun-
dantly filled with motet-like traits, not to speak of the multifold
influence exercised by the smaller song-forms of the Neapolitan
villanelle, etc.

Italy's special national contribution—though in this case a
joint production of Netherlanders and Italians, showing to what
extent the former had absorbed the latter's feeling for language
and form even in the Willaert generation—was the madrigal (with
its more song-like and more popular or pseudo-folk collateral types
like villota, villanella, villanesca, aria Napolitana, madrigaletto,
etc.); it became by far the most important and most consequential
achievement in the realm of secular social art of a high order. Its

origin in the canzona is definite; the transition can be clearly seen in Andrea Antico's *Canzoni nuove* (1510) and Ottaviano de Petrucci's *Musica di Messer Bernardo Pisano* (1520). Other early publications confirm the development: out of the frottola texture eased up by pseudo-polyphonic treatment there emerges a mainly chordal but lightly counterpointed and elegantly balanced music that is most closely adjusted to the underlying freely composed poetry, and with the *Madrigali nuovi di diversi* (1533, the first edition having appeared as *Madrigali di diversi libro primo,* 1530), the name and the characteristic features of the species are given, the mixture of Netherlands and Italian composers now constantly recurring (in this case Costanzo and Sebastiano Festa, Nasco, Verdelot, and others). In the High and the Late Renaissance the madrigal became not only the definitive type of a music based on literary requirements for high society, for Castiglione's "orecchie esercitate" and "auditori disposti ad udire," for Vicentino's "privati sollazzi di Signori e Principi"—in this only somewhat limited by the rivalry of the new French chanson—but it also became the most important bearer of the new pathos.

Far more than the motet, the madrigal—from its beginnings with Arcadelt, Verdelot, and Festa onward to Willaert, Corteccia, Gero, Jachet Berchem, Ferabosco, to Vicentino, Rore, de Wert, Gioseppe Caimo, Nasco, Ruffo, Orso, to Palestrina's discreet juvenile madrigals and to the grand creations of Lasso's old age (the madrigals for Dr. Mermann, 1587, say, or the *Lagrime di San Pietro,* 1595), to say nothing of the somewhat stiff conventionality of Monte and the Romans like Antonio and Leonardo Barré, the two Surianos, the two Naninis, and finally the richly emotional and dramatic art of Rore, Marenzio, Luzzaschi, Carlo Gesualdo, and Monteverdi—provided an incomparable field for progress and innovation of all sorts, in notation, in the invention and elaboration of motifs, in the free handling of dissonance as well as in the exhaustive use of simple diatonic and artful chromatic chords, in verbal declamation, in emotional expression to the point of dramatic tension, in imitation of nature verging on romanticized mood-painting. Far more than the motet the madrigal was bearer of those humanistic learnings toward antiquitarianizing

that led Vicentino to experiment with imitation of Greek enhar-
mony and many madrigalists (like Willaert, Rore, Marenzio) to
direct symbolization of Antiquity by means of chromaticism. Be-
sides all this the madrigal did more than any other type of composi-
tion to forge the link with the dramatizing tendencies of the
Florentine Camerata and of Monteverdi and in its late form
presented itself as the ideal experimental field for testing out one
of the types of singing modeled after supposed Antiquity: no other
type could have merged so naturally into the Baroque *a voce sola*.

With all this one should not fail to understand that these
tendencies inherent in the madrigal (or at least not evident on the
surface) are a matter not of the composer's individual views and
personal feelings but of a rational descriptive vocabulary, of
maniere, (set formulas of the musical idiom), as in the motet, yet
with incomparably greater mobility, penetrative power, and ver-
satility. Indeed, the motet would itself have remained much poorer
without the steady stream of inspiration that emanated from the
madrigal. For this reason too the Italian Baroque has its deepest
roots in the madrigal, and it was not lastly on this account that
the Italians participated in such increasing measure in this par-
ticular field, until with the retirement and dying off of the last
Netherlands composers (Lasso, Monte, Wert) at the very end
of the century they remained sole heirs to the species. "It is
clear that in the late *cinquecento* for every Lassus there was a
Palestrina." [29] The madrigal truly became the melting-pot: in no
other field did the Netherlanders become so thoroughly Italianized.

If the Renaissance age in the Netherlands-Italian area ran out
without a break into the Baroque, if the hegemony of the Nether-
landers was smoothly and naturally eased to an end through that
of the Italians, if Spain, England, and Germany stood receptive
on the banks of the great stream, in France there developed at
the same time a characteristic national movement that, based on a
feeling for homogeneous form, likewise came to light in the various
types of musical composition. Its effects remained limited prin-
cipally to France herself in the 16th century, yet in the course of
the 17th came to exert a deep influence on the development of the

29. Reese, *Music in the Renaissance,* p. 380.

European Baroque.

A special branch of Mass composition arose in France that led to a distinctly more compact and accordingly more homophonic treatment of texture than that customary among the Netherlanders. It seldom goes beyond four voices. Duos and trios are inserted. These Masses are marked by simplicity of melody and harmony, smoothness of rhythmic and structural relationships, easily intelligible text, in the main set syllabically. Even the cantus firmus, if present at all, is succinctly handled, sometimes even stripped of its melismas. Similar traits characterize French motet composition; compared with Josquin or Willaert, it is often spare, terse, unadorned in effect. A tendency toward regular rhythm appears early on. Motifs are pithy and sober in form. Here, too, much else is sacrificed to intelligibility of text. Masses and motets of this sort were written by a group of French composers the oldest of whom were born around or before 1500 (Clément Janequin, Claudin de Sermisy, Pierre Cadéac, Pierre Certon) while the youngest continued active in the second half of the 16th century, some even into the 17th (Claude Goudimel, Claude Le Jeune, Guillaume Costeley, Eustache Du Caurroy, Jacques Mauduit). In this church music a specifically French style took shape that is closely connected with the secular chanson, that met related tendencies in the aspirations of Jean-Antoine Baïf's *Académie,* and that found an ideal field of activity in composition of the Calvinistic Psalter (Goudimel, Le Jeune, Du Caurroy, and others). Even if all these composers, who came to the fore with Attaignant's first publications and then became widely known through the productive music publishers of Paris and Lyons, occasionally made use of other forms—wrote Masses more in the Netherlands-Italian style, psalms in free motet form with cantus firmus plain or embellished in simplest four-voice as well as in richly polyphonic six-voice texture (Goudimel and Du Caurroy also used polychoral settings)—still there is no mistaking the fact that France went her own way in these things, aloof from the great Netherlands-Italian current, creating a "French Renaissance" of her own.

In secular music the development in France ran wholly parallel. With Attaignant's first chanson publication (1528) a whole group

of French composers entered the field with a specifically French chanson art, differing fundamentally from the contrapuntal chanson in the French language cultivated by the Netherlanders through its chordal and rhythmic simplicity, its bravura parlando declamation, its conciseness and precision, its wit and spirit, and not infrequently too in the frivolity of its texts (Claudin, Certon, Janequin, Cadéac, Passereau, Pierre Sandrin, Guillaume Le Heurteur, and many others). The origin of this art—which as a rule is not clearly enough distinguished as the "Parisian" chanson that it is (even if not all these composers lived in Paris) from the continuing French chanson of the Netherlanders—is still not clear. Janequin and Claudin had several times accompanied Francis I on state journeys to Italy and may there have entered into relations with the Italian frottolists (both moreover left some Italian madrigals); on the other hand a number of Italians were active in the two French court establishments of *chambre* and *écurie*.

More important than this question is the fact that the influence of this "Parisian" chanson spread far beyond France, that Arcadelt, Willaert, and Rore as well as Othmayr, vom Brandt, and Forster were affected by it, that French chansons of this sort were widely spread in Italian and German publications, and that the type belonged, together with the madrigal, villanelle, etc., to the high order of international entertainment music of the period. Its influence carried far beyond the turn of the 17th century in the instrumental *canzon francese* that stemmed from it. The Parisian chanson established itself as well in Gastoldi's *Balletti* as in Dowland's *Ayres,* in Monteverdi's *Scherzi,* in Regnart's *Villanelle* as in Hassler's *Lustgarten.* Strong (and doubtless predominant) as was the influence exerted by the Italian types of madrigal and song on the origin of the Baroque song types in the different countries, the continuing effect of the Parisian chanson should not be forgotten. The influence of French psalter composition on the German Evangelical *Kantional* song-form (a simple chordal setting with melody in the top voice) from Lucas Osiander to Michael Praetorius and beyond constitutes a parallel to it.

This French art of the chanson reaches its highest importance in the 16th century, however, in that it too—like the frottola some

forty years earlier, when it became influenced by literature and passed into the madrigal around 1520–30—rose to a higher literary and musical level. *The Académie de la poésie et de la musique,* founded by the poet Jean-Antoine Baïf together with the musician Joachim Thibaut de Courville (1570), not only purposed to cultivate both the arts but from the start undertook to regulate both after the model of Antiquity. Here, quite at the end of the Renaissance period, there appears most clearly in music that aspect of the *rinascita* which related to the "renascentes bonae literae" of Erasmus and which was to lead in the circle of the Florentine cameratisti—Galilei, Mei, Jacopo Peri, Giulio Caccini—to the renewal of vocal music, the re-establishment of solo singing on the "antique" model, and finally to the opera. While the Italian theorists had in the main pressed only in a general way for an approximation to the antique example in poetry and music, while Vicentino had attempted to resuscitate the antique genera, the *Académie* now demanded in full earnest the revival of antique prosody and verse-forms in the French language. Partly in agreement with Joachim Du Bellay and Pierre de Ronsard, partly in contrast to them, Baif called for the application of long and short values to the French language and poetry in *vers mesurés* that composers like de Courville, Caietain, Le Jeune, Mauduit, later Du Caurroy too and others, set to *musique mesurée à l'antique.* The idea extended to the writing and composing of psalms also; Le Jeune, Du Caurroy, and Mauduit composed *psaumes mesurés* as well.

Chanson composition *à l'antique* busied Netherlands composers too, and Josquin (the greatest cosmopolite of his time in this also) became one of its most inspired representatives. The parallel to German ode composition in the first half of the 16th century is close; but this is rather to be looked upon as a pedagogical resource than as an independent art-form of higher pretensions and remained very limited in influence, while the French *musique mesurée* was applied also to the theater and the dance, receiving palpable expression in, for example, the *Ballet comique de la Reine* (1581). Though this academic art in its strictest form remained but temporary and local, one should not overlook the fact that it continued to have its effect on French *airs* and dances

of the early 17th century and through these directly on the French theater and later on the opera, and that here lies the root of that *"academic"* movement which together with and in spite of all its Italian foundations was to make such a deep impression on the shaping of music in the Baroque period (cf. *Baroque Music*, Chapter VIb).

V

The Musical Achievement
of the Renaissance

The culture of the Renaissance was filled with music, permeated by it, probably to a much higher degree than the culture of any other period and certainly in no lesser degree than that of the following periods up to and into the 19th century. Music was an indispensable element in the ordering of life and exercised a highly necessary function in court ceremony as in divine service, in middle-class life as in school, in the cultured society of the times as in the systematic thinking of scholars. If in the Middle Ages church and aristocracy were responsible for a highly developed promotion of principally monophonic music (beside which polyphony played a part only in very few ecclesiastical centers and select intellectual circles), from a quantitative point of view the achievement of the Renaissance that most obviously comes to mind is the extraordinary, indeed the overwhelming diffusion of polyphonic music. The major part of such polyphonic music as was composed and played in the 13th and 14th centuries was limited to the cultural area of France and Northern Italy, and in so far as other countries shared in it, the sources show, it was this music that they took over, or in any case imitated. With the transitional period covering the end of the 14th and beginning of the 15th century, and with the appearance of the Netherlanders on the scene, there nevertheless began surprisingly quickly a lively activity in the most various fields of polyphonic music, in England, the Netherlands themselves, Burgundy, Germany, Spain, Portugal, in all parts of Italy, renewed in France too, as well as in all Eastern European countries; from Scotland to Sicily, from Poland to

Andalusia, in short, in the whole of Europe.

Though priority lay and remained with the Netherlanders alone in the 15th and 16th centuries, the generally European character of their music more and more appears as the attribute that clearly distinguishes the Renaissance from the Middle Ages. Bearers of this musical culture were the courts and princes, the aristocracy and cultured classes, the citizenry and the cities, the cathedrals and the cloisters. Polyphonic music spread through all levels of society that had never been touched by it before, and for the first time in music history a sort of cultured middle class made up of the learned and the literary, painters and plastic artists, and the city patriciate, whether as patrons or themselves creators, began to play a role. The use of music was extraordinarily widespread, the part taken in its cultivation by nations, religious denominations, social classes, public and private institutions, in the creation of new works as well as in their execution was incomparably greater than in the Middle Ages, and hence the tasks set composers and performing musicians multiplied.

In connection with this broadening of activities occurred the immense growth in construction of instruments in all countries, and also the rapid upswing in music printing that followed directly upon Petrucci's perfecting of printing techniques, and connected with these in turn the remarkable development of music as an economic factor, which, by virtue of the custom of dedicating works and the development recent research has brought to light [30] of what appears to have been an awareness of musical copyright, quickly won great importance for musicians.

In consequence, the increasing demands of composers, patrons, and audiences upon the quality of musical performance combined with the multiplying of musical establishments and other centers of musical activity, there arose for the first time a professional class of musicians of all sorts, including virtuosos. Instrumentalists and singers became well-known figures, attaining fame of their own apart from that of the composers, *magistri puerorum,* and court conductors, who at the end of the period stand forth as a

30. Cf. H. J. Pohlmann, *Die Frühgeschichte des musikalischen Urheberrechts (1400–1800)*, Kassel, 1962.

special group of artists highly paid and highly esteemed on their own account. This in turn brings about the classification of the musical profession into conductors, composers, and virtuosos, the trumpeters and drummers, the regular salaried court and town musicians, the professional musicians united in corporations, guilds, confréries, and the strolling companies of jugglers and mimes, who in part were a heritage from the Middle Ages, in part had become differentiated and refined.[31] Of course all this was not just suddenly there; remnants of the Middle Ages survived throughout the whole period, just as, inversely, Dufay's personal fame and artistic freedom lead to the surmise that a new epoch was about to dawn.

As widely diffused as the tasks of the musicians were the musical centers themselves. Alongside the great princely courts and cathedrals a striking number of small and very small churches, cities, cloisters, even the houses of upper-class citizens came to be of account musically in the Renaissance. Significant are the numerous musical academies set up in Italy and France, and the rise of similar institutions in other countries. They made a very important contribution to the social history of music in that they brought members of various social strata and professions into close contact with musicians and thus led to the creation of a class of musical amateurs and connoisseurs that became one of the most potent forces in European music in the following centuries. They prepared the ground on which poets, painters, architects, sculptors, scholars, amateurs, and wealthy patrons could exchange creative ideas with musicians, and on which a common esthetic ideal could be built up, as witness the writings of Leon Battista Alberti in the early days, later those of Marsilio Ficino or Leonardo da Vinci, and in the field of music those of Tinctoris, Aron, Lanfranco, Vicentino, Zarlino, and many others, and as laid down by Castiglione in summarizing the recognized views of a life of high intellectual, spiritual, and social standards. These trends brought about a connection between the various musical centers that was unknown to the Middle Ages. Not only were the

31. On the social history of court orchestras cf. Martin Ruhnke, *Beiträge zur eine Geschichte der deutschen Hofmusikkollegien im 16. Jahrhundert,* diss. Free University, Berlin, 1962.

musicians continually on the move from one place to another, spreading the music of the Netherlanders that quickly won European esteem: the ubiquitous activity of the Netherlands musicians themselves who increasingly absorbed Italian music and in the 16th century worked more and more with the Italian musicians, gradually produced a unification of European art music that was something totally new. Josquin, Willaert, Marenzio were performed in London as in Cracow, in Stockholm as in Lisbon.

All the national peculiarities and divergent tendencies that are undeniably present do nothing to alter the fact that since the end of the 15th century and increasing throughout the 16th there was a guiding European image of noble art music that finally achieved undisputed universal recognition in the works of Lasso, Palestrina, Monte, and Andrea Gabrieli. The emergence of such a general European ideal out of the development from Dufay's time to the sanctioned *ars perfecta* of Glarean's and finally to the *prima pratica* of the Romans is a grandiose achievement and testifies to the fact that the Renaissance forms a coherent unity in musical history. If further proof were needed that this epoch came to an end around 1570, it offers itself automatically with the beginning of the Baroque, when this unity falls apart again in a number of divergent tendencies.[32] From the trunk of this unified Netherlands-Italian style-ideal national characteristics grew out to a certain extent as branches. However great the differences that unquestionably exist between a *psaume mesuré* of Le Jeune, a setting in Lechner's *Neue Lieder* of 1582, a Marenzio madrigal, a Byrd madrigal, one of Regnart's villanelle—if one of these composers turns back to the Mass or to the motet he clearly shows that he handles national characteristics as such, but for the rest follows the unified European model. This model is one of the enduring gifts of the Renaissance to the music of Europe.

Like this and other contributions of the Renaissance that were important for their quantity and extent and that remained definitive for the music of the following centuries, there is also a series of achievements that for their quality can lay claim to the highest historical rank. The absolutely definitive one among these is

32. Cf. *Baroque Music*, Chapter VIa and p. 153.

probably the transition from successive to simultaneous composition. For the first time in the history of music the composer conceives his work of art as a whole and a unity, the elements and forms of which are not set for him by inherited patterns and schemata but rather for him to shape according to his individual judgment. The process has its parallels in other areas of intellectual creativity. Thus painting gives up the medieval superposition of narrative scenes and arrives at the conception and "composition" of the "unified" panel picture; Masaccio, for example, raises central perspective to a definitive element of form that calls for concentration of the picture from a single point of sight. In architecture one may compare, say, Brunelleschi's reaching back to the cube and the sphere-segment. In music the technique of successive composition, which had been practiced from the beginnings of polyphony until mid-15th century and had even been described by Aegidius of Murino in the 14th, gives way to simultaneous conception and hence to a methodically planned "composition" such as had never been known before. The pre-formed disappears just as does the arbitrary and the colorful motley of medieval music, the patchwork and the schematic, and its place is taken by the unique and unmistakable work of art conceived thus and not otherwise by the creative individual. Josquin's psalms or his *David's Lament* are (like hundreds of other works by countless composers) eloquent testimony of the breakthrough of an individual artistic intent in music. It took a long time before the remnants of medieval song-forms and groupings of voices, isorhythm, the cantus-firmus technique, mensuration and canonic puzzles and the like were overcome; some of these (and sometimes with altered significance, as for example the chorale cantus firmus in Protestant church music) outlasted the period as show-pieces or as ground plans for constructing different types of composition. The decisive turn, however, was accomplished by the Josquin generation, as its own contemporaries saw, and with it the Renaissance left to the world to come its greatest lasting gift, taken for granted since close upon half a millennium now: the freedom of the individual in his creative work.

The need for form in this period resulted not in the develop-

ment of fixed patterns but in an unlimited abundance of perfectly free formal possibilities. The work of art carries its law within itself: a Mass section of Ockeghem or La Rue, a motet of Josquin or Lasso, a madrigal of Arcadelt or Willaert are perfectly poised in themselves, in a state of delicate, labile equilibrium that is immediately sensitive to disturbance through addition or subtraction of a voice (there are many examples of such modifications), through lengthening or shortening; even the underlaying of another than the original text, as may easily be studied in the example of the motets counterfeited by Lasso's sons in the publication of his *Magnum opus,* can impair the effect. Form-schemes occur only in semi-popular song types like the villote or villanelle, in the *Bar* form (AAB) of German lieder, in certain refrain patterns in motets; but these schemes are very flexibly and freely handled, strictly dealt with probably only in the many dance species. In characterizing the Renaissance period in this respect it is well to observe that the tendency to develop more or less fixed patterns begins with the Baroque. The characteristic High Renaissance types in any case, motet and madrigal, give proof of the fullest freedom of form. Out of this there became available to composers a super-abundance of basic formal possibilities in respect of melody, harmony, rhythm, and sonority, to which there is nothing analogous in earlier centuries.

A decisive factor may have been that the formal conception and "composition" of a work emanates no longer from prescribed dimensions, *cantus prius facti,* strophic schemes, and so forth, but from sonority, as we learn in the case of Josquin. For the first time in the history of music sonority becomes the active agent in composition, and this proved to be a further gift of the Renaissance to later times; up to the present it has not suffered from attrition and it only became antiquated through the "return to the Middle Ages" the 20th century has accomplished in subjecting the composer to prescribed intellectual schemes. The sonority that gives rise to the musical conception, however, springs from the fully and uniformly exhaustive exploration of the tonal space that lies within the extreme upper and lower limits of the human singing voice. For the first time it is not selected, predetermined pitches that are

used but the entire extent of what today still constitutes the average range usable in music (for all practical purposes some four octaves). Within this space equivalence, equipollency, equilibrium reign: humanity owes to the Renaissance a music in which each voice unrestrictedly, in equal freedom, value, authority, can weave at the whole fabric and each voice is an individuality intimately interwoven in the whole. This was a further achievement of immeasurable importance. The content of this tonal space was not only turned to account, but investigated and explored to the limit, inasmuch as the twelve tones of the octave were calculated and used, their relationship recognized in the circle of fifths: according to Lowinsky [33] Willaert "sailed around" the twelve steps of the circle for the first time in the year of Magellan's circumnavigation of the earth (1519). Vicentino experimented with fifth tones and a 31-step division of the octave. The argument over interval and scale relationships in Greek music, over the calculation of intervals and key-systems, lasted throughout the entire period. Ramos was the first (1482) to recognize theoretically the consonance of the third and the sixth, and the comma problems that resulted from full exploration of the twelve-tone scale were not conquered until Aron (1523), Zarlino (1571), and Salinas (1577) introduced "mean-tone" temperament. In principle the range of sonority acquired and used in the Renaissance period was tested and exploited for all its diatonic and chromatic possibilities; what remained for later centuries to do in the realm of this diatonic-chromatic system was the differentiation and new combination of these possibilities, not actual discovery of new territory.

To the fundamental historic achievements of the period belongs, furthermore, the new relationship composers found to language, to word and verse, to prosody and meter, to the pictorial and emotional content of their texts. Medieval composers had no direct interest in their text; the correlation of tone and word remained haphazard. Almost any music could be composed to almost any words, and in what form the composer set his text to music depended not on him but on purpose and custom, tradition and convention. It is certainly true of word-tone correlation

33. *Journal of the History of Ideas*, XV (1954), 540.

too that it took a long time before conventions and traditions of this sort were surmounted. But even Ockeghem, still more Josquin, and particularly all later composers took a totally opposite attitude toward the word: music is born of the word as *imitazione della parola*. The *orazione* becomes the wellspring of music, the *cosa principale* of the composition. If in the beginning the underlaying of words to the notes of a part is still frequently left to the taste of the performer, the scope soon narrows. In numerous works of the Josquin-La Rue group the distribution of syllables is based almost exclusively on principles of meaningful declamation; in the Willaert-Gombert group only a few doubts remain. In 1559 Zarlino summed up the laws for text-underlaying in ten famous rules, and around 1570 a certain Gasperus Stoquerus (Stocker, or some similar name) dedicated a whole treatise of his own to the question.[34]

Hence musical conception now springs from two sources, from sonority and from the word. That Josquin composed according to the meaning and accent of the words is expressly vouched for by the writers and there can be no higher praise for him. The composer takes the affect and the picture from the text, and represents them in the media specific to music, by *armonia* and *numero*. By this procedure a freer and more independent approach to the word is also achieved.

While in the Middle Ages the traditional text models preformed the composition without the composer having to adopt any individual relation to them, from now on he exploits his text (in many cases also doubtless chosen by himself) according to his own judgment. This process is connected with the high literary level of the texts used in the Renaissance. Busnois and Morton (like all composers working at the Burgundian court) had already set to music the verses of important poets (Chastellain, Molinet, Christine de Pizan). With the Italian frottolists names like Serafino d'Aquila, Galeotto del Carretto, Veronica Gambara, Luigi Pulci, Cariteo, Angelo Poliziano (Politian) become associated with music. Through Pietro Bembo, cardinal and scholar, there was an

34. Lowinsky, *A Treatise on Text Underlay by a German Disciple of Francisco de Salinas*, in *Festschrift Heinrich Besseler*, Leipzig, 1961, p. 231.

upsurge of Petrarchism in the same circle and no poet of any nation was so often set to music in the 16th century as Francesco Petrarca. And again in the same circle there awoke (as almost simultaneously in Germany) an interest in setting Roman poets to music, especially Horace and Virgil. From Josquin via Ghiselin-Verbonnet, de Orto, Mouton, La Rue, Brumel, Willaert to Arcadelt and Rore the composing of Virgil found highly important representatives, its last and most brilliant being Lasso. Then with the commencement of madrigal composition begins a sheerly endless series of highly respected poets' names, like Michelangelo, Vittoria Colonna, Jacopo Sannazaro, Ariosto, and many others, and on to Tasso, Gabriele Fiamma, Giovanni Battista Guarini, Luigi Tansillo, et al. In France Marot, Baïf, Ronsard were set to music, in Germany Hans Sachs, Martin Luther, Burkart Waldis, Kaspar Ulenberg. Running beside the highly literary texts and already clearly distinguished from them in Gian Giorgio Trissino's *Poetica* (1529) there is a semi-popular literature that—in Italian villote and villanelle, Parisian chansons, German *Reuter-* and *Jäger-liedlein* (little riding and hunting songs), English carols, and so forth—everywhere and variously crosses in and out among them, providing the basis for a corresponding music, whether properly semi-popular or a persiflage on national characteristics. In this field, furthermore, Lasso is again the last prominent figure.

To the wealth of texts in national languages and dialects there was added finally a wide choice in neo-Latin poetry that was very important for compositions for special occasions, and above all there was the Latin prose of the liturgy and the Bible. In the Renaissance all restriction in choice of biblical or liturgical texts fell away; evidently the composers selected what they wished, including (after Josquin) many texts not used for divine service. The preference for Passion texts from the Gospels is to be noted, as well as that for Passion poetry, for Job and Jeremiah, and beginning in the late Renaissance the inclination of composers to set the *Song of Songs* (to which Palestrina dedicated the whole fourth book of his five-voice motets in 1584); though this last reached the peak of its popularity only with the Baroque composers. In hardly any other epoch of music history was the com-

posers' demand on literature on so high a level as in the Renaissance. This reflects not only the demand of the society this music served, but also the close personal relation of the composer to the poet, of tone to word, as the theorists kept calling for it and as it has since then long been taken for granted in Western music. With the beginning of the Baroque in this field too a split took place: proper high literature goes its own way, and from Guarini, Ottavio Rinuccini, and Gabriele Chiabrera to Metastasio (and far beyond) there is a particular *poesia per musica* for the purposes of composition. In the new correlation between word and music that the Renaissance period achieved and that is closely connected with the whole humanistic movement, this epoch laid the grounds for human expression in tone which provided for centuries to come the foundation of all musical intent and thinking.

A whole series of further accomplishments in the field of music during the Renaissance, though of no less historical importance, recedes into the background in comparison with these fundamental achievements. This would apply, for example, to the gradual coming into its own of instrumental music, to the beginning of stylization in dance music, to the progressive penetration of polyphonic texture by chordal elements, to the displacement of the modes through major-minor, to the slow development of accentuated rhythm and a feeling for measure in contrast to the purely metrical orders of the Middle Ages that held sway throughout most of the 15th century, to the evolution of an emphatically consonant, regularly ordered "strict setting" and thus of a theory of counterpoint that again was handed on into the 19th century. To these should be added innovations in the practical execution of music like polyphonic choral singing, whether *a cappella* or with every variety of combination with instruments, the techniques of using divided choruses and multiple choirs in their antiphonal form (which the Baroque was forthwith to develop into the polychoral concerto), the execution of instrumental and mixed vocal-and-instrumental music by choirs of homogeneous instruments, and an abundant practice of combining voices with instruments according to the discretion of the performers, from which at the end of the period came the further practice of solo singing to the accompaniment of an instrumental ensemble or instrument capable of

chords, a practice that as the Baroque began advanced to the use of fixed instrumentation or the systematic separation of vocal and instrumental, solo and choral parts. In the field of notation the Renaissance is to be credited with getting rid of the old over-complicated ways of writing music down and introducing a final simplification into mensural notation. The result of this process was a notation that remained practically unaltered ever after and led straight to the form we use today. For the writing down of instrumental music the period worked out the greatest variety of tablatures (not yet known in the Middle Ages); in large part they remained in use well into the Baroque. Nor did the printing of music change in the Baroque period, at least not fundamentally. Movable type was still used for printing the parts, the first scores, which had already appeared in the Renaissance (Lampadius, 1537; Rore, 1577), being produced by this method. Copperplate engraving first came along in the Baroque. All such achievements are more or less by-products of those fundamental transformations in which the Renaissance in the field of music too is revealed as a true period of "rebirth"—if not the rebirth of Antiquity, yet that of the human spirit itself.

There should be little difficulty in achieving a bird's-eye view of the Renaissance age and an easier understanding of the various phases suggested by these fundamental transformations if one proceeds from the idea that the important processes took place in the Netherlands-Italian period of its music history, and that the special achievements of the various nations are to be evaluated separately and not confused with the fundamental occurrences.

One may look upon the period of Dufay and his school as Early Renaissance, for here the first transformations (at least in Dufay's late work) were accomplished. New forms of composition, simplified notation, the basic feeling for harmony, full sonority, the new tonal space were achieved; and not infrequently too the inner unity and equilibrium of the setting, the equal authority of the voices, among other things, are, at least in an accessory sense, already taking shape.

One may consider the Ockeghem-Busnois group together with all the Burgundian and French music more or less from the 1460s to the 1480s as an intermediary stage between Early and High

Renaissance, although Ockeghem himself stands nearer to the latter than to the former. The assumption frequently met with that this group represents a "northern late Gothic" does not do justice to its production; so-called Gothic overhangs merely obscure a close connection with the development in process of consummation from Dufay to Josquin.

A High Renaissance is then realized (in the period of the popes from Sixtus IV to Julius III, in the period of Maximilian I and Charles V, Louis XII and Francis I, in the period of the first Tudors and Philip II, and of all that is highest in the achievements of Western society associated with these names) in the two central groups, the first around Josquin-La Rue-Obrecht, the second around Gombert-Willaert-Clemens non Papa. Here all the great musical conquests come to light in their full extent: the concept of simultaneous composition and the new correlation of word and tone take over, and individuality in artistic creation wins perfect freedom. Between the two groups there is no difference in standing, no difference in artistic intent. The difference lies rather in matters of technique and of sonority, in details of stylistic modification, in the greater emphasis on new types of composition, in the intensive carrying through of the basic harmonic sense that is of Italian provenance. Not for nothing did these two central groups receive, as we have seen, equal and highest recognition in their own time.

Finally, if this outline of phases holds good, those composers approximately contemporary with Lasso, Palestrina, and Monte constitute a Late Renaissance. In them appear the influences of the Counter Reformation, the tendency to devotional self-expression, of emotion to become pathos, in them harmonic thinking slowly comes to replace genuine linear polyphony. A texture that is fundamentally harmonic is in preparation and as the antagonism between discant and bass begins, an entirely new sense of form will shortly come to the fore. In the work of art sensuous delight in color and extremes of soul-stirring emotion take the place of moderation and the flow of harmony. The Baroque casts its shadow before. The Renaissance is at an end.

BAROQUE MUSIC

I

The Term "Baroque"
as Applied to Music

In music history the term "Baroque" is in the main understood to apply to a style period.[1] It extends, roughly speaking, from the end of the 16th to about the middle of the 18th century (we shall discuss the dates more particularly in Chapter VII). The features characteristic of works of art and of the types of sound considered ideal in this period and which as a whole determine the nature of its specific style are called "baroque." By this is meant not that all the stylistic qualities of every work composed during this period are or need be "Baroque"; for these works can also possess other style elements, as we shall see (Chapter VI). By definition, then, its first meaning deals with a question of style. The further question of in how far this style (like any style) gives form to an intent common to all artistic expression of its period and whether such a common artistic intent can be traced back to a deeper layer of psycho-spiritual attitudes of the time, leads to another problem: can such a delimitation of a period derived from its style tell us something about the spiritual foundations of that period (cf. Chapters III–IV)?

In a further sense the word "baroque" is often used in music, as in the plastic arts and poetry, to mark not a specific historical period but certain individual characteristics of a master or a work that may stand out from their surroundings as eccentric or bizarre, that tend to overstrain or oversharpen the stylistic norm of their own time or that tend toward deliberate copying of the music of

1. When it is used in this sense here it is spelled with a capital "B".

the Baroque era. In this further sense one can speak of a "baroque Gothic" in a work like Ockeghem's *Missa prolationum,* much as one might label Wagner's *Tristan* "baroque Romanticism" or Bruckner's last symphony "Romantic baroque" or Richard Strauss's *Rosenkavalier*—with a touch of malice—*"Jugendstil* with Baroque accessories." In the nature of Romanticism—at least German Romanticism—there lies a deep relationship with the baroque. Not by chance has Shakespeare found such a wide audience through the translations of Schlegel and Tieck, one of his most effective musical settings in Mendelssohn's *Midsummer Night's Dream.* Not by chance was Johann Sebastian Bach revived in the early Romantic time. Bach's oratorios and late cantatas are in large part "romantic baroque," and for that very reason found a spontaneous echo in the Romantics. Every such use of the word "baroque," however, is obviously a matter of individual feeling and thus liable to be arbitrary. The "woodcut" quality contrasting with the "romanticism" in Bach's style has often been felt as a sort of "last gothic." However arbitrary such an evaluation, it does express a sense of relationship, in itself not unfounded, between latest Gothic and latest Baroque on the plane of a super-temporal common German feeling for art, a feeling intensified to full conscious-ness in the Romantic era and thus contributing substantially to the historicizing movement of the 19th century. But such arbitrary applications of the word "baroque" to music evade definition and will be omitted in the following discussion.

 The question naturally arises whether a third use—that in which "baroque" stands for a periodically returning manifestation in human history—can have significance for music. According to the thesis of Eugenio d'Ors (*Du Baroque,* Paris, 1935) "baroque" occurs in all cultures (Inca, Hellenistic, Roman, Nordic, etc; in this thesis for example "gothique flamboyante" is treated as "gothic baroque") and is the mark of less-developed or retrogres-sive societies or times in contrast to the "classicity" of the highest stages of development. This sort of hypothesis is deduced from the European Baroque era; to apply in music antitheses like the "intellectuality" of the classic to the "vitality" of the baroque would be tempting but dangerous. For this idea is irrelevant to

music because enough assured comparative values to support it are to be found only in the Western culture of the last thousand years. The view represented by Henri Focillon (*Vie des formes,* Paris, 2nd ed., 1939) that "baroque" is a final stage in the aging of every style, can for the same reason be applied in music only to the era of the 17th-18th centuries. Here it coincides with the usual use of the term, which goes back to the art historian Heinrich Wölfflin, insofar as for the period of history that embraces Renaissance and Baroque and extends from approximately the middle of the 15th century to the middle of the 18th, a strong inner coherence of style is to be observed and in this larger period the Baroque appears in a certain sense as a "stage in the aging of the Renaissance." But in no case may one disregard the fact that this "aging" consists at the same time of a thorough "rejuvenation" whereby in all the arts of the Baroque period new forces take over and remodel the aging forms of the Renaissance into totally new forms (as we shall see in Chapter VI).

Finally, in applying the term "baroque" to music one must remember that this word did not originally apply to a style concept and that in the course of time it came to stand for a certain psycho-spiritual attitude (see Chapter VI); in the common parlance of all languages it is associated with a pejorative implication of the abnormal, eccentric, or exaggerated and in this sense is applicable to the most multifarious activities and expressions of mankind. This is probably why the word has remained liable to lose the character of a scientifically definite term in style history, slipping into the vaguer terminology serving psychic and spiritual tendencies, and why no limits have been set to its arbitrary application to music. In what follows it will be used exclusively in its sense of a concept in the history of style and as designating the period of history outlined above—that is, roughly speaking, from the end of the 16th century to the middle of the 18th.

II

Introduction of the Word "Baroque" into the Writing of Music History

The word "Baroque" in the sense of a style period, and at that a unique, more or less definitely delimitable section of historic time in the history of Western music, first came into use about 1920. Hugo Riemann, in his *Handbuch der Musikgeschichte* (II, 2, published in 1911) does not yet use it for his classification. His section on *Generalbass-Zeitalter* (The Thoroughbass Period) takes its name from a technical feature that belongs mainly to the Baroque style and hence as regards its temporal range is approximately covered by the Baroque style period. Guido Adler, in his *Handbuch der Musikgeschichte* (1924), also avoids the word in his classification and calls this chapter in history the "3rd Style Period." Hans Joachim Moser, on the other hand (*Geschichte der deutschen Musik,* II, 1922), used a division into "Early Baroque" and "High Baroque." In the *Handbuch der Musikwissenschaft* edited by Ernst Bücken the volume by Robert Haas dealing with the period is entitled *Musik des Barocks* (1928). It was Curt Sachs who had introduced the term into German writings on music history to designate a style period; for his part, he followed Wölfflin (*Renaissance und Barock,* 1888; *Kunstgeschichtliche Grundbegriffe,* 1915) and Alois Riegl (*Entstehung der Barockkunst in Rom,* 1908) and he carried over the point of view as well as the terminology of the plastic arts to music (*Kunstgeschichtliche Wege,* 1918; *Barockmusik,* 1919). The writing of music history came in the course of time to be influenced by further writings on art history,[2] and indirectly also by literary his-

2. Werner Weisbach, *Der Barock als Kunst der Gegenreformation,*

tory, which in its turn had been stimulated by art history.[3]

The introduction of "Baroque" in the sense of an empirical style period—a period with positive achievements of its own that were indeed closely related to the Renaissance and issued from it but that differed therefrom through its own vital forces, its own bestowal of meanings, and its own forms—took place around 1920. It was predicated upon a revaluation of the word's meaning from the general vague sense of spiritual tendencies to a well-defined graspable process in the shaping of spiritual history. It was in this revaluation that the writing of art history took precedence. It consisted of two perceptions, in themselves independent and yet corresponding with each other: one, that the Baroque, seen purely from the point of view of style history, was no mere manifestation of old age or decay in the Renaissance but an independent achievement of the highest rank, and the other, that this achievement grew out of a spiritual conception essentially different from that of the Renaissance. These points having been proved valid for the history of music as well, chiefly by Curt Sachs, provided the assumption upon the grounds of which the word *Barock* could win the place it has occupied since about 1920 in German music historiography.

From here "Baroque" passed into American writings as a concept in music history (Manfred Bukofzer, *Allegory in Baroque Music*, 1939, and *Music in the Baroque Era*, 1948; a periodical was begun under the title *Journal of Renaissance and Baroque Music*, edited by Armen Carapetyan and Leo Schrade, I, 1946). In French musicology the idea seems not yet to have taken root; the music history edited by Norbert Dufourcq (*La Musique des origines à nos jours*, 1946) still does not use the word "Baroque" in its classification of periods, and in Dufourcq's own work on Bach (*J. S. Bach, Le Maître de l'orgue*, 1948) it is studiously avoided.

1921, and *Barock als Stilphänomen*, in *Deutsche Vierteljahrsschrift für Literaturwissenschaft und Geistesgeschichte*, II (1924); Wilhelm Pinder, *Das Problem der Generation*, 1926; Émile Mâle, *L'Art religieux après le Concile de Trente*, 1932.

3. Herbert Cysarz, *Vom Geiste des deutschen Literaturbarock*, in *Deutsche Vierteljahrsschrift für Literaturwissenschaft und Geistesgeschichte*, I (1923), and *Deutsche Barockdichtung*, 1924; Joseph Nadler, *Literaturgeschichte der deutschen Stämme . . .* , I, 1920.

English musicology is similarly shy of its use. Thus J. A. Westrup (*Purcell,* first published in 1937) avoids the expression, and Ernst Hermann Meyer (*English Chamber Music,* 1946) introduces it only with caution (p. 152). Nor, so far as one can see, has there up to now been any critical discussion in the French and English literature of the use of the term in music. The Belgian musicologist Suzanne Clercx (*Le Baroque et la musique,* 1948) has made a start at investigation of the "Baroque" in music. In Italian music historiography, on the contrary, the introduction of the idea in the sense of an individual style period has met with sharp rejection. Here Andrea Della Corte in *Il Barocco e la musica* (1933), and, together with Guido Pannain, in *Storia della musica* (I, 1942), both following Benedetto Croce (*Storia dell' età barocca in Italia,* 1929), cling to the pejorative sense of the word "baroque" and regard the music of the first half of the 17th century as the true "classical" product of the Renaissance age that only begins to acquire a "baroque" element in the second half-century's "manifestations of decay." (How the concept of "Renaissance" in music and the 16th century's historical function become disarranged from such a point of view must here remain unexplained.) The "baroque" appears here in the older use of the term, implying a deterioration if not aberration of taste, lack of creative capacity, even decadence. This is caused in part by the fact that the concept of the "baroque" in Della Corte is all too strictly limited to the marvelous, the astonishing, the passion for effect, and, since this formula does not seem to fit the first half of the 17th century, is co-ordinated with another period. Yet it is not to be denied that behind this difference between the Italian and the German interpretation of the word "baroque" there lies hidden a problem that is twofold: linguistic on the one hand, in that the word "baroque" is filled with different meanings and implications in the different languages, and historical on the other, in that it raises the question of simultaneity in the arts. The former calls for philological investigation, the latter will be discussed in Chapter IV.

III

The Meaning of the Word "Baroque" in Music

Today the word is mostly held to derive etymologically from *barucco* or *barocco,* originally meaning irregularly round, as the shape of a pearl, say, and then taking on the further sense of something unusual, that has got out of its normal shape, eccentric, perverse, scurrile, even tasteless and decadent. To this corresponds the depreciatory implication that has always clung to the word in its application to artistic productions and which it apparently has not yet lost in the Romance languages. French, Italian, and English dictionaries still explain it first of all in this sense.[4] As denoting an artistic style it probably appears for the first time in Diderot's great *Encyclopédie des sciences des arts et des métiers* (1750 ff.), where in an article by Rousseau "baroque" is applied as an adjective to architecture and is equated with the bizarre, the exaggerated (which makes Borromini, correctly seen, appear a figure historically parallel to Guarini). The word already occurs in the same sense around 1739–40, in the *Lettres familières* of le Président De Brosses; that it here shares the pejorative implication with "gothic" shows that, as in comparisons of this sort today, the sense of a late manifestation of aging styles already hovers about it. The word was then used throughout the whole 19th century in this derogatory sense in the historical and plastic arts and literature (among others by Burckhardt in his *Cicerone*), but still without acquiring any special reference to music.[5]

4. Cf. also Curt Sachs, *The Commonwealth of Art,* p. 200.
5. Cf. the history of the concept in *Journal of Aesthetics and Art Criticism,* V (1946).

It was not until Wölfflin and Riegl altered the meaning of the word to stand for a positive achievement and an independent style that it became connected, through Curt Sachs, with music (see Chapter II). This connection, as Mme. Clercx is probably right in saying, appeared mainly by the roundabout way of interpreting "baroque" as the art of Jesuitism and the Counter Reformation. For here it was easy to find for music the spiritual basis and psychic tendencies it has in common with the other arts. Since Weisbach and Mâle the pictorial and plastic art of the Baroque counts to an outstanding degree as expression, even as a "psycho-pedagogical tool," of the church militant and the church triumphant. After the building of the great Jesuit church of Il Gesù in Rome (1568), and in painting after Tintoretto and El Greco, a "pathos" begins to make itself felt in the basic attitude of the artist, the impassioned excitement of which increasingly contrasts with the measured circumspection, the "ethos" of the Renaissance, even though the forms in which it expresses itself are not newly invented but have developed out of those of the preceding period. The clear sense of reality of the Renaissance age gives way more and more before the inclination toward withdrawal from the realism of life here below, toward mystic enchantment with the life beyond, toward the marvelous, the stupendous, the supernatural. The graspable dimensions of the Renaissance work of art are exaggerated to the boundlessly grandiose, magnified to the realm of what may only be guessed at. The equilibrium of psychic continuity is disturbed by excessive change and movement, by the heroic and the violent, by the erotic, the stress on the sensuous. The *virtù* of genteel reserve and self-control is transformed into the drive of the *affetto* for fulfillment and display. An inflamed self-consciousness, an ego-cult that verges on narcissism, a boundless urge to abandon the soul to all torments and delights, from a suicidally contrite, agonizing consciousness of sin to ecstatic release in the celestial radiance of divine mercy—these demand direct and comprehensible representation and develop means both coarse and fine in order to achieve it. The overrich scale of motifs of Baroque pictorial and plastic art in the Jesuitic spirit reaches from the athletic brutality of the hangman to the morbid disembodiedness of his victim, as that of

poetry reaches from the massive balling of heavy word-clumps to the preciosity of a subtle esoteric play of vowel sounds. It is the same in music, which in a few decades undergoes a tremendous broadening of its expressive capacities, its wealth of motif and figuration, its technical apparatus, and its means for producing sound. The spirit identified with the names of Ignatius of Loyola and Pope Paul IV thoroughly upset the measured humanitarianism of the Renaissance, replacing it by the reckless ardor of the zealot, sensual asceticism, violent self-discipline and mystical self-abandonment.

This spirit transformed the artist's feeling for life. The uninhibited serenity of an antique Arcadian need for beauty that counterbalances the remoteness from reality of its subjects through the vital realism of its irony and contemporaneousness is replaced by the sullen melancholy glow of an ecstasy-inspired piety, the fervor of which draws nourishment from the futility of the temporal in the face of the eternal. Representation of the sensually perceptible world leads to an interpretation of the psyche that is bent upon exhibiting, teaching, preaching, persuading, converting. Rhetoric and mimesis provide the vocabulary for all the arts. Illusion and allegory are employed to this end. The symbolistic quality inherent in music from time immemorial, its peculiar capacity to be a sign language for meanings that lie behind it, the ability with which it has always been credited of calling forth definite psychic reactions through its tonal forms—all this leads it directly to a preferred place among the arts of the Baroque: nowhere else can all effects so concentrate upon the single goal of persuasion and catharsis. The opera scene becomes illusion just as does the painted heaven of the cupola through which the saints soar upward, as the altar painting becomes painted Jesuit theater, the word becomes gesture, the musical figure a form of speech. According to Haas (*Die Musik des Barocks*) the German poet Georg Philipp Harsdörffer puts it thus: "The art of rhyming is a painting, the painting a similar-sounding music, and this in turn, as it were, a rhyming art endowed with soul." It is astonishing to see how quickly, all in the same stretch of historic time, artists and works of art are transformed in this spirit. Bartolomeo Ammanati expresses regret (1582) about the nude figures he has carved in his earlier sculptures and

promises to place his chisel at the service of purified doctrine. Torquato Tasso submitted (after 1581) his *Gerusalemme liberata*, already in print, to the Inquisition to be expurgated, resigning himself wholly to its verdict. Orlando di Lasso repents in his old age the so-called lasciviousness of his earlier works and in the very year of his death (1594) composes for himself—after undertaking a pilgrimage to Loreto—"per mia particolara devozione" Luigi Tansillo's penitent *Lagrime di San Pietro* cycle, while even the pious Palestrina thought it necessary (1584) to repudiate, grieved and blushing, the alleged sins of his youth. Art soon quite officially subjected itself without much resistance to ecclesiastical censorship. For a time it seemed theology would triumph over art and ban everything that did not correspond with dogma and the exaltation of the Church.

The period that spiritualized Petrarch, that moralized Boccaccio, and that could never slake its thirst for sacred contrafacta of secular songs or sacred parodies of secular musical works, was nevertheless unable to wipe out all forbidden joy in the sensual and erotic. On the contrary, the more zealously it was striven against, the more clearly did the craving for physical and spiritual nakedness peer forth from under the cloak of education and the imparting of dogma. As painting acquires a brilliant technique in the handling of the nude, so poetry and music achieve a glittering language of sensual excitement and sad-sweet malleability that puts all Renaissance effects in the shade. By way of the spiritual and the mystic the whole gamut of emotions lying between the heroic and the erotic now indeed becomes the theme of the pictorial and plastic as well as the rhetorical arts and gives music the opportunity to unfold a heretofore unknown enchantment of the senses. The more strong and palpable effects are called for, the better does the art of antithesis command material and its presentation. The technique of achieving striking contrasts becomes in the Baroque a main objective of all the arts. According to Weisbach, Bernini's *St. Theresa*, in which the ecstatic surrender of the languishing maiden's soul to Christ is contrasted with the Eros-like angel plunging his golden arrow into her heart, is the "peak of Baroque illusionism," typifying the way "mystery is mingled with *coup de théâtre*." Themes like some stage hero's tempestuous raging set

against the magic sweetness of a love-scene, a pitiless martyrdom at once horrifying and sensually exciting, Magdalens tender and coquettish in their repentance, the heroic rider pitching headlong before the flaming apparition of the Saviour—all these in their violent antithesis altogether suited the painting, sculpture, and poetry as well as the magic of the Baroque; and in such themes the capacity of music to express extreme contrasts and the wildest passions had developed along with that of the other arts. Here it becomes clear how justifiably the word "Baroque" could be applied in the same sense to music as to the other arts, once the formerly derogatory term had come to be accepted as standing for a positive style. Bernini's *St. Theresa* and Borromini's quiet cupola of San Carlo alle Quattro Fontane (both Rome, 1644), Rubens's picture of Loyola with the healing of those possessed of a devil and the mystical poetry of Giambattista Marini and his circle (both c. 1620), realize the same artistic intent as Orazio Benevoli's colossal festal Mass for the dedication of the Salzburg cathedral (1628)[6] and Alessandro Grandi's monodies (between 1620 and 1630).

If the inclusion of music in the concept of "Baroque" seems particularly easy to understand in the spiritual realm with its turning toward a new religiosity for which it sought artistic expression, it should not be overlooked that an analogous turning was taking place in the realm of secular subject-matter. As in the pictorial and plastic arts the *maniera grande* (the grand manner) was indiscriminately applied to all motifs in painting and sculpture, to the secular as to the sacred in architecture, to the worldly as to the spiritualized subjects of drama or poetry, so in music too the means, once wakened, of representing emotion, movement, and color were applied to all subjects without distinction. Nietzsche's view (*The Birth of Tragedy*) that the opera was the good man's "opposition dogma" to the church's representation of the corrupt and lost, sprang from false assumptions. It is perfectly obvious how the landscapes and figures of the opera "are nothing but Christianity covered by Arcadian veils." [7]

The "Baroque" as a style took shape not only out of a changed

6. Facsimile of a page of the score in Haas, *Die Musik des Barocks,* plate V.

7. Karl Vossler, *Aus der romanischen Welt,* 2nd ed., Leipzig, 1940, vol. I.

religious disposition of mind. Rather, the whole altered attitude of the second half of the 16th century led, in religious feeling and thinking, to what is summed up as "Counter Reformation and Jesuitism," and in art to the style and the formal and expressive means that are called "Baroque." One is not the cause of the other, but both grew from the same spiritual disposition. The new religiosity and the new art could both unfold so rapidly, side by side and intermingling, because they both encountered the heightened psychological readiness of a transformed age. Hence it is not surprising to observe that the same excitement and sensibility, the same urge to exploit every passion, every monumental and every poignant effect, assert themselves also where the arts, free of compulsion, busy themselves with the traditional subjects of ancient mythology. Tasso's *Aminta* when first performed in Ferrara in 1573 was still set in the Arcadian scenery of the realistic Renaissance stage; but at a performance in Florence in 1590 the theatrical engineer Bontalenti deployed in the same work the entire illusionistic magic of the Baroque stage. Thus it was possible for Tasso's *Gerusalemme liberata* and Ariosto's *Orlando furioso,* both thoroughly un-Baroque in intention, to become the source for the largest part of Baroque opera: it was a matter of revaluing the content in the sense of the new pathos. Similarly Sannazaro's *Arcadia* and Tasso's *Aminta* could become main sources of lyric texts, of the solo madrigal and of all that followed upon it. The miraculous element had been just as much at home in the older pastoral and chivalresque poetry as it was now in the later. It is evident that it was not a question of revealing new content and new motifs, but of reassessing the old. This was true of the plastic arts as well: subject-matter and problems remained the same; what changed were the values and the development of new artistic technical means by which to realize these values.

This is exactly what happened in music too: it achieves a revaluation of the old substance and content in the sense of pathos, of emotionality, and of antithesis, and develops for them new means of expression. Thus it fits fully with the spiritual and artistic changes of the age, and its new style can be set beside that of the other arts. It bears the name of "Baroque" with equal justification. For it as

for them the term defines a style the artistic techniques of which serve to bring to striking expression the pathos of a deeply stirred age, to provide the eloquent language of the passions, to teach and guide the spirit, to stir the soul or calm it, at the same time sacrificing the harmonious symmetry of repose, self-assured within its limitations, to the titanic plunge into the enigma of the boundless.

IV

The Synchronism of the Arts

When it is recognized that the Baroque in music consists not in the more or less questionable agreement of external style-characteristics with those of other arts but in the unity inherent in the spirit of the age, any doubt about the synchronism of music with the other arts—doubt often expressed in the literature and traceable to Nietzsche—disappears. "The spirit of the age" is here understood not only in the sense of a factor in itself inexplicable, operating to impel the people of a given time and area to think, feel, and express themselves in a common form, but also in the sense of a definite manner in which those people look upon themselves and place themselves in relation to the physical and metaphysical worlds. Genuine synchronism is not demonstrated simply by the drawing of possible analogies between certain external style-characteristics of painting or poetry and those of music. To set the decorative wealth of late-Baroque architecture on a par with ornamentation in vocal music or the *agréments* of keyboard music remains a vague undertaking if it cannot be proved that both mean the same thing, spring from the same urge to expression, the same way of seeing oneself. To relate the arpeggios of Bach's *Chromatic Fantasy* to the *sfumato* of Watteau's landscapes remains but an ingenious game so long as it cannot be shown that Bach's broken chords really stand for a sort of pleinairistic mistiness.

Whenever such analogies do intuitively touch something in the sentiment of the time they may easily degenerate into arbitrary views and lead to such statements as Hartlaub's that there is "no better analogy to Bernini's St. Theresa than Isolde's *Liebestod*," in which the wide disparity between the evangelistic significance

of Bernini's sculpture and the auto-intoxication of Wagner's opera is totally overlooked. For the listener of today finds great difficulty in understanding the synchronism of Baroque music with Baroque sculpture because the motifs and the forms of the latter unmistakably convey to the modern eye something of what they want to express, while the blunted ear of our time is unable, without some schooling in history, to perceive how utterly different is the nature of the Baroque musical language from that of the Renaissance. In other words: mind and spirit of the Baroque age still speak intelligibly to us directly through the artistry of its sculpture and architecture, yet we can understand its tonal forms only through the intermediary of comparative style history. Monteverdi's crassest modernisms are to the listener of today mere gentle nuances in comparison with Josquin's Masses or Arcadelt's madrigals. This fact is often disregarded.

Nor does it suffice to set up the analogy between music and the plastic arts along the lines of Wölfflin's much-quoted paired concept (line—color; surface—depth; closed form—open form; relative clarity—absolute clarity) as Curt Sachs and after him, though with some modifications, Robert Haas have done. It does not suffice because these categories are derived from empirical style-forms without reference to the value of their testimony, and because furthermore they cover only the case of the visual arts and are applicable to music only under compulsion. Comparisons between empirical style-forms in music and the pictorial and plastic arts also readily come to grief since the distinction between what in these forms is really "Baroque" and what remnants of older forms or the result of anti-Baroque reactionary currents is frequently ignored (as, for example, by Haas, Schenk, Hartlaub). As we have seen in Chapter I and shall see again in Chapter VI, not everything about Baroque works of art is necessarily Baroque.

In his *Commonwealth of Art* (1946) Curt Sachs undertook to prove true synchronism for music, dance, and pictorial and plastic arts on a broad basis and in connection with an outlined comparative history of art. "All arts unite in one consistent evolution to mirror man's diversity in space and time and the fate of his soul." The arts of a time are not more different than the expressions eye,

hand, voice, and gesture of a single body give to one and the same psychic impulse. Lasso and Palestrina, all differences between them aside, make use of the same restlessly shimmering harmonies to express exuberant ecstasy in the same period in which Tintoretto and El Greco paint the ecstatically rapt figures of their saints and martyrs and Tasso and Luis de León write their exalted visionary verses. Monteverdi's *Lamento d'Arianna,* and after him a whole literature of compositions of the same sort for which it had become the model, came into being, as did Grandi's monodies, Peri's solo madrigals, Agazzari's sacred concertos, Vecchi's and Bianchi's madrigal comedies, indeed all early opera, at the time when Guarini's *Pastor fido* became the unexcelled example for a whole century's style and fashion, when Marini, Góngora, and Lope de Vega were writing their poetry, while Caravaggio's naturalism was suffering the same rejection as Monteverdi's *seconda pratica.* Bernini, Borromini, and Rubens strive for extremes of uninhibited show and reckless grandioseness, delicate preciosity and sensual subtlety as did in their time the massive Roman polychoral style of Paolo Agostini, Abbatini, Benevoli, as did the heroic-erotic opera—Monteverdi's *Incoronazione di Poppea,* Luigi Rossi's *Orfeo,* Pier Francesco Cavalli's *Giasone*—as did also the stage décors of Fernando Tacca, Lodovico Burnacini, Filippo Juvara. When the French tragedy of Corneille and Racine appears with its regulatory academicism, it finds its counterpart in Mersenne's *Traité de l'harmonie* (1636) with its first attempts at regulation of musical rhetoric and affective language. A few years later Marco Scacchi (1643) and Athanasius Kircher (1650) arrive at a systematic theory of musical style. Throughout the entire period this sort of "synchronism," in the sense of "like-mindedness," of music with the other arts is demonstrable. It is prompted step by step by the same impulses as they and like them develops its own fitting means of expression out of the same psycho-spiritual needs, until in the end, merging into the *style galant,* it reaches a final stage of airily fantastic decoration (François Couperin, say) analogous with the Rococo of the pictorial and plastic arts or is absorbed by the natural human sensibility with which early Classicism begins (for example, Wilhelm Friedmann and Philipp Emanuel Bach).

Research into comparative evaluation of productions in the various other arts and in music has barely begun. Thorough study will still be needed to verify the like-mindedness heretofore observed only between particularly striking works of art by following more deeply into the contrary tendencies that intermingle with or cut across the similarities. A fairly balanced view is often made more difficult through the fact that impressive achievements in one art at a given time and in a given nation need not necessarily correspond with equally impressive achievements in others. Matthäus Pöppelmann's pavilion in the Dresden Zwinger (1711–22), the Asam brothers' little church of St. John of Nepomuk in Munich (1739), Dominique Zimmermann's pilgrimage church at Wies (1745), Johann Lukas von Hildebrandt's Belvedere palace in Vienna (1713–16) find in the operas of Johann Joseph Fux, Antonio Caldara, Francesco Bartolomeo Conti as given with the contemporary stage settings of the two architect brothers Galli Bibiena, correspondences like-minded indeed, but scarcely as strong and as original as they are.

V

Fitness and Need of the Word "Baroque" in Music History

Despite a profound similarity in the psycho-spiritual bases out of which the stylistic forms and expressions of the so-called "Baroque" age grew in all the arts, it may appear questionable whether purely as a matter of terminology it is suitable or necessary to introduce into the history of music this designation or others taken over from the plastic arts (like "Gothic," say) or from the history of literature (like "Romantic") on the assumption that they are scientifically valid classifications—that is, style-categories of precisely definable content. Certain it is that music would be perfectly capable of suggesting words from the vocabulary of its own terminology that could characterize a style period with adequate clarity, as happened successfully with, for example, the generally accepted concept *ars nova*. Yet it will always be difficult to find a nomenclature for styles in music history that would be broad enough not to bog down in merely technical designations (as in Riemann's *Handbuch der Musikgeschichte*) and definite enough not to get lost in the ambiguity of general categories like "Classic" and "Renaissance." That music historiography today has developed most of the terminology for its classifications not from the stylistic criteria of music itself but by adopting analogies is due not to the lack of sufficiently sharply profiled musical style-concepts but to its always having, as a late-comer among the disciplines, more or less admittedly tried to place the music of a given period in relation to that period's other forms of expression. Thus it was that Riemann, for example, came to explain the music history of the 14th century as a parallel to the "Renaissance" in Michelet's sense of the "discover-

ing" of man and the world.[8]

In music history some ambiguity will of necessity continue to cling to all extraneous terminologies applied to its styles, whereas all terminologies formed from intrinsically musical criteria, while they may be more pregnant, must isolate music from its inherent relationship to other spiritual activities. All future music historiography will be faced with the choice of either setting up purely musical style-categories labelled in purely musical terms that do indeed stand unequivocally for specific musical matter but remain dissociated from the intellectual ambience and origin of these styles and intelligible only to the professional musician, or using to characterize its own style-periods and style-forms terms that are at the same time applicable in other fields and familiar to the non-musician also, even though because of this they suffer from a certain ambiguity. But since in the last analysis every categorization of spiritual phenomena is a belated abstraction from the versatile fullness of real life, such ambiguity can be accepted into the bargain if it helps overcome the isolation of music within its own technical history and makes this art comprehensible as a product of the impelling spiritual forces of its time. Hence it comes about that the introduction of the concept "Baroque" into music history, while in no way necessary, is useful since through the precedence of historical research in art and literature the word stands for certain definite currents and forces in man's spiritual history.

This is not the decisive point, however. The application of borrowed terms to the history of musical style is questionable only when, through the analogy between certain external style-forms, connections are set up that may not meet the nature of the case (see the preceding chapter), or when the taking over of extra-musical concepts drags in a structural system that cannot serve as a scaffolding for the subject-matter of music. Now it is incontestable that at the same point of time when the pictorial and plastic arts and literature begin to develop the new style-forms today called "Baroque"—i.e. sometime in the last two to three decades of the 16th century—a similar process begins in music: the nature of the Baroque style in music consists not in opposition to the style-forms

8. Cf. *Renaissance Music*, p. 5.

of the Renaissance but, as with the other arts, in a revaluation and further development of these forms corresponding to the new sense of life. And it is equally incontestable that in all the arts at the same point of time—namely somewhere in the second or third decade of the 18th century—there is to be observed in part a dissolution of these style-forms, in part their conquest by new forms. The taking over of the concept "Baroque" therefore does not introduce a forced periodic structure into music history.

VI

Style, Form, and Expressive Means in Baroque Music

A] THE HETERONOMY OF BAROQUE MUSIC. ITS RHETORIC

To understand how the Baroque came about, one may start out from the idea (in reality an oversimplification, but pedagogically useful) that the classicity of the Renaissance consists in a sort of persistence, a reposing in its own laws, and that in opposition to this the beginning Baroque creates a disturbance, a disintegration of this state; in part the imitation of external models (actions, events, noises, etc.), in part the expression of inner agitation (psychic states, emotions) impair the pure autonomy of music and from outside force it to adapt its language to such content. Even in the Renaissance, however, the seemingly perfect autonomy of music was really also shaped to a certain extent by tasks of representation and expression that were heteronomous—i.e. not purely musical but imposed by the text. Consequently, the demands this early Baroque feeling laid upon music bring about not the invention of entirely new style-forms but only the revaluation and further development of those already extant. Josquin's psalm compositions are already full of heterogeneous motivic matter engendered by the descriptive or emotional content of the words, Arcadelt's and Verdelot's madrigals often seek to pursue the motifs of the poetry into the smallest detail, and Lasso's *Penitential Psalms* served his contemporaries as models of penetrating emotional expression. Once the Renaissance had raised to a principle the correct setting of the text in accord with its grammatical and syntactical significance (Coclico, Vanneus, Finck, and many others), such correct setting inevitably

came to include the presentation of the content as well, and with
this the pure autonomy of music was obliged to yield to the pressure
from inside and out. The difference between what the Renaissance
recognized as *musica reservata* and what the Baroque demanded
of music in imitation of life and in affects lies not in any fundamen-
tal difference in the relationship between word and tone but in a
revaluation of this relationship. The perfected equipoise between
text and composition, which in fact developed during the Renais-
sance (even if it was violently and unjustly decried by the modern-
ists of the Florentine Camerata circle around 1590 as unbalanced
in favor of music), shifted toward the preponderance of the word
to such a degree that Caccini (in the foreword to *Nuove Musiche,*
1602) could call the older music a "lacerating of the poetry" and
Monteverdi in self-defence against Artusi (*Scherzi,* 1607) could
pose the radical demand that the text should be mistress, not serv-
ant, of the harmony. The violent literary polemics that broke out
between adherents of the old direction and proponents of the new
show how incisive even their contemporaries felt the change to be,
but also how conscious was the intent to coin a style that should
correspond with the new life-feeling. That the theorists of the new
music sought to base themselves on Plato and on the model pro-
vided by examples of Greek music (as yet undeciphered, hence in
practice not known at all) proves nothing with regard to their posi-
tion between Renaissance and Baroque and does not stamp this
music as a product of humanism. Since early Christendom and the
Middle Ages, Antiquity has been invoked at all times.

A principal means for developing an affective style was the con-
sistent application of rhetoric to music. This too was not new. How
far back the connections go has not yet been investigated; but at
least from Pietro Aron (in the 1520s) and Johannes Cochlaeus
(1511) on, the theorists of the Renaissance base themselves upon
it, and by "affectus exprimere" even the 16th century understands
chiefly the "inventio" of musical forms fitting the rhetoric. But
from Bardi, Caccini, and Peri onward composition theory con-
sistently demands that the construction of a piece of music must
correspond to that of the rhetoric of the text (which is variously
expounded; according to Mattheson, for example: Exordium, Nar-

ratio, Proposito, Confutatio, Confirmatio, Peroratio), the individual musical "figure" (in modern terminology perhaps "motif") to the rhetorical figure (and at times far more than a hundred such figures were taught). Like these theories of the parts of speech and of figures, so also those of *inventio,* of *loci topici,* of kinds of style, declamation, *elegantiae orationis,* and so forth became fundamental to the development of the Baroque style as a whole.[9] "From now on the opera becomes not just a scenic stage but also a speaker's platform" (Schmitz). Hence the pathos of the new affective style rests not upon free and arbitrary expression but on the "right" application of artistic rules (which is not to say that the emotional power of a personality could not express itself to the desired degree of effectiveness). Even Monteverdi (see above) does not say that "la parola" or "la poesia" should be mistress of the music, but "l'orazione." Thus right from the start the Baroque builds a fixed vocabulary that can be taught and transmitted. Its guardians are the great Italian masters, to whom half Europe made pilgrimage, and this vocabulary is still very much alive in Bach's *Orgelbüchlein,* his Passions and cantatas. That the system of this musical rhetoric was set up at the end of the 16th century and not earlier, is significant. Basing his work on the Italian theorists of the closing 16th century, Joachim Burmeister established in three treatises around 1600 a comprehensive theory of musical figures (*Figurenlehre*). From here on the doctrine is handed along in various degrees and shades, up to Andreas Werckmeister in the second half of the 17th century, to Johann David Heinichen, Johann Gottfried Walther, Johann Mattheson, all born in the early 1680s but living, respectively, until 1729, 1748, 1764. It is significant in another way that Johann Adolf Scheibe a generation later knew only what Schmitz calls a "sifted theory of figures" on the pattern of Charles Batteux's *Les beaux arts* (1746) and Johann Christoph Gottsched's *Versuch einer kritischen Dichtkunst* (1730), and that the art of musical rhetoric is then gradually lost in the generation of Bach's sons, which replaced outlived oratorical formulas by the natural outpouring of the human heart. It is of the greatest import-

9. The subject has been explored especially by Heinz Brandes, H.-H. Unger, Arnold Schering, Karl Ziebler, Arnold Schmitz, Martin Ruhnke.

ance to an understanding of the Baroque to recognize this sequence of events. In this period inner tension was released not through the intuition of free fantasy, as in the Classic and Romantic periods, but in firmly delimited, regularized, transmissible formulas.

B] ACADEMICISM. METER AND CHROMATICISM

There is thus no such deep-reaching difference as might at first glance appear between this early Baroque—mainly Italian—practice based on rhetoric, which soon spread over the whole of Europe, and academicism—mainly French. For this latter too concerned itself with bringing about a reform in music leaning more or less closely on the writings of Antiquity, a reform that should assure a meaningful linkage of music with poetry, subject composition to the demands of the text, and realize again in contemporary terms the much-vaunted ethical influences of Greek music. In practice the reawakening of these influences was to be achieved by re-introduction of the modes and meters of Antiquity. But ethical and affective influences coincide at this time; ἤδη (eide, images) are identified with affetti. So that even if this movement had not sprung directly from the need for enhanced affective expression but from the humanistic demand for a revival of music in the ancient Green sense (as then understood), it led in the end to the same result. Hence it is understandable that the challenges issued by Baïf and Ronsard (after 1570 also by the *Académie de la poésie et de la musique*) and Tyard soon infiltrated those of the Florentine Camerata circle (Caccini, Peri, Bardi, Mei, Doni). Marin Mersenne was probably the last to represent and systematize these demands. The composers of *musique mesurée à l'antique*— like Courville, Caietain, Le Jeune, Mauduit, Lasso too being among them—created with their compositions fixed metrical patterns that in France by way of the *ballet de cour,* in Italy by way of the *stile rappresentativo* and the *favola pastorale* became components of the Baroque style in music. The question whether these effects went beyond mere academic speculation and condensed into actual influences on the style of the music has been convincingly answered in the affirmative by D. P. Walker.

In this same context furthermore belongs also the broadened awareness of tonality through the inclusion of chromatics. This expansion too did not spring spontaneously from the composers' expressive needs, but came about through that part of the humanistic effort which aimed at an ostensible reconstruction of the antique *genera*. What the term *cromatico* in the titles of the madrigal collections of Rore, Orso, Ruffo, Ceretino, and others is really meant to convey is not quite clear even today. There is no doubt, however, that chromaticism (in the modern sense) was already widely used in the Italian madrigal of Rore, Orso, Lasso, Marenzio, and others before it underwent radical intensification in the works of Nenna, Monteverdi, Gesualdo, Saracini, and the rest, and that it was much favored precisely in these early days (around 1570) in compositions to Latin texts in antique verse-meters (as among others in Rore; Lasso's *Prophetiae Sibyllarum* are presumably a very early model). Even if, as Walker suggests, this does not really imply an attempt at restoring the antique modes, still such experiments are at least linked with the idea and enter around 1600 into the practical achievement of the full 12-step chromatic scale (to which, however, equal temperament does not yet apply, but the mean-tone temperament introduced by Salinas, 1577). The process signifies a radical overthrow of the sense of tonality from the standpoint of the basic diatonicism of the Renaissance and its *pura e semplice modulazione* (Zacconi, 1592 ff.). In any case, the humanistic efforts in every country at some form of revivification of Antiquity in the new music, especially when working together with French academicism and Italian rhetoric, were of great importance in the formation of a style, in that they contributed to the rise of Baroque monody, Baroque motivic material, Baroque tonality, and therewith to the development of all elements of the entire Baroque musical language. Research into the assumptions underlying the rise of the Baroque style in music is still in its beginnings; countless detailed questions are still to be cleared up. Meanwhile it is possible to track down to this extent the concerted action of Renaissance tradition, humanistic efforts at revival, and specifically Baroque requirements of expression.

c] Retardative Elements.
The Classicistic Undercurrent

One should not fail to understand, however, that to the academic demands of the humanists and to the heritage of forms from the Renaissance there clung retardative elements that in part continued well on into the Baroque, in part indeed were awakened to new life in that period, contributing to its particular stamp. Since the tendency of the time aimed, not, as is often wrongly supposed, at the composer's freeing himself from the bondage of regulated forms, but on the contrary at the shaping of new forms corresponding with its own expressive intent, inherited style-forms could to a certain extent remain viable. It is a mistake to assume that with a new style-period everything characteristic of the preceding period is rejected. Every style begins with transmitted means that it reshapes, and even when this reshaping is far advanced, remnants of the old forms remain. In J. S. Bach's day churches were still being built in Gothic style in Germany, and Gothic forms survived in architecture throughout the Renaissance and Baroque periods. Such "stylistic hangovers" may lead a sterile existence as faithfully preserved heirlooms, for ceremonial purposes perhaps, the way the medieval motet survived as the state motet till toward the middle of the 15th century, opera seria as court display-piece till towards the end of the 18th; or they may gradually disintegrate, as did the polyphonic madrigal in the second third of the 17th century, the suite after the middle of the 18th; or, again, they may call forth under- and counter-currents in the period that takes them over, as did the fugue in Haydn and Beethoven, or Classicism in the 19th century. This is a very pronounced phenomenon in the Baroque era that has given rise to many misunderstandings. As we have already said (Chapter I), not everything in a Baroque work of art is or need necessarily be Baroque.

Thus the striving for an academic regularity (again and again based in some form upon the authors of Antiquity) that was nourished by humanism remained alive all through the Baroque and comes to light at the most various points as a "classicistic"

under- or counter-current. Vignola, builder of the great Jesuit church of Il Gesù in Rome, published in 1567 a treatise on the "five orders of architecture" after Vitruvius, and Palladio, who explains the relatively classicistic bearing of his architectural works in a manual of 1570, remains throughout the Baroque, beside and despite Borromini, the model for architects up to Inigo Jones (1573–1652), who in turn expressly requires of architecture "regularity" and "affectlessness," to Jules Hardouin-Mansard, who built the Invalides, begun in 1675, and Christopher Wren, who built St. Paul's, also begun in 1675. With Bronzino the Raphael tradition remains a classicistic influence in Italy, beside and despite Tintoretto and Veronese, as it continues to do with LeSueur in 17th-century France. The French historical painters Nicolas Poussin and Charles LeBrun founded in the Rome of Bernini and Borromini the classicistic movement in French painting. With the first surviving example of the *ballet de cour,* the *Ballet de la Royne* (1581), a tradition of academicism was started that outlived the ballet de cour into the first half of the 17th century, tinged early Italian opera, and in France itself continued until the wave of Italian Baroque's rhetoric-ruled affective style swept over it through Luigi Rossi and Jean Baptiste Lully. Even so, French opera too, supported on this tradition and on the antiquarianizing, regulatory tendencies of tragedy according to Corneille and Racine, retained its own special "classicistic" imprint throughout the entire period even though in the forms of its texts and its music, in its motivic language, in stage technique, in its orchestra, etc., the "Baroque," full-fledged, had long since broken through. It is significant that in France a *tragédie lyrique* could come into being, but not an opera seria. Unlike the grandiose and the expressive in Italian and German "Baroque," French Baroque always remained within bounds. The need to set limits to the dangerously limitless is manifest in the founding of academies: in 1635 that of language and literature, 1648 that of painting and sculpture, 1663 that of the fine arts, 1666 that of the sciences, 1671 that of architecture (according to Sachs, *Commonwealth*). Descendants of the Baroque like Quantz and Leopold Mozart regard French music as somehow stiff, regulated, out of date, always the same.

This classicistic academic undercurrent continues to have its
effect even in the Italian opera reforms of the great dramatic poets
Apostolo Zeno (from 1718 on) and Pietro Metastasio (from 1730)
and along into the beginning of the early Classical period. It is
already perceptible in Vicentino and Artusi, Cerone, Mersenne,
Kircher, and Doni and lives on in the German writers of Mat-
theson's time. It was a sort of regulative that in course of time
worked, now more strongly, now less, against the exaggeration
inherent in the Baroque, thus exerting upon the formation of that
style an influence not to be underestimated, indeed decisive. It is
probably to be thought of in this sense rather than as breaking from
time to time through the genuine Baroque tendencies, and the idea
that the Baroque started in with a "primitivizing and reclassicizing,"
as Sachs suggests (*op. cit.*), is hardly tenable. In the last analysis
we are dealing with an enduring component of Western culture:
in one form or another reflection upon classical Antiquity came into
operation again and again, and in the Baroque this happened
under an antinomy, in that on the one hand the changed spirit
of the times developed the elements of its specifically Baroque
style out of humanistic efforts, while on the other these humanistic
efforts worked as a control against Baroque exaggeration.

In all these style-forming processes it becomes evident to what
a high degree transmitted ingredients were absorbed into the
Baroque, how little this period can be looked upon as a rupture
and new beginning, with what vitality on the contrary it set about
a fundamental alteration of these transmitted materials and forms.
For this reason too it will hardly be possible ever to judge whether
this or that transmitted element acted as reaction or hindrance on
the road to the Baroque. Rather, the style-forming forces of this
period were great enough to draw all transmitted material into the
whirlpool of its activity, to put to use all available forms and means
of expression, reshaping them to its own purposes. No more than
the Romanesque structure of the Mainz Cathedral hindered the
architects of the 18th century in remodelling its west choir to give
the powerful impression of a convincingly Baroque prospect could
all transmitted components—the humanistic demands for restora-
tion of the meters and modes of Antiquity, the categorical barriers

of the Renaissance in madrigal and motet, the arts of counterpoint and canon, the textural construction based on cantus firmus, and the other many heritages—hold back the impetuous self-unfolding of the Baroque. On the contrary: just as academicism and the efforts to restore the music of Antiquity became progressive style-elements in the hands of the Baroque masters, so it was also with all other transmitted matter.

d] "Meaningful" Music

This is especially true for the extraordinarily complicated domain of Baroque musical sign-language (to choose the least restrictive term possible for it). That music is not only sound and form as such but signifies something beyond, possesses an expressive value, has been a view of all peoples and times, and its capacity to achieve such expression has never, from the antique high cultures of Asia and Europe onward through a history of several thousand years, been seriously disputed. The existence of an expression-free music, valid in itself purely for its sensuous beauty, has been conceded only at times, and then only as a possibility, an extreme, a last resort (for example, by Aristotle, Zarlino, Hanslick). Aside from this, music has always and everywhere been held to mean something. If in the days of the Enlightenment people found themselves confronted by a certain disconcerting instrumental music that wished only to "be," but not to "mean" anything; if Rousseau damned this music and found justified the exclamation that had become famous, of his contemporary Fontenelle (frightened by a symphony): "Sonate, que me veux-tu?"; if even Goethe had his difficulties understanding it and clung to Diderot's "musique naturelle" and "musique imitative" in explaining to himself the antithesis between an "autonomous" music (i.e. that just *is*) and a "meaningful" music (i.e. that points to something other than itself)—all this only goes to show how long the intuitive idea of "significative" value underlying the whole of Western music from primitive times and still basic to the Baroque, had remained viable. A music without meaning (according to Goethe, autonomous music) first actually appeared in the 18th century, the idea of an "absolute music" not

until the 19th. Concerning *what* music was to express, the most
varied requirements have been put forth in the course of over a
thousand years of Western music history, concerning the *how,* by
what means it could happen, the most varied views. As a con-
sequence the most varied "sign languages" have become almost
inextricably intermixed in this long history. The whole nexus of
problems is today often erroneously lumped together under the
term "musical symbolism." In reality it consists, from the systematic
as well as the historical point of view, of a number of different
complexes the disentangling of which not only has not been com-
pleted, but indeed has scarcely begun. In considering the sign
language of Baroque music, we can only try here to expose a few
threads in this web.

In the *ars perfecta* of the Renaissance, that is, while it was still
at the apex of its style in the generations of Josquin and Gombert,
the two tendencies interpenetrate: one towards a pure music, poised
in the autonomy of its own beauty of sound and form, serving
sensuous enjoyment (a music simply "being"), and one towards
a music determined by extraneous ideas and content serving to stir
the intellect and the emotions ("significative" music). In this latter
there are already very various means of expression. It undoubtedly
contains a good proportion of medieval semantics (Josquin's
number and solmisation structures, for example, the art of canon
writing, etc.) which however has not been investigated for that
period. That such a semantics, consisting particularly in the trans-
lation of content into musical signs by means of numerical symbols,
must have existed is apparent from its revival in the Baroque (from
Kircher to Werckmeister, for example). It is linked with the
presenting of content through musical figures "found" according
to the rules of rhetoric.[10] Another possible "sign-giving" consists
in genuine symbols if by these one understands such musical signs
as translate word-content into tonal figures "emblematically" and
cannot simply be "understood" from the sensuous effect of those
tonal figures but must be consciously "known"—for example: the
word "sun," Latin "sol," is set to the note G, the solmization
syllable *sol;* "nox" or "tenebrae" are represented by blackened notes,

10. See p. 104.

the blackness of which cannot be heard; "confundere" is reproduced by an equally inaudible, complicated notating of a rhythm that in itself is and sounds simple; the "suspirium," by now a quarter rest, occurs where the text speaks of "sighing."

The last of these examples impinges closely upon another branch of this sign language, allegory, if one understands by that a keying of contents to musical signs that can be "understood" by the hearer simply from the sensuous effect—for example: "fall," "plunge," but also "abyss," "sin," "damnation," are expressed by descending voices, stepwise or by leaps; "serpent," but also "sin," "entanglement," by intertwined voice-leading; "light" and "dark," but also "heaven" and "hell," "salvation," "damnation," by contrasting high and low registers; "length," "effort," "hardship" by sustained rhythms in contrast to the quick rhythms for "hurry," "flying," "rapture"; at "standing" the voices pause, at "fugere" they chase after each other breathlessly in close imitation; yet this last example may also hide a technically symbolic meaning inasmuch as here there is also a play upon the term "fuga" for "canon." Bukofzer [11] may be right when he regards the introduction of this allegorization into the Renaissance as the true mark of *musica reservata*.

In addition to these "signs," "imitation" (*imitatio naturae*) was known in the Renaissance, if one understands thereby the direct copying of sounds and noises (chime of bells, birdsong, storm, brook, etc.). It was so current indeed that Vincenzo Galilei could, as we have seen, call even Palestrina, unusually reserved in the use of such means, "quel grande imitatore della natura."

To all these tonality was finally added as a meaningful "sign"; the theorists bear frequent witness to the expressive significance that lay in the use of keys. A "significative" use of tonalities is even expressly required of the composer, and provides a base for the humanistic demands that the ancient modes be revivified (see Chapter VIb). This side of the question as it is met with in both Renaissance and Baroque cannot be taken up here because it is still too little clarified. With these Renaissance signs everything the

11. *Allegory in Baroque Music*, in *Journal of the Warburg Institute*, III (1939–40), 1.

Baroque knew in the way of expressive means was already given. In this domain too there took place only a revaluation and further development.

To arrive at some systematic distinction between these types of meaningful communication would be one of the most difficult tasks research into Baroque music history could assume. The different categories—imitation, allegory, symbol—are here inseparably mixed from the beginning. If in Leonhard Lechner's *Deutsche Sprüche von Leben und Tod* (*German Aphorisms of Life and Death*) of 1606 "peril," "fall," "instability," the rocking boat, and in his earlier songs (1582) the "dead man," "bitter gall" are meaningfully expressed in "figures," there is here just as much imitation as affective depiction, allegory, and even to some exent genuine symbolism. This is not a question of the religious content; the same holds for secular madrigals of Marenzio and Lasso. Nor is it a question of music only; exactly the same is true in painting.[12] If in Heinrich Schütz's *Psalm 116* three sharply contrasting "rhetorical figures," set for six voices, tumble over each other within a few measures at the words "Stricke des Todes hatten mich umfangen, und Angst der Höllen hatten mich troffen" ("The sorrows of death compassed me, and the pains of hell gat hold upon me"), we have here three obviously graspable pictures "imitating nature," but in addition there are in the first the symbolism for "confundere," the allegory of "being bound," and the emotion of "finding no way out of the entanglement"; in the second, the "imitation of plunging" links up with the allegory for "Hell" and the affect of "being condemned"; in the third, the madrigalistic picturing of the whizzing arrow or the flash of lightning (in Italian synonymous with *saetta,* arrow) floats before the composer's imagination and brings out the allegory of the "victim struck": like Sebastian bound, the soul is penetrated by the pain from the arrow, and the affect of "consciousness of sin" is created. In this process the affects are not only mirrored, but are simultaneously reawakened in the hearer.

12. Cf. for example Rudolf Wittkower's interpretation, highly illuminating for the whole period, of Titian's painting, the so-called *Religion Succoured by Spain* in *Journal of the Warburg Institute,* III (1939–40).

The way the uses of these meaningful signs are here deliberately so closely interfused shows that the early Baroque was already dealing with a late stage of these arts. But in our assessment it is to be remembered that however much the composition may seem to today's listener to have sprung from the personal reaction and "sympathy" of the composer, it is really a matter of the latter's application of rules, word-sounds, of a rational transmission of conceptual content in musical symbols—in this case particularly impressive through the power of the creative personality behind it—hence of an intellectual process, not of an intuitive expression of inner feelings. Comparison with the other compositions of Psalm 116 in Burkhard Grossmann's collection of 1623 is highly instructive (and note also the semantics of number that runs through the whole collection and the allegorical pictures on the title page): all the composers have chosen similar "figures" for the separate ideas they are representing and give their music "meaning" in fundamentally the same manner. This observation applies more or less to the entire Baroque, up to Bach. The great composer is not the one who out of the fire of his genius captures in some freely chosen musical shape the emotions roused in his own bosom by the meaning of the words, but the one whose power of apperception and of invention exceeds that of others doing the same thing but with feebler ability. This point as it applies to the whole Baroque period (from Lasso to Bach) is mostly misunderstood, and it is obvious that the rebirth of the Baroque in the 19th and 20th centuries (like the return of Shakespeare, at least in Germany) shows a colossal misunderstanding of the creative process.

The music of the entire period is sustained on this saturation with "meaning," and the same elements, used in the greatest variety of blends and emphases, remain the tools of the composer. If Bach in his Cantata 56 (*Ich will den Kreuzstab gerne tragen*), uses countless raised tones (#), this is a case of pure symbolism, for these signs cannot be "heard" and thus directly "understood"; they must be "read" and "known," a process in which the pure symbolism of this "communication" (Bukofzer has called attention to this fact) in this case becomes particularly evident, because in Germanic languages the # = cross, so that in a translated text

the symbolism may not be conveyed by the music. If in Cantatas 8 and 161 (*Liebster Gott, wann werd ich sterben* and *Komm, du süsse Todesstunde*) he reproduces the sound of ringing bells, that is just as much natural imitation as it is allegory and rousing of emotion, and one may argue about which is the determining factor.[13]

The construction of the *Actus Tragicus* (Cantata 106, *Gottes Zeit ist die allerbeste Zeit*), in the way it handles the antithesis between Old and New Testament views of death, the way it unites these opposites—the fear, the joy—under the chorale allegory (subjection to God's will) in the middle movement (somewhat *confutatio*), and in its almost naturalistic imitation of the dying man crying out to his Saviour and audibly breathing his soul away (graphically, as on some Baroque tombstone), is a mixture of the most various meanings built up by a highly original and forceful genius. Yet for all that, this cantata is only a typical example of late-Baroque significative sign-language, and it is an error to think Bach was expressing his own sentiments in it: a state of affairs that is looked at quite rationally is conveyed through a masterfully managed skill in combining inherited forms of expression.

The descriptions Johann Kuhnau gives (in 1700) in his *Musikalische Vorstellungen einiger biblischer Historien in 6 Sonaten, auff dem Claviere zu spielen* (*Six Sonatas for the Clavier depicting certain Biblical Stories in Music*) are in part, as he himself says, pure imitation; they verge on the later "tone-painting" and provide a first step toward "program music." In part, however, as Kuhnau says, they "aim at an analogy" and hence are close to allegory too. When Marin Marais, on the other hand, in a sonata for gamba and basso continuo, depicts an operation for gallstones (*Tableau de l'opération de la Taille*, 1717) and explains in a commentary the meaning of the individual notes, this can hardly be taken as "significative" music in the Baroque sense, but is rather, for all its quite Baroque formal resources, a naturalism that comes

13. On Bach's many-layered use of symbols, allegories, metaphors, etc., cf. Arnold Schering, *Das Symbol in der Musik*, Leipzig, 1941; Manfred Bukofzer, *Allegory* (see fn. 11 above); Arnold Schmitz, *Bildlichkeit der wortgebundenen Musik Bachs*. An exemplary model is the first movement of Cantata 77, *Du sollst Gott, deinen Herren lieben*.

close to that of H. W. von Gerstenberg's underlaying of programs to the clavier fantasies of Philipp Emanuel Bach. Vivaldi's *Four Seasons* concertos, Op. 8, supplied with a "program" in the form of sonnets, are very close to genuine program music since they reproduce, still with familiar Baroque "figures," the feelings their subject arouses in the observer. It is indicative that by 1754 Charles-Henri Blainville could raise the question whether Vivaldi's concertos spoke to the emotions, and that from the point of view of that new time it was answered in the negative. Telemann's *Gulliver* suite, from his *Der Getreuer Musikmeister* (*The Faithful Music Master,* 1728) on the other hand, is made up through a mixture of very old note-value symbolism and figure allegory, now drawn into the service of caricature.

The long-forgotten domain of semantics has for the first time been taken up again by recent Bach research (Wilhelm Werker, Martin Jansen, especially Friedrich Smend). It may be taken as settled that—aside from the specific "number cabalistics" that seems to have been peculiar to Bach and his circle—there still existed or had been revived in Bach's day a "semantics of number" inherited from early Christian and medieval times for biblical and liturgical texts [14] and which probably had never quite died out as an undercurrent in the Renaissance and the Baroque. Research will follow up the subject in the future. That this too could merge into the hodge-podge of "significative" communication in Baroque musical style is one more proof of how closely this age was linked with its predecessor through overlapping traditions, and how strong, on the other hand, was its capacity to revalue, further develop, and blend together those traditions.

E] COUNTERPOINT

From the Baroque view, then, the entire complex of significative figures forms a hangover from earlier periods, but a fruitful one in which the creative forces of the new time manifested themselves in the formation of a style. The situation is the same for counterpoint—that is, for polyphonic composition. The *ars*

14. See Friedrich Blume, *Syntagma Musicologicum: Gesammelte Reden und Aufsätze,* Kassel, 1963, pp. 406 f. and 463 f.

perfecta of the Renaissance had fallen heir to it but had organized it through and through, achieving the perfect coordination of voices, full and balanced exploitation of the tonal system, a diatonic modality approaching the major-minor system, the principle of pervasive imitation, and equilibrium between line and chord—if the gigantic achievement of the Renaissance age in this field may be summed up in such a simplified formula. Developed to final maturity in madrigal and motet, the polyphonic writing of the Renaissance passed as a heritage to the Baroque.

This heritage was dealt with in four ways. One led to adaptation and assimilation. The norm of the four- to six-voice setting was taken over, with the "significative" vocabulary in the thematic material, with chromaticism and enharmony in the harmony and tonality, replete with free use of dissonances, suspensions, passing notes or chords, cross-relations, and the like, causing the balance to shift from the linear toward the chordal; and in formal construction it was totally subordinated to the demands of the text. In this process the need for contrast furthered the use of shifts in tonality, melodic antitheses, emphatic pauses, double counterpoint (by which interchangeable voices simultaneously present contrasting content), changes of tempo and meter, smaller note-values, rhythmic animation and interruption, while the need for formal consolidation, for grouping and symmetry, helped bring about structural framing and ritornello forms, intensification areas and climax points. The Italian madrigal and the Latin motet, to a lesser degree the German lied and the German motet, are the categories in which this process is consummated—a process that clearly began around 1580 with the madrigals of Lasso and Marenzio, continued, in Italy through Monteverdi to its extreme point with Gesualdo, in Germany through Leonhard Lechner to Johann Hermann Schein and Heinrich Schütz, in the "motets" of these latter, which in part are really spiritual madrigals, there also mingle with elements from the Lasso tradition and from Italy other style-forming elements of the most various sorts. Thus there comes into being by assimilation a "Baroque vocal polyphony" in which the picture of the Renaissance heritage appears completely changed.

The second way of dealing with this heritage was by total

negation. While Monteverdi in Mantua and Gesualdo in Naples were proving that Baroque intentions found satisfactory expression in polyphonic writing, the Florentine radical group around Bardi and Corsi, Vincenzo Galilei at their head, declared war on counterpoint and condemned motet and madrigal as inventions of barbaric times and uneducated people. Their doctrinaire humanism provided a starting-point: music should be thoroughly subordinated to the text, laying claim to no value of its own, and hence ought in no case to confuse matters by presenting different words in several voices at the same time. Ideas similar to those of the French *académiste* groups came to the fore: presentation should be ruled by rhythm and meter, the word clearly set forth. For this purpose the four-voice homophonic setting might perhaps be suited, which, as in *musique mesurée,* is used in the *favola pastorale,* but better, since the Greeks knew only monophonic music, is the pure solo, to which only the support of a few chords in accompaniment is allowed. One result of this negative attitude was the rise of monody as it appears in the solo madrigal, in the "aria," in the *stile rappresentativo* of early opera.

The third way of dealing with its polyphonic heritage is no less characteristic for the whole mental attitude of the period. For the first time a decided split in style begins between certain kinds of sacred music and progress in secular composition. Not at all in the sense that church music was bound exclusively to the one style, the other becoming a secular domain. Yet the final sessions of the Council of Trent (1563)—which refrained from any direct intervention in the technique of composition though it wished to ban strong instrumental effects as well as everything "worldly and unclean" from church music—nevertheless had an aftereffect in that the new Baroque style in its extreme manifestations was not considered appropriate to the church or at least not to public divine service, the norm for liturgical purposes being the motet and Mass style arrived at with Palestrina as its peak and the "Roman school" of Francesco Suriano, the Nanino brothers, Felice and Giovanni Francesco Anerio, and the rest. The so-called "Palestrina style" was opposed as *prima pratica* to the affective style Monteverdi had dubbed *seconda pratica* and under these names—but

also as "stile antico" and "stile moderno" or "stylus gravis" and
"stylus luxurians"—the distinction held fast throughout the entire
Baroque period; and indeed is still effective in the contrast between
"strict" and "free" counterpoint as taught today. From the Artusi-
Monteverdi quarrel onward, controversies between adherents of
the two styles lasted for 150 years; the polemic carried on between
Mattheson and Bokemeyer, concerning the relative merits of
counterpoint, canon-writing, etc. as opposed to simple melody,
was still based on it. Begun by the Roman school surrounding
Palestrina, and on through Viadana, Carissimi, Pitoni, to Caldara
and Lotti, in Germany through Hans Leo Hassler and Christian
Erbach to Peter Gutfreund (Bonamico), Johann Stadlmayer,
Johann Schmeltzer (and then throughout the 18th century), but
similarly also in England, France, and Spain, *prima* endured beside
seconda pratica. The very masters who unleashed the attack on
counterpoint and conducted it in all severity, like Galilei, Caccini,
Monteverdi, but also the late Baroque masters of *concertato* style
and opera, like Alessandro Scarlatti, Leonardo Leo, and so on,
were not to be talked out of composing at the same time motets,
Masses, madrigals in "stile antico." Opinion on the value of the
old style vacillated all through the Baroque. Angelo Berardi (1689)
considers the split in styles to be a real gain and looks down
contemptuously on the Renaissance, which knew no difference
between styles and handled a motet as it did a madrigal. Half a
century earlier Pietro della Valle (1640) had felt Palestrina to be
a historical, obsolete figure. Instinctively the composers who carried
on the "stile alla Palestrina" adapted to it the changing melodic
and harmonic sensibilities of their time. Then, by soon after mid-
17th century, a sort of "Palestrina Renaissance" took place (ac-
cording to Otto Ursprung)—a revival, that is, of Palestrina's own
works, of which but few were known—through the Bernabei, father
and son, then through Caldara and Lotti, while earlier, in the late
Roman school, around the middle of the 17th century, Romano
Micheli, Pier Francesco Valentini, Matteo Simonelli, and many
others had even gone so far as to historicize, to return intentionally
to Palestrina's example.

 This third way of dealing with counterpoint is so thoroughly

characteristic of the Baroque because in it there took place a continuously fruitful renewal through the tension between the two consciously manipulated styles. For these styles, theoretically kept apart, in practice blended into each other again, as was inevitable. Neither Lully nor Schütz or Henry Lawes, neither Purcell nor Rameau or Johann Joseph Fux, Bach, or Handel can be thought of without such a reunification.

As early as 1648 Schütz had made impressive use of "Palestrinian counterpoint," while with Fux the process led to the *Gradus ad Parnassum* (1725), the textbook that lent it canonic validity and further bequeathed it to the 18th and 19th centuries.

In a fourth way, lastly, polyphonic composition flowed equably along, uninterrupted and inviolate, though constantly subjected to reshaping. In instrumental music this was especially true for organ, harpsichord, and clavichord. What the 16th century had handed on in the way of forms—fantasia, canzone, ricercar, etc.— was further transmitted in a straight line to Scheidt as well as to Frescobaldi, to Chambonnières, Froberger, Bernardo Pasquini, to André Raison, Buxtehude, Pachelbel, and Bach. It is in this context that, through transformations, which however never amounted to drastic shifts in direction, the Baroque fugue finally came into being. In this process cantus-firmus composition was also preserved as a heritage from the Middle Ages and the Renaissance. At the same time instrumental music was of course continually being imbued with the expressive means and the style-forms of the new age, and out of the old in part quite new species took shape—the sonata, for example, out of the canzone; but on the whole it was a matter only of adaptation and revaluation of inherited material.

F] STYLE-CONSCIOUSNESS AND IDIOM

As Bukofzer rightly observed, there is apparent in all these processes a distinct "style-consciousness." One composed in definite styles, intentionally, with forethought. For every species and every purpose of music there was a special style, and even from about mid-17th century on, music had come to be grouped in three categories: *musica ecclesiastica, cubicularis, theatralis* (music for church, chamber, stage)—although without binding

definite forms or styles fast to one or another of these species
(research into the history of these categories is yet to be under-
taken). Henceforth the stylistic unity of the Renaissance was no
longer understood. Just as little was it understood how an earlier
age could destine a composition "to be sung or played on all sorts
of instruments." In the Baroque, vocal style parted company with
instrumental style: within the vocal the separate *pratiche* are kept
apart; within the instrumental, the tonal characteristics and tech-
niques of the instruments. In Italy Giovanni Gabrieli and Monte-
verdi had already arrived at specifying instrumental settings, in
Germany Michael Praetorius (1617) and Heinrich Schütz (1619);
that is, they write for the individual instrument in accord with its
technique and the character of its tone, and in their scores delib-
erately point up the contrast in tone-color from section to section.
The Renaissance unity of tone color resolves into that variety of
color in which the Baroque finally achieved whatever was humanly
possible, not to be outdone even in the Romantic era, in exploita-
tion of tone color, spatial effect, vocal-instrumental combinations,
and the "idiom," as Bukofzer called it, of the individual instru-
ments.

As a result of this consciousness of style and tone quality
the solo voice-part received its specific stamp of ornamental virtu-
osity, beginning with the closing 16th century's practice of im-
provisation and its instructions for ornamentation, and ending with
the fully developed *bel canto* doctrine and the total exploitation of
the human voice in the brilliance of Neapolitan virtuoso coloratura.
The line may be traced from Lodovico Zacconi (*Prattica di musica,*
1592) and Giulio Caccini (*Nuove musiche,* 1601) to Pier Fran-
cesco Tosi, the great castrato singer and teacher (*Opinioni de'
cantori antichi e moderni,* 1723) and Nicola Porpora with his
Solfeggi, on which the last great prima donnas and castratos of
opera seria were brought up. By reason of this style-consciousness
the style of choral singing differed from that of solo singing from
Praetorius to Bach.

Composition for wind and string instruments in their own
idiosyncratic terms begins with Giovanni Gabrieli, Biagio Marini,
G. B. Fontana, G. B. Buonamente, and others, ending with the

violin concertos of Bach and Vivaldi, the wind-instrument concertos of Bach and Marcello, the dizzyingly virtuoso gamba, cello, and violin soli of Bach, Marin Marais, and Vivaldi. Specialization of technique and differentiation of idiom lead to full development of the tone color of each instrument, to the exploitation of all its technical possibilities, and to the appearance of the professional virtuoso. This too is only carried further and improved upon in the 19th and 20th centuries, occasionally overdone, but not fundamentally altered or surpassed.

With the beginning of the Baroque the organ is released from the neutral sound-complex of Renaissance music by acquiring an independent music of its own. The cantus-firmus arrangements of Girolamo Cavazzoni, the preludes and ricercari of Jacques Buus and Claudio Merulo, the *tientos* of Antonio de Cabezón, even the canzoni of Andrea Gabrieli are fundamentally still neutral polyphony which, discounting a few characteristic figures, could also be performed by an instrumental ensemble. Much of this practice continues actively in the 17th century, especially in English consort music. But with Girolamo Diruta, Giovanni Gabrieli, and Frescobaldi, with Praetorius, Sweelinck, and Samuel Scheidt an organ music begins that can unfold its wealth of tonal color only on the organ and is often technically performable only on the organ. The instrument itself departs from the monochromatic diapason stops of the Italian-Renaissance organ and undergoes, in ways very different according to country and region, a thorough change to polychromatic registration and in so doing demands of organ composition a well-distributed tonal language that utilizes these possibilities. This idiomatic writing for organ extends to the time of André Raison, Nicolas de Grigny, and the Couperins, to Böhm, Buxtehude, and Bach, gradually sinking back after the end of the Baroque period to the monotony of a grisaille-like neutrality.

While lute music once more attains simultaneously a high florescence and a color-language and technique of its own, clavier (i.e. stringed keyboard) music for the two chief types of instrument, harpsichord and clavichord, also becomes differentiated from the tonally neutral Renaissance order. In certain fields, such as for example cantus-firmus and chorale settings, or the composition of

toccatas and variations, clavier and organ music do for a time run
parallel: Froberger's toccatas can still be played on clavier or organ,
and in Böhm's chorale-variations the treatment is scarcely dif-
ferentiated. But with the English virginalists a pure clavier music
had come into being as early as the end of the 16th century, un-
folding its own idiom and its own tonal effects. A direct connec-
tion runs from the beginnings to Domenico Zipoli, Handel,
Couperin, and Bach and did not break off so long as the Baroque
keyboard instruments remained in use. Wilhelm Friedemann and
Carl Philipp Emanuel Bach, like Domenico Scarlatti, carried on
the playing technique and color sonority of Baroque keyboard
music in a new age, charging them inevitably with new expres-
sive content.

G] THE BLENDING OF STYLES.
THE *Gesamtkunstwerk*

While it is perhaps "idiomatic" writing and sonority
that from the outset most strikingly mark the objective of Baroque
style, one must not overlook the fact that the late Baroque inclines
toward a merging into each other, a mutual assimilation, of the
individual sonorities and techniques. Vivaldi and Bach, but even
Lully and Alessandro Scarlatti too, offer many examples of this.
The so-called instrumentalism in Bach's solo voice-parts is the
best-known result of this process, which however is just as much
to be found in instrumental music: the trumpet in the Second
Brandenburg Concerto behaves like a violin, the organ had long
appropriated violin figures, and the *agréments* of lute ornamenta-
tion merged into the late-Baroque French clavecin style. This proc-
ess of assimilation lays the foundation for the creation of the
late-Baroque *Gesamtkunstwerk,* in which every conceivable ele-
ment of style and sonority in music unites with stage architecture,
stage painting, mimicry and gesture, the rhetorical art of word-
and verse-values into one total impression. Since this total work
of art is most vigorously embodied in the opera, and since the
opera in turn has its organic place in the total work of art that
is court life, fitting as it does into the frame of castle and theater
construction, of garden architecture, etc.—indeed, embodies in its

own characters and ideas the ceremonial hierarchy and the ideology of absolute monarchy—it represents the final and highly refined crystallization of an aristocratic life stylized to the least detail, a life that was itself a "total work of art" and in which the European spirit for the last time in history shaped for itself a completely adequate form that took in the whole sum of life.

The Church did something analogous. As in the architecture of the pilgrimage church at Wies, of the great Benedictine abbeys of Weingarten and Ottobeuren, the organ forms but a component of the whole plan, standing out merely as one member among others in the decoration of space, so the magnificent unfolding of Mass composition in the hands of Alessandro Scarlatti, Johann Adolf Hasse, Johann Dismas Zelenka passes into the bewildering splendor of the theater-like rendering of divine service, and to the ring of high trumpets the musical allegories vanish in air with the painted saints and angels in the light cascading from the glory in the dome. This too is latest Baroque *Gesamtkunstwerk,* a final unfolding of a oneness in the feeling of life, held together by the unity of many styles perfectly blended into one.

H] THE TECHNIQUE OF COMPOSITION.
BASS AND CHORD. FROM MODALITY TO TONALITY.
CONSONANCE AND DISSONANCE

The forces driving, as the Baroque began, towards new tonal and stylistic means for its new feeling of life and need for expression rapidly absorbed and transformed during the last decades of the 16th century those style elements it had inherited. The reshaping of rhetoric and of significative symbols in the Baroque sense had taken place by around 1600. The development of the new affective language in melody and motif had at least entered a first conclusive stage with Giovanni Gabrieli and Claudio Monteverdi. The blending of this language with counterpoint had also been achieved around 1600. With idiomatic vocal and instrumental writing, the new arts of sonority and color came into being in rapid course up through the 1620s and '30s. And together with these things two basic and enduring characteristics of Baroque compositional technique had already been firmly developed by

around 1600. The first is that the co-ordinated homogeneity of the voices in the Renaissance changed into a polarity, inasmuch as the main importance fell upon the outer voices (soprano and bass), between which a sort of tension was set up, while the middle voices were used for filling in. The second is that the state of equilibrium between linear and chordal writing achieved by the *ars perfecta* had shifted in favor of the chordal. The outer voices provide the framework of the composition, in monody as in the polychoral concerto, and the chord had become a recognized building-stone in its own right. Chord progressions no longer appear as a secondary consequence of linear part-writing; rather, the voices proceed for the purpose of forming chords. Tonal harmony occupies the foreground even in contrapuntal textures like that of madrigals and motets (insofar as they do not belong to *prima pratica*.) Homophony, consciously used since the Italian art of lauda and frottola in the closing 15th century and in Josquin artfully contrasted with polyphony, first became a dominating technical tool in the Baroque, although its chord progressions did not yet rest upon a modern sense of tonality. The chord is elevated to expressive effect for its own sake or in its relationships but is not yet a link in a functional chain.

With this preponderance of the outer voices and the emancipation of the chord, the center of gravity of the composition fell spontaneously into the bass, which in the Baroque became the "fundament." To set down the unimportant middle voices in figures instead of writing them out was merely a technical simplification. By the end of the 16th century the long-familiar practice of concentrating the lower voices of a piece for accompanying one or more upper voices on a chordal instrument or a group of such instruments had resulted in the invention of the thoroughbass. It was customary by at least around 1580 to extract from polyphonic compositions fundamental basses which at first (as *basso seguente*) followed only whichever voice was running lowest in the score; printed parts of this sort came into circulation in the 1590s. The first genuine figured basses are to be found among the Italian masters of around 1600. Caccini uses the term "basso continuo." In the first twenty years of the 17th century instructions for the real-

ization of the basso continuo were published in Italy by him, by Jacopo Peri, Viadana, Strozzi, Agazzari, Banchieri, Bianciardi, and others and in Germany by Michael Praetorius, Gregor Aichinger, Johann Staden, Christoph Demantius. The figured bass remained a chief article of faith in Baroque music theory as a whole up to Francesco Gasparini, Friedrich Erhardt Niedt, Heinichen, Mattheson—that is, up to around 1740. Nor was it by any means exhausted at that time: it carried on through the second half of the 18th century and throughout the 19th, being gradually remodeled into the "harmonic theory" of today.

The figured bass itself remained the *basso fondamentale* and thus the strong underpinning of all Baroque music, whether more soloistic-concertato or more polyphonic in character. The fusing of such fundamental-bass practice with counterpoint in the late Baroque became the foundation for the fugue technique of Bach and Handel. It remains characteristic right through the whole Baroque style that the structure of the top voice rises over the *basso continuo,* that is to say it is borne by it and stands in a certain contrast to it. Even though the resumption of counterpoint in the late Baroque (cf. Chapter VIa) led to a renewed genuine polyphony and a denser linear weaving of texture, the bass always remains bearer of the whole system, and thus it goes on to uphold the late Baroque organization of form according to the measure in which this develops out of the relationships of functional harmony. No matter, therefore, whether the texture tends more strongly toward the chordal or the polyphonic, the tension between top voice and bass continues to exist. Herein too lies the difference between this Baroque "continuo homophony," as Bukofzer calls it, and the homophony of the early Classic period. For the latter the principle holds that melody is independent of all accompaniment, can even exist without any; for the Baroque, that melodic voice and bass are organically and inextricably linked together.

That in the course of time the most various tasks fell to the bass—exalted as it was to the position of mainstay in Baroque composition—was a consequence of the general shift in gravity of tonal relationships, even though these different practices had their origin partly in pre-Baroque times.

The cultivation of the *ostinato,* the "obstinate bass," as foundation of the instrumental variation (as in ground, chaconne, passacaglia, passamezzo), of the soloistic or choral strophic variation (as in the opera aria, the Italian cantata, the French opera's ballet-finale), of freely *concertato* melody construction (as in slow movements of solo concertos), and finally in its freer quasi-ostinato forms as foundations of every sort of composition (as with Bach) —all this is a consequence of the Baroque treatment of the bass. And the "standing" and "moving" basses, as Haas calls them, the development of rhythmic, persistent bass forms as underpinning of entire movements, the composition of canons on a ground bass, and so forth—all these reveal the truly "fundamental" significance of the bass in all Baroque music. The more the feeling for the chord grew and composers composed "above the bass," the more clearly did definite, recurrent chord-forms and chord-progressions take on their characteristic stamp, and the stronger also grew the need for a tonal center to which to relate chordal connections. The development of definite, deliberately fixed chord-forms—triads and chords of the seventh with their inversions, etc.—is, after all, generally speaking a product of the Baroque. The piled-up sequence constructions, throughout the period, the regularly occurring chains of sixth and seventh chords in the late Baroque, belong to the firmly established style elements of Baroque composition.

All these conditions resulted in an outcome decisive for the whole history of music: namely, the rise of modern "tonality" out of the old "modality." For the Renaissance period the parity of all the modes, that is, the church-mode sectors of the diatonic scale, was still valid, even though an increasing tendency toward major and minor becomes noticeable in the course of the 16th century. The early Baroque still ranges the deliberately isolated consonant chord-constructions "modally" side by side. It destroys the formerly so strictly regulated dissonance relationships between them, in that it uses the dissonance more or less freely, as a rhetorical-affective means or in imitation of life. The lasting influence of what Monteverdi, Claudio Saracini, Gesualdo achieved of boldness in free introduction and free resolution of dissonances, but

also in the use of their tone color, indicates a radical turn in awareness of consonance and tonality as compared with the Renaissance. In the course of the Baroque this extreme was given up again in favor of an equilibrium between dissonance and consonance. In the late Baroque era, however, about from Lully and Corelli on, modality is transformed into tonality, which is to say that the basic succession of chords becomes on principle a grouping around fixed centers: tonic, dominant, and subdominant (this being the order of their importance in Baroque music) become the focal points of these groups, and these centers stand to each other in the functional relationship of modern major-minor tonality. In the days of Rameau, Handel, Telemann, Couperin, Domenico Scarlatti, et al., the modern functionality of major-minor tonality is in practice fully developed. Rameau's attempt, in his *Traité de l'harmonie* (1722), to build up the entire system not out of the scales but out of the chords and their inversions, totally ignoring in the process the tonal relationships between them, was but a delayed confirmation of this fact.

If with the close of the Renaissance the equilibrium between linear and chordal composition was abandoned in favor of the latter, the Baroque in its own final stage created tonality that was functionally centered, built up on the chord, and in polyphonic composition subordinated linearity to it. Upon this new tonal foundation Bach could once more dare chromatic-enharmonic and dissonant audacities that recall the early Baroque; but upon this foundation also he was able to develop the style of his "romantic Baroque," which opened the road for him into the 19th century. Even in this field the Classic-Romantic era may well have vied with and outstripped the Baroque in many ways, but fundamentally it never surpassed or conquered it. Only the use that the later era made of the newly achieved tonality was different; tonality itself remained unaltered up to the time of Richard Strauss and Max Reger. But since tonal relationships provide the one premise upon which understanding of music is based, it is comprehensible that the revival of the Baroque in the Romantic era should have sprung from its closing stage, incarnate in Bach. For the same reason in the

practice of music today "Baroque" is quite predominantly taken to mean "late Baroque," while the earlier stages of that period are more or less considered to "sound strange."

i] FROM *Tactus* TO MEASURE.
TEMPO AND RHYTHM

Like certain techniques of composition, like chordal writing, like tonality, the modern measure is one of the lasting phenomena that evolved out of the general style elements of the Baroque. Art music of the Renaissance was regulated throughout its course by the *tactus,* a basic note-value to which all other note-values were related in strict proportion. This *tactus* was simply a time-beating unit that controlled the sounding together of the voices but did not represent a regular succession of heavy and light beats or any sort of accentual system. Since over and above this the note-values of the voices in a polyphonic composition cut across each other and come together only at planned caesuras to a common cadence, *ars-perfecta* composition offers today's ear no rhythmic orientation; indeed, it even sets insurmountable obstacles in the way of drawing barlines in a modern score. This means that the Renaissance knew no beat in the sense of a mechanically recurring pulse of rhythmic units, or rather, it purposely avoided such a beat; for in the dance and in simple song forms like frottola, lauda, villotta, villanella, chanson, etc. a genuine beat is often enough apparent. If with the beginning of the Baroque the modern "beat" enters art music, this too means, as with so many Baroque style elements, a revaluation: what earlier had been a characteristic of lower musical species rose to enter art music (a process, moreover, that in a certain sense is repeated at the beginning of the early Classical period).

This tendency toward a fixing of rhythmic measure, that is, the mechanical repetition of heavy-light groupings, coincided with the efforts of the humanists (cf. Chapter VIb) to give effect in music to the metrical schemata of ancient poetry, and in the strictly homorhythmic delivery of such metrical verses in *musique mesurée à l'antique* there spontaneously emerged units of measure that similarly strove toward the "beat"; their after-effect on rhythm

is to be clearly traced in the early Florentine recitative. Not only in the Italian *balletto* of Giovanni Croce and Baldassare Donati but also in the "ayres" of Dowland, the *airs de cour* of Pierre Guédron and Antoine Boesset as naturally in all ballets and dances, in the *Lieder* in Hassler's *Lustgarten,* in the virginal music of Farnaby, Bull, and Gibbons as in the instrumental suites from Schein's *Banchetto musicale*—everywhere there is already present by around 1600 a mechanically pulsing system that at least very closely approaches the modern arrangement in measures with regularly recurring stresses. Polyphony too fits into this system: the madrigals of Monteverdi and Schütz can already be notated in regular measures, whereas this raises difficulties with Marenzio and is hardly possible with Lasso.

Yet "measure" in the sense of regular recurrences of accent should not be equated with the unalterably rigid sequence of metrical-beat patterns (3/4, 4/4, 6/8) nor with rhythmic rigidity of any sort. The Florentine monodists, it is true, were already using a barline-like sign of articulation. But up to Carissimi, to Schütz's late *Symphoniae sacrae,* and to Adam Krieger's songs the practice continued of considering the "barline" movable and to frame with it groups of tones that belonged together rather than rigid rhythmic patterns. Lully strictly observes verse-meters in his recitatives, capturing them in variously prescribed measures (4/4, 3/2, 2/2, etc.), and thereby showing the tendency toward a further fixation of metrical schemes. Then in the late stage of the Baroque—as happened in the case of tonality and functional harmony—with the French opera and the French ballet (overture), with the Italian concerto grosso and concerto solo, fixed measure in the modern sense developed.

There is probably no time in music history when rhythmic freedom pushed ahead so far in rhapsodic expression and rubato as in the early Baroque. Monteverdi uses the "senza battuta" and for the most part hands over the rhythm to the free, emotional delivery of the singer, who was obliged to carry out the *stile recitativo* with grimaces, gestures, sighs, and outcries, while the performance of a violin solo of Biagio Marini or a toccata of Frescobaldi, of an early solo madrigal of Peri or Saracini is, even aside

from the numerous notated contrasts and alterations of rhythm, to be thought of as extremely free. Only in the course of the Baroque did there follow a stabilization of the rhythm as well as of other elements, when the composer constructed each movement on a definite rhythmic motif, as is to be observed in the opera arias of Cavalli or Cesti, Lully or Blow, or in the suites of Chambonnières and Froberger. And it was the late Baroque that first evolved that motoric element which relentlessly repeats a rhythmic motion established at the beginning of a piece—if necessary with interpolated contrasting sections, or, in a polyphonic texture, with simultaneously contrasting rhythmic forms of motion that nevertheless pervade the various voices—and which overpowers the hearer by its merciless persistence. Bach, Handel, and many others offer examples at every turn.

What the Baroque created in the way of rhythm and measure retained a lasting influence, even though the use made of it by the Classic and Romantic periods was at times fundamentally different. More recent centuries have not provided any basically new element in the organization of time in music. Only the employment of extreme tempos has brought any essential distinction from the Baroque, which as a rule did not seriously overstep in either direction a certain tempered mean, *tempo giusto*—or only in highly exalted moments, perhaps, like the "mente cordis sui" in the "Fecit potentiam" of Bach's *Magnificat,* or the beginning of the last movement of Cantata 34, "Friede über Israel." The sharp tempo contrasts in Neapolitan *opera buffa* already lead out of the Baroque.

J] FORMS AND THE FEELING FOR FORM

The fact that the names given to categories of musical composition have outlasted their periods should not mislead us into forgetting that the same or similar names may conceal not only quite different categories but also quite different forms. "Motets" have existed from the 13th century to the 20th and the word covers widely disparate species, forms, content, and styles. The "madrigal" of the 14th century has almost nothing to do with that of the 16th, and this in turn goes on changing in the 17th and 18th centuries into new forms. Instrumental species like "fantasia,"

"capriccio" signify in the 16th century something entirely different from those of the 19th. So that the appearance of familiar names in the Baroque must not encourage us to seek fixed formal patterns among them. Even those names that first emerge in the Baroque and are characteristic of it do not imply fixed formal designs. "Aria" is a solo vocal piece, but of what form depends on the style-phase, the country, and the context in which it appears. Throughout the Baroque words like "sinfonia" or "sonata" serve quite different uses. "Partita" may equally well mean a suite, a set of variations, or even a free succession of movements. In the Classic-Romantic period "sonata," "symphony," "sonata movement," "rondo," "scherzo," etc. are linked with fixed formal and cyclical designs; even the "fugue," a purely Baroque product, is pressed into a set scheme in the 19th century (by Czerny). The Baroque does not know fixed form-schemes, or only in its final stage, and uses fixed appellations only for certain established types, dances in particular. By "pavane," "galliard," "allemande," "courante," etc., up to "minuet," passepied," "loure," and the like one understands approximately the same "dance form." Yet these are not really "forms"—for "form" consists, except in the oldest dances like pavane, etc., mostly of two analogous sections—but rather types of motion. Terms like "recitativo," "concertato," "arioso" imply the style of composition or of performance, and "sonata," "canzona," "cantata," "toccata," "motetto," "ricercar," "opera," "missa," etc. stand for types but not for "forms" if under forms one understands fixed formal designs. The unified style of the Renaissance had no need of a terminology for different styles, and the species took their names from the content or the purpose of the music. The differentiated styles and the style-consciousness of the Baroque stipulated such terminological distinctions, but for the rest the titles of the species referred only to content and purpose and at most announced a general principle of organization. They did not mean a fixed form-scheme. Such schemes came into being only in the last phase.

The Renaissance feeling for form aimed at the even course of a succession of equivalent or similar sections; contrast and repetition were used but were not necessary, not constitutive, did not

determine the form. The Baroque feeling for form was at first directed toward the greatest possible variety, toward diversity, wealth of contrast, rhapsodic freedom, and changed gradually toward the development of more fixed formal unities, more pervasive logic, more inward linkage, and it ended with the fixing of stable form-patterns.

Four basic characteristics are to be distinguished in the Baroque feeling for form. One of these is connected with the retention of the *prima pratica* (cf. Chapter VIe) and is evident in polyphonic compositions (vocal or instrumental) in the preservation of loose successions of similar sections in the Renaissance manner, even though two new tendencies appear in the process: one toward stronger contrasts between the sections, toward their eventual connection by means of refrains, codas, or construction of a framework, the other toward thematic unification. The motets of Schütz's *Geistliche Chormusik,* for example, are characteristic for the vocal branch: deliberately following "Palestrinian counterpoint," they yet take over from the affective madrigal strong contrasts between the individual sections, and from the concerto, framework and codas; the same still holds for Bach's motets. For the instrumental branch it is characteristic that, with Giovanni Gabrieli as with Frescobaldi and Bach, the ricercar firmly retains the sequence of sections, whether these are built on various themes or on several variations on one theme (variation-ricercari) or finally on one and the same theme, a process that ends in the parity of ricercar and fugue. In motet and fugue this trend continued to hold even in later times.

Over against this conservative trait of Baroque feeling for form runs the opposite trend toward entirely free, rhapsodic or improvisatory form, a trend that in the vocal field found its expression at first in the solo madrigal and the *stile rappresentativo* of the Florentines; it still lived in all the different sorts of recitative and arioso until the end of the Baroque, continuing thence into later periods. Ornamental improvisation also belongs here. Its instrumental counterparts are the toccata, even when it is mixed with ricercar- or fugue-like constructions, the preambles, preludes, and other free preluding forms that in the late phase—with Bach

—often take on a fugal or canonic stamp, and finally the pieces for keyboard instruments—fantasy-like in the modern sense—that merge straight into the free piano fantasy of C. P. E. Bach or Mozart.

The Baroque feeling for form takes on a third trend, which expresses itself in sequential structures, that is, the stringing together of parts that are in themselves complete, a procedure related to but not identical with the stringing together of sections in polyphonic compositions. Of this, in the vocal area, the "cantata" is particularly characteristic, retaining essentially—as it does from its first appearance (around 1620, with Alessandro Grandi, Francesco Turini, Giovanni Rovetta) and on to the chamber cantatas of Handel and the church cantatas of Bach—the sequence of movements complete in themselves, even if it occasionally borrowed from the concerto forms that gave framing and symmetry. The same holds for opera and oratorio, which on the whole both remained successions of movements from Monteverdi and Carissimi to Bach and Handel, though sometimes architectonic connections are to be found that link their movements into groups. In the instrumental field suite, variation, and canzona behaved similarly. The suite ("partita"), despite a frequently observable schematic order of the dances, always remained a loose succession of stylized dance movements, even if it opened with a "sinfonia," a "praeludium," or an "ouverture." Couperin's *Ordres* for harpsichord still prove that the unschematic succession of free dance-like movements based on a single key corresponds to the Baroque's intrinsic sense of form and cyclic connection was not within the intent of this type of composition.

The variation is to such a degree inherent in the most diverse species of Baroque music that it can without hesitation be called *the* Baroque form. As *basso-ostinato* variation it dominates from time to time the solo cantata, the opera, and the ballet, and as ground, chaconne, passacaglia, it is prominent in clavier and organ music right through to solo music for string instruments; as free variation connected with a basic motif it functions in the variation-suite from Schein and Peuerl on, and it is superabundantly cultivated in florid top-voice variation from the English virginalists

and Sweelinck up to Handel's "Harmonious Blacksmith" Varia-
tions and Bach's *Goldberg Variations*. Even this last set of varia-
tions is interspersed with elements of polyphonic or concertante
derivation, but it remains a series of movements, even when Bach
brings back the theme in its original form at the end.

The canzona, freed since Frescobaldi from its leaning upon
vocal models, at first consists of a motley succession of contrasting
sections ("Flicken-Kanzone" Riemann calls it, a patchwork can-
zona), gradually increases the dimensions of these sections and ar-
rives at separate complete movements of no specified number that
eventually develop in the late Baroque in the direction of the
chamber sonata—that is, to a suite-like series of an optional num-
ber of movements—or alternatively, toward the church sonata
and thus to a fixed grouping of mostly four movements.

A fourth basic feature, finally, also present from the start in
the Baroque feeling for form, aims at further development of group
forms. It is closely connected with the *stile concertato*. Since the
primal element in the concertante style is "confrontation," con-
trast, as against the "succession" or "juxtaposition" of the poly-
phonic style, there evolved at the very beginning—with the con-
certo for few voices of Viadana, Banchieri, Schein, right up to the
end of the sacred solo cantata with Schütz and Buxtehude—the
tendency to handle the beginning and end as independent parts
related to each other (framing forms) or to fashion in more am-
ple shape some recurrent part of the text ("Halleluia" or such),
repeating it as a salient pillar-like member (ritornello form), or to
connect constructions of this sort by means of a well-planned arch-
itectonic structure laid down around a central axis (symmetrical
forms). Between the supporting outer members lighter intermedi-
ate members are just as planfully grouped, and the middle group
may crown the whole the way the Eosander portal crowned the
Palace in Berlin or the cupola crowned the Frauenkirche in Dres-
den. What was possible in the vocal concerto for few performers
could happen still more effectively with the massed means of the
polychoral concerto style and did happen from Giovanni Gabrieli
on, through Antonio Maria Abbatini and Orazio Benevoli up to
the choral groupings in Carissimi's oratorios, to Lully's and Marc-

Antoine Charpentier's motets with orchestra, to Purcell's and Handel's anthems, and finally to Bach's *Magnificat* and B minor Mass. Group formations took shape as occasion arose in the course of the Baroque in cantata, opera, and oratorio and eventually, in the late-Baroque instrumental concerto from Corelli, Torelli, and Vivaldi to Bach and Handel, produced a sort of last concentrate of this trend in the Baroque feeling for form.

The stable form-schemata evolved during the late Baroque of necessity rest upon this fourth trend—since by their nature the other three resisted schematization—and came about in the style-blending process (cf. Chapter VIg) through the fact that those other and essentially opposite trends were pushed aside or permeated by the need for group constructions. A prerequisite for the building up of group forms was the development of tonality and of the regular measure (cf. Chapter VIh and i). Contrasting tonalities and rhythms were required to bind together several movements into a balanced group structure, contrasting keys to give architectonic unity to the individual movement. Prototypes are the late-Baroque instrumental concerto and da-capo aria, which in individual cases, as in the Bach E major Violin Concerto, are close enough to merge into each other. The statement of the ritornel (as a rule four times) on different key-levels in the concerto movement, the solo episodes (thematically divergent or the same) being inserted between those statements in corresponding tonalities, the analogous structure of the third movement, which moves, however, in contrasting meter and rhythm, provide a dual order of pillar construction: the outer movements form the main supports of the whole concerto, the light elegance or passionate improvisation of the middle movement being suspended between them, while the ritornels in the outer movements form the pillars between which stretches the garland-like ornamentation of the solos. The most perfect symmetry is achieved, and the scheme took such deep root that Vivaldi maintains it despite the program in his *Four Seasons*. The concerto was the last and the most clear-cut design of the Baroque and became one of the models for the later rondo as well as for the sonata movement.

The da-capo aria, after vacillating between simplest four-line

song strophes, variative strophes, and composition in several sec-
tions in the hands of composers from Caccini to Caldara, Conti,
Steffani, and Pietro Torri, emerged with Alessandro Scarlatti and
among the Neapolitan group of Francesco Durante, Francesco
Feo, Leonardo Leo, et al. into the firmly established pattern that
is found (alongside two-part forms) in all masters of the late Ba-
roque. A main section, consisting of ritornel and song-section, often
laid out in a dual arrangement with tonalities in reverse order, was
repeated as a third section, the middle section, on the other hand
(resting on similar or on contrasting motifs), was set off against it
in key and instrumentation and often in rhythm also, so that an-
other symmetrical group came into existence that far outlived the
Baroque, standing open at all times, of course, to countless modi-
fications in detail.

Among further more or less stable form-schemes, the late Ba-
roque evolved the two-movement orders of recitative and aria as
well as prelude (toccata, etc.) and fugue, the two- or three-
movement design of the French overture, and the four-movement
church sonata. After the early-Baroque highly pathetic style of
recitative had been simplified into sung speech for narrative, dra-
matic, or connecting texts and the simple song-like aria had been
transformed into the substantial lyric song in bel-canto style (with
Luigi Rossi, Carissimi, et al.) the two-movement combination be-
came that of recitative and aria, a design the importance of which
grew ever greater, the more opera, oratorio, and cantata rid them-
selves in the late Baroque of all other constituents. The two-part
form of prelude—or other free pieces—and fugue appeared in
the late Baroque as a fixed order arising out of the combination of
the toccata with fantasy- or ricercar-like movements. Like the reci-
tative-aria form it survived into later times. The French overture
developed between 1640 and 1660 out of the multi-sectional
"symphonies" used as introductions to the *ballets de cour;* two-
part form appears from 1640 on, the *rhythme saccadé* of the later
overture not until 1651 (*Les Fêtes de Bacchus*), the first combin-
ing of a slow introduction and a fugato movement in 1658 (Lul-
ly's *Alcidiane*), while Lully wrote the first full-grown French over-

ture in 1660 for the Paris performance of Cavalli's *Serse,* still two-part. His late-Baroque successors added the repetition of the first part (or some similar sort of slow movement) as a close, and in this kind of design the French overture dominated the entire late Baroque as the important court-ceremonial orchestral form, its after-effect long outliving the period.

Alongside the French overture for the *stylus theatralis* and the concerto for the *stylus cubicularis,* the sonata da chiesa became the representative form of the *stylus ecclesiasticus.* It developed out of the many-sectioned form of the canzona through reduction in the number of its sections and a broadening stabilization of these sections into separate movements (with Pietro Andrea Ziani and Legrenzi still mostly five; after Corelli, from 1680 on, four) that assumed the regular arrangement of slow—fast (fugal)—slow—fast (fugal or dance-like). The church sonata adhered to this scheme, whether in solo, trio, or quartet settings, while the chamber sonata did not develop a fixed form. All other so-called "forms" of the Baroque are either styles (like the recitative) or chain constructions (like the fugue) or loose successional arrangements (like the suite), but not formal patterns.

Cyclical forms of large dimension the Baroque did not create, or only as exceptions in its late stage. Opera and oratorio as a rule go no further than a succession of movements, even though single sections in Bach's Passions and Handel's operas unite into musically closed scene-complexes in which form-groups are set up through tonal and thematic relationships. There is no effort to achieve tonal or structural or thematic unity beyond the opera act or the oratorio part. Large architectonic key structures occur in Handel's late oratorios, but these can no longer be measured by Baroque standards. Bach's B minor Mass (formally speaking, a torso) and the *Magnificat* provide obvious exceptions (what similar cases there may be is yet to be looked into). It is still highly questionable whether the *Musical Offering* and the *Art of the Fugue* were intended as anything more than successions of movements. Nor do the *Goldberg Variations* build a cyclic whole, while Part III of the *Clavierübung,* like the key-successions of the Two-

and Three-Part *Inventions,* of the *Well-Tempered Clavier* and those works analogous to it of Kuhnau, Johann Kaspar Fischer, Georg Andreas Sorge, Bernhard Christian Weber, and others, are indeed governed by externally given principles of order, but by no urgent drive toward cyclical construction.

VII

Delimitation and Organization of the Baroque in Music

The unity of every period in the history of style is relative. Each takes over an extensive heritage in stylistic forms, means of expression, species of composition, objectives, and techniques that it finds ready to hand. One part of this heritage it faithfully preserves and cultivates as an antiquity worthy of respect. Another it little by little lets fall into disuse. Still others it remodels to serve its own intent. In corresponding fashion a dying epoch hands on to the next what it has created, leaving the altered spirit of the new time to make of it what it will. Considering the unity of a style epoch in the light of the relativity implied in this limitation, we may assume from the foregoing (Chapter VI) that the Baroque was a stylistically unified period in music history. That it conformed in timing and pace with the other achievements of the Western spirit in the same historical period has already been shown (cf. Chapter IV). Hence it will have become evident that the word "Baroque" covers a style period in music history in analogy with those other achievements (cf. Chapters II–V). The course of the Baroque in music history must now be more precisely delimited and logically organized.

For a correct account of the start of the Baroque our observations concerning "revaluations" of its heritage from the Renaissance are of importance. A cultural epoch begins not at the point where it lays before us the first definitely characteristic products of its style, but rather where revaluation has fundamentally altered the original significance of the inherited material. That humanistic requirements, the polyphonic madrigal, *prima pratica,* symbolism,

and other inheritances are still alive in the 17th century does not mean that the spirit of the Renaissance is still expressing itself in these forms. *Prima pratica* has become a piously preserved relic of the past. Symbolism has merged into Baroque expression as one of its possible languages. Academicism runs on as an undercurrent, regulating, conciliating. All these have changed their original significance. We cannot deduce from their presence a continuing existence of the Renaissance, any more than we may decide that the Baroque carried over into the time of Haydn and Mozart because the harpsichord was still in use, because fugues were still (or again) being written, because the instrumental concerto was celebrating a resurrection and the opera seria was still the show-piece of court life. The erroneous assessment of such stylistic hangovers on the one hand, the erroneous assumption on the other than a historical epoch begins at the point where it presents finished products, have led to the disagreements reigning in the literature (Moser, Schenk, Haas, Bücken, Bukofzer, Clercx, Della Corte, Pannain) with regard to the boundaries of the Baroque. It is just as erroneous to expect of an epoch total stylistic unity and to put historical unity in question altogether (as Kroyer does) because it does not fulfill this requirement. The human spirit has at no time worn uniform.

The arrangement that has become customary in the writing of music history has the Baroque begin with 1600 because its first stylistic and technical products (thoroughbass, monody, opera, concertato writing, etc.) appear at this point in time; at the end of the period it forces Handel and Telemann, and even Hasse and Graun into the Procrustean bed of an alleged "Baroque," quite failing to see that the two former (and their period with them) were turning *away* from the Baroque, while the two latter had nothing left in common with it but stylistic hangovers. It seems more correct to place the beginning of the period at the point where the new feeling for form and need for expression are decisively adapting the old forms and means to their own use, and its end at the point where a rising new period is decisively revaluing that Baroque world of form and expressive language or discarding it entirely.

The loud chorus of the Florentine reformers gave voice to its demands for the subordination of music, for heteronomy and conformation derived from the word, at a time when practice had long been taking the realization of these demands seriously. As early as around 1570 the Italian madrigal (Cipriano de Rore, Giovanni Nasco, Vincenzo Ruffo, Lasso), for all its strict retention of polyphonic setting, had already shifted its weight markedly toward emphasis upon the chord. Harmonic tonal effects and the shaping of musical "figures" (motifs) born of the word by far outweighed interest in the perfected beauty of the composition as such, which had long been taken for granted. The results of this process are then to be seen in the 1580s and '90s, with Marenzio, Gesualdo, Monteverdi, and their contemporaries. Chords (despite retention of a polyphonic garb) have taken the place of linearity, free use of dissonance that of *prima-pratica* prescriptions, invention is word-born through and through, the design determined by contrasts in sonority and motion; organization in regularly accented measures has pushed its way into the place of an even flow.

What followed was but a consistent further development: the concertato and soloistic madrigal. Boundary lines naturally remain flexible. Lasso, who in the foreword to one of his publications (1555) distinguishes between different sorts of composition, already shows at this time pronouncedly Baroque features, while his Meermann madrigals of 1587 at least in form are still quite "Renaissance-like," whereas it is just in this last work that inner tension and the urge to confessional self-expression have risen to a high degree of passionate excitement. In the dedication to the last motet collection (1593) he himself describes through the parable of the young and the old vine, how he sees his own change. With older masters such as Monte a certain composure, a Renaissance-like sense of equilibrium, retained its influence for some time even in the madrigal. What is true of the madrigal also holds for motets and other categories. In his motets and German lieder of around 1570 Lasso goes through the same transformations as in his madrigals. Palestrina's Masses, from as early as Book 2 on (dedicated to Philip II of Spain, 1567, and containing the *Marcellus Mass* among others), and his motets at least from Book 4 on (dedi-

cated to Pope Gregory XIII, 1584, comprising the Songs of Sol-
omon) can certainly not be considered examples of lofty indiffer-
ence to affects or of calm equanimity: under cover of beautiful
proportion and flowing symmetry there appears in them an excite-
ment, a restlessness of shimmering color that may be compared
to the painting of Greco and Tintoretto. Jacobus de Kerle had pre-
ceded them in 1562—the same years that the first castrati appeared
in the Papal Chapel—with his *Preces speciales,* a work that reflects
the spirit of reformed Catholicism not only in its dedication dated
from Rome to the College of Cardinals and its use for divine serv-
ices at the Council of Trent, but also in its style.

Robert Haas has shown how the technique of accompanied
solo singing came into being in the course of the 16th century in
connection with pastoral and mythological stage works; in the
Florentine intermezzi of 1589 (published by Malvezzi in 1591) it
was fully developed and needed only to be taken over into the first
"operas"—Peri's *Dafne* (1597?), Caccini and Peri's *Euridice*
(1600)—as well as in the solo madrigals of Luzzaschi (1601) and
Caccini (1602). The Paris *Ballet comique de la Royne* (1581),
for all its formal limitations and reserve, set the model for the
whole *ballet de cour* species until far into the 17th century. To
musique mesurée Jacques Mauduit, Claude LeJeune, and the rest
bear authoritative witness from 1570 onward. That France did
not merely remain bogged down in academicism is shown by the
allegorical monodies of Pierre Bonnet (1600) like, among others,
the *Dialogue sur la mort d'une demoiselle où le dessus chante seul
représentant la demoiselle et les parties respondent en représentant
Charon (Dialogue on the death of a young lady where the top voice
sings alone representing the young lady and the [other] parts re-
spond representing Charon),* which went right along with the
Mantuan and Florentine creations of this nature.

The technique of vocal concertante writing with various choirs
in contrasting settings is so far developed by 1590 that the word
"concerto" can be used on title-pages (Andrea and Giovanni
Gabrieli, 1587; Cristofano Malvezzi, 1591). With Banchieri (1595)
and Viadana (1602) the style of the sacred concerto, choral as
well as soloistic, is fully established.

In instrumental music the boundary between Renaissance and Baroque runs less clearly in consequence of their peculiar special style relationships (cf. Chapter VIe); yet its independence of the vocal model is already achieved by Giovanni Gabrieli. For Italy, in any case, the moment of revaluation and assimilation of the heritage can safely be placed at around 1570–80 and this decade may be accepted as the early boundary-line of the Baroque, though of course this does not apply to all countries.

One can hardly regard the English madrigalists of the closing 16th century as "Baroque" in style. But Dowland—who was personally involved in the religious battles of his time, and though a Catholic, became a Jesuitophobe—in the course of his German journey to the courts of Heinrich Julius of Brunswick and Moritz of Hesse, and in Italy in association with Giovanni Croce and Marenzio, takes on a characteristically Baroque attitude (also in his epistolary style) and around 1600 inaugurates a pronounced English Baroque with his songs and instrumental works. His contemporaries Bull, Gibbons, Tomkins, et al. represent keyboard music in what is not an opening but already a closing stage and could thus set the pattern for a great deal of the Continental keyboard music of the entire Baroque. Italianate monodic composition made its appearance in England about 1620 with Martin Peerson and Walter Porter, in the form of ayres, chamber duets, and similar pieces in concertato style; Peerson was the first English composer to figure his basses.

In Sweelinck, especially in his vocal works, *prima* and *seconda pratica* still interpenetrate, much as they do with Hassler, while his organ and keyboard compositions are conceived in fully Baroque style and form. In Germany a perfected Baroque style grows, slowly but for that reason the more clearly defined, out of the *stile antico* of the Italian 16th-century motet, long preserved and persisting through all the Baroque, and out of choral and soloistic concerto, monody, affective madrigal. The polychoral concertos of Praetorius (between 1605 and 1619) and Schütz (up to and after 1619) allow us to follow the process just as clearly as we are able to do in the small concerto, song, and chamber suite of Schein and in organ music from Praetorius to Scheidt. The beginning of Ba-

roque requirements in form and expression lies much further back, as Lechner's works from 1575 on and Eccard's compositions of a little later show. Slowly likewise the turn to the Baroque took place in Spanish and Portuguese organ music, with Pedro Heredia, Francisco Correa de Arauxo, Padre Manuel Rodriguez Coelho. That all these European countries did not precede Italy but followed her was an automatic consequence of the alterations that took place in national structures at the beginning of the Baroque, as we shall see in Chapter VIII. For each of them the early boundary line must accordingly be drawn somewhere between 1570 and 1600.

The end of a style period is always more difficult to determine than the beginning, because the hangovers remain in effect for such different lengths of time, yet their after-influence must not mislead us into considering the style of the dying epoch to be still dominant. The determining consideration is what the following period makes of that style and what it has to set up in opposition to it. The one decisive counterthrust to the Baroque occurred in Italy in the field of intermezzo and comic opera from about 1730 onward, and even the fully developed *opera seria* of this and the following time, though it still worked for a while with Baroque stylistic means and forms, is no longer a fruit of the Baroque spirit but a classicistically simplified creation whose various stages of preservation, decay, and transformation between 1740 and 1790, along with the concerted Mass, build one of the strongest style bridges between Baroque and early Classic. The serious opera of the Rameau-Destouches group in France similarly bridged for a time the change in style, while in *comédie-vaudeville, Singspiel,* and the dance-drama resulting from Jean-Georges Noverre's introduction of dramatic action into the dance, completely new ideas had long permeated composition. German Baroque opera died out in the 1730s. In the realm of keyboard music the Baroque lost its hegemony in Italy from the 1740s on with Domenico Scarlatti, Domenico Alberti, Giovanni Marco Rutini, Baldassare Galuppi, and others, in North Germany even from the 1730s on with Wilhelm Friedemann and Carl Philipp Emanuel Bach, in Austria with Georg Christoph Wagenseil and others.

The second determining counterthrust came from the group of the Austrian, Bohemian (Mannheim), and North German symphony and chamber-music composers, partly also from the Italian group around Pergolesi and Sammartini, and from the mid-1740s on led to the predominance of the new symphony and related categories—sonata, divertimento, string quartet, etc.—over the remaining species inherited from the Baroque—fugue, suite, concerto, etc.—that had by no means died out.

Around 1750, too, the national and social structure of European music underwent fundamental changes. All stylistic hangovers and mixtures notwithstanding, one may state that around 1740 the Baroque style period in the music history of all European countries, has, if not quite faded out, at least been overcome. Telemann's and Handel's late cantatas and oratorios are, like Graun's *Tod Jesu* and Hasse's *Pellegrini,* absolutely un-Baroque in nature, even though like opera seria they still make use of Baroque stylistic means. Bach in his late works has grown far beyond the question "Baroque or not Baroque?" It was precisely in his own closest circle that many decisive transformations leading towards the new age had been worked out, and he himself, after Scheibe's attack on his style in a discussion of artistic conventions in 1737 and after the controversies with the Leipzig school authorities in the 1730s, had been drawn into the general spiritual and social readjustments of the time. In opposition to the loftiest refinement and complexity of the Baroque style, from around 1740 a new primitivism everywhere took root. To what extent the survival of the Baroque constituted a sort of "musical Rococo" is a question that cannot be entered into here.

Within the temporal boundaries indicated, the Baroque style period falls into three phases the limits of which, though differing in different countries, are yet everywhere more or less clearly distinguishable. In Italy the exaggerated declamatory and affective style, the battle against counterpoint, the fussy, detailed patchwork character, the inflexibility of always emphasizing merely soprano and bass, the experiments with dissonance and chromaticism, yield around 1630 to the trend toward developing a more cantabile vocal style (whereupon recitative and aria definitely part

company), an equilibrium between word and tone as well as between instrumental and vocal music, a richer textural technique that gives renewed value to counterpoint, an expansion of small into larger sections of always greater independence, an increasing tonal, rhythmic, and metrical unification of those sections. With Venetian opera, the oratorio, and the cantatas of Luigi Rossi and Carissimi arose the *bel-canto* style, which in the Bolognese school of Maurizio Cazzati, Vitali, Legrenzi, and the rest extended to string music as well and also found a parallel in the keyboard music of Bernardo Pasquini.

Out of this stage a third phase of the Italian Baroque grew around 1680, distinguished in all types of vocal and instrumental music by the triumph of a small number of separate movements over multiplicity of sections. Stabilized modern major-minor tonality rules in the individual movement; the functional quality of harmony develops fully in the course of this phase, which runs from 1680–1740. Motor rhythm and the modern measure also become full-grown. From Corelli, Torelli, and Vivaldi on, the concerto, grosso and solo, becomes the second definitive instrumental form-pattern alongside the church sonata, the final form of which also goes back to Corelli. With Giovanni Maria Casini, Azzolino Bernadino della Ciaja, Alessandro Scarlatti, and Domenico Zipoli the late Baroque categories—partita, fugue, variation series—come into their own in keyboard and organ music as well. The da-capo aria in opera and chamber cantata undergoes an analogous development to its final Baroque design. With Alessandro Stradella, Alessandro Scarlatti, the Bononcini brothers, Jacopo Antonio Perti, Attilio Ariosti, Agostino Steffani, Antonio Lotti, Pietro Torri, the Pollaroli (father and son), Caldara, and Conti the Baroque opera seria reaches its concluding stage before the classicistic reform of Metastasio and Hasse.

The three phases thus outlined in Italy's music history appear somewhat later in the other countries. In England in the 1650s, following upon the masques of Henry Lawes and Matthew Locke, there took place an intermingling of English ayre and Italian *bel-canto* style, while the full union with the late-Baroque Italian cantata and opera types respectively occurred—though with a

very English accent—with John Blow's *Venus and Adonis* of 1682, although without the stylistic possibilities of the two earlier phases having been exploited in England to anything like the extent to which they had been in Italy. The stylistic development of church music suffered an interruption during the Commonwealth years (1649–60). Yet beside the full anthem, the style of which may be considered analogous with Italian *prima pratica* and which lived on throughout the 17th and 18th centuries, it had already evolved the verse anthem that linked up with the Italian practice of solo song and figured bass. After the Restoration (1660) composers like Blow, Pelham Humfrey, Locke rapidly caught up with the Italian style development and full union with the late-Baroque phase in this field as in the solo cantata and opera was reached with Purcell; Purcell's position in England corresponds to that of Scarlatti in Italy. Keyboard and organ music, after its leading achievements early in the 17th century, seems to have stepped into the shadow for a while; in this field also it was with Purcell that England achieved the late-Baroque stylistic stage of French clavecin and organ music.[15] In chamber music the consort long remained independent, only slowly absorbing genuinely Baroque elements of style and sonority; even the viol maintained its role of chief instrument much longer here than in other countries. Around 1600 the viol-players of the Dowland-William Brade-et al. group had exerted a stimulating, even decisive influence, similar to that of the virginalists, on Continental practice. Later the consort became a local English affair. With Lawes, John Jenkins, Christopher Simpson, Christopher Gibbons, Charles Coleman, John Hilton, Matthew Locke, and so forth, there followed after 1650 a rapid acceptance of the Italian chamber-music style, until here too Purcell took over the definitive late-Baroque style. England, then, reflects the three phases to this extent: up to about 1680 the Baroque was received into local practice but slowly and with resistance, the assimilation nevertheless becoming complete in the last phase.

In France also a national heritage, strengthened by humanistic and academic leanings, offered a certain resistance to the Italian

15. An organ toccata of his found its way by mistake into the Collected Edition (Vol. XLII) of Bach's works.

Baroque. Mersenne stated the antithesis clearly in 1636 (cf. Chapter VIb). The *ballet de cour* with its *airs* and *récits,* in which not only the *musique* but from time to time even the *ballet* itself was "mesuré," during the first phase retained a disinclination toward Italian affective character and rhetoric, but also toward the now reviving counterpoint as well as all free dissonance and chromaticism. Not until Italian opera had made its entry into the Parisian court under Louis XIV through the interest of Mazarin and Colbert, respectively, and the cooperation of the Barberini—with Sacrati's *Finta pazza* (1645), Pietro Francesco Cavalli's *Egisto* (1646), and Luigi Rossi's *Orfeo* (1647), delighting its audience through the stage settings of the "magician" Giacomo Torelli—not until ballets were inserted in Italian operas—Louis XIV's wedding being celebrated by a festive performance of Cavalli's *Ercole amante* (1662) with countless interpolated ballets by Lully—did a national French Baroque, nourished at Italian springs, suddenly break through, promptly achieving its full height in Lully's operas, ballets, church and instrumental music, to be carried on essentially unaltered in *tragédie lyrique,* ballet, *ballet-comique* and *comédie-ballet* up to Rameau's day. Meanwhile, however, France independently evolved out of lute music (Denis Gaultier's, for example) from Chambonnières on (c. 1650) a harpsichord style that, beginning with the elder Couperins, Jean Henry d'Anglebert, Nicolas Antoine Le Bègue, and the rest, continued to develop up to François Couperin, Charles Dieupart, Louis Marchand, and others. Less with its opera, but very definitely with its *ouverture* (orchestral suite) that emerged out of opera and ballet, with its orchestral practices and its harpsichord music France gave its stamp to European late Baroque, in which from 1680 on Italian and French style were in part ever more closely blended but in part too kept moving side by side (cf. Chapter VIII). As in England, the early phase of Italian Baroque had been assimilated only with reservations in France, the merging of Italian and French styles not taking place until the middle phase. In French music too the late Baroque with its tendencies to encroach upon the whole of Europe stands as a separate phase, in part markedly French-nationalistic, in part combining with Italian late Baroque.

Germany began very early to take in the Baroque style. If Hassler, Praetorius, Gregor Aichinger are still rooted altogether in the *prima-pratica* tradition and the German song-setting of Reformation times respectively, Hassler nevertheless took over to its full extent the new technique of the Italian *balletto,* Aichinger and Praetorius that of the solo and group concerto. They had even been preceded by masters of the second half of the 16th century, like Leonhard Lechner and Johannes Eccard, and the late works of Lasso not only originated in Germany but received their widest diffusion in that country. By the early 17th century, the time of Schein, Scheidt, and the young Schütz, the early phase of Italian Baroque had been fully assimilated and merged with the German tradition. That the solo song, and especially the recitative, was adopted slowly is due to the fact that conditions did not at first exist for court opera and vocal chamber music. The works of Schütz's middle period (the three parts of his *Symphoniae sacrae* and the *Sieben Worte* more than the *Kleine geistliche Konzerte*) show how the style of the second phase became established here too, always, it is true, under the influence of strong national elements as in England and France. With the solo song of Heinrich Albert and Adam Krieger, the keyboard music of Froberger, Wolfgang Ebner, and Johann Caspar Kerll, the lute music of Esajas Reusner, the instrumental suite of Johann Rosenmüller and Diedrich Becker, the organ chorale and the free organ composition of Franz Tunder, Jan Adamssoon Reinken, Heinrich Scheidemann, Matthias Weckmann, Buxtehude, Pachelbel, the large and small vocal concerto of the Schütz group up to Rosenmüller, Johann Vierdanck, Thomas Selle, Weckmann, Christoph Bernhard, Buxtehude, with the chamber canzona and chamber sonata from Vierdanck to Johann Heinrich Schmelzer and Heinrich Ignaz Franz von Biber—with all these a superabundance of music was produced in Germany that took a similar course to that of the middle Baroque phase of the Italian style development. In the late phase in Germany masters like Friedrich Zachow, Johann Kuhnau, and Johann Philipp Krieger achieve the comprehensive blending of the all-European Baroque in music that is summed up in the names of Telemann, Handel, and Bach and

that with the somewhat younger generation from Gregor Werner and Johann Joachim Quantz to Christoph Nichelmann and Leopold Mozart led a remarkable after-life in the doctrine of "mixed taste" (*vermischter Geschmack*). The three phases of the Baroque in Germany are clearly separable and by the same temporal boundaries as in Italy: namely, 1630 and 1680.

Manfred Bukofzer calls the three phases "Early, Middle, and Late Baroque." For the French language Suzanne Clercx suggests "Baroque primitif, plein Baroque, Baroque tardif." In German terminology they may most suitably be called "Früh-, Hoch-, Spätbarock" (instead of H. J. Moser's "Früh-, Mittel-, Hochbarock" or Erich Schenk's "Früh-, Mittel-, Spätbarock").

VIII

Nation and Society in the Music of the Baroque

The Baroque was the period of Italian supremacy in music. Italy's rise to the accomplishment of this historic mission took place suddenly, in the course of a single generation. During the Renaissance all Europe had been musically a province of the Netherlands. Netherlands musicians, forms of music-making, types of composition, and techniques set their stamp upon the period from around 1430 to 1570–80. Even the national musical categories characteristic of the various peoples—the French chanson, the Italian madrigal, the German lied, the Spanish villancico—all entered the sphere of art music clad in the Netherland style, having heretofore carried on a more or less hidden existence as folk music on a lower level of society; indeed, even after their breakthrough into art music they remained to a considerable extent in the hands of Netherlands musicians and were developed by them. To this Arcadelt, Verdelot, Willaert, Rore, Lasso, Ivo de Vento, Matthaeus Le Maistre and many others bear witness. The few Italians among them either remained limited to small forms—Bartolomeo Tromboncino, Marco Cara, and others of their circle—or may be considered exceptions—Costanzo Festa and Domenico Maria Ferabosco, for example—in that they appeared garbed in the Netherlands style like guests among the Netherlanders, just as these had come forward among the small Italian masters of frottola and lauda. Even into the Lasso generation (born generally speaking around 1532) European music was dominated by the Netherlanders.

It was with this and the following age-group, however, that

those masters emerged in Italy who were to develop the Baroque
and—with the reservations described in Chapter VII—bring it
into force throughout Europe. Francesco Portinaro, Vincenzo
Ruffo, Giovanni Nasco, Marcantonio Ingegneri came to represent
the Italian madrigal while leadership in this form still lay with
Lasso, Monte, Giaches de Wert, and others. With the next age-
group, born in the second half of the 16th century—Marenzio,
Giovanni Gabrieli, Gesualdo, Monteverdi, Costanzo Porta, Adri-
ano Banchieri—Italian music achieved the ascendancy in all Eu-
rope. For Michael Praetorius these masters together with Pal-
estrina were the unquestioned authorities, just as all these same
composers together with Orazio Tigrini, Baldassare Donati, Felice
Anerio, and the rest were for Thomas Morley in England. At the
same time Palestrina was moving into the legendary role of a
"savior of music" (through Banchieri) and the historical function
of Delphic Oracle in counterpoint (through Giovanni Maria Artusi
and others), both of which he retained (through Giovanni Andrea
Marco Scacchi, Angelo Berardi, Fux) until the end of the pe-
riod.

The Roman school with Palestrina, Anerio, the two Nanini,
Suriano, as well as the Venetian school with Andrea Gabrieli,
Zarlino, Vicentino, et al., provided the model of *prima pratica*
for the European Baroque, thus drawing down upon Italy the
ephemeral fame of having been the bearer of *ars perfecta,* which
did not at all correspond to her real function in the Renaissance
period. Monody, concerto, opera were from the very beginning
regarded as Italian art and set the example for all countries. Strong
as were the national traditions and special usages that opposed the
growing supremacy of Italy in the early Baroque phase, they could
not prevent the Baroque style, Baroque techniques, Baroque forms,
of Italy from taking over, even in those regions where the prime
assumptions—the Baroque feeling for life and need for expression
—were not yet present or had only begun to appear. The fact that
at the beginning of the 17th century there existed in German music,
and perhaps also in French and English music, Baroque style and
Baroque forms without a genuine Baroque spirit—the early works
of Praetorius are an example—testifies to the powerful influence of

this Italian music, a subject that still needs to be investigated.

As time progressed, the Italian hegemony became established. But one must not overlook the fact that with the increasing acceptance of this style in the music of other nations, composers at the same time the more emphatically developed their own distinctive national traits. In the *bel-canto* period Italian opera, chamber cantata, oratorio, violin music, chamber canzona, etc. reigned everywhere but, as we shall see presently, everywhere underwent intense penetration by existing national characteristics.

Together with their music Italian musicians themselves pressed vigorously forward. While during the early Baroque phase they had won leading positions in few places outside of Italy—at the Imperial court under Rudolf II, Matthias, and Ferdinand II, the outlying Habsburg courts, the South German residencies—from about 1630 on Europe was overrun with them. In Vienna the succession of Italian chapelmasters and composers, of castratos and prima donnas, of virtuosos and impresarios was unbroken from Giovanni Valentini (1619) to Antonio Caldara, Francesco Bartolomeo Conti, and Marc'Antonio Ziani (1653–1715). In the late Baroque Italians dominated in Munich from Ercole Bernabei and his son onward, in Dresden from Giovanni Andrea Bontempi, Marco Giuseppe Peranda, Vincenzo Albrici; the last-named even achieved at some time the post of organist at the Thomaskirche in Leipzig. In Paris Luigi Rossi, Francesco (Paolo) Sacrati, and Pier Francesco Cavalli were guests under Mazarin, the Italian-born cardinal (1602–61), and Lully, also an Italian, set up a national monopoly of French music.

Spain and England held out longest in stiff-necked resistance to the personal advance of the Italians, until the beginning of the 18th century, though Coperario (John Cooper), Bartolomeo Albrici, Antonio Draghi, the castrato Giovanni Francesco Siface, and others worked for a shorter or longer time in London. In Warsaw Marco Scacchi and Tarquinio Merula were active, in Hanover Agostino Steffani, in Berlin Ariosti and Bononcini, in Düsseldorf Marini, in Copenhagen Fontana. Alessandro Scarlatti was for a while chapelmaster to Queen Christina of Sweden in Rome. At the end of the 17th century, following Nicola Matteis and Pietro

Reggio, acquaintance with Italian music had become widespread in England, and in 1711–12 Francesco Gasparini's first operas were given in London. Where a princely wedding or a political act was to be celebrated, a theater opened, even in places that then meant little in music, Italian compositions were called for, if not the composers themselves—as, for example, at the inauguration of the Amsterdam Theater in 1680 with an opera of Ziani.

The background to this rise of Italian Baroque music lay in the concentration of secular power in the hands of absolute monarchs, of spiritual power in those of pope and cardinals in the Church of the Counter Reformation. Power calls for ceremony, and the Italian Baroque evolved ceremonial music for such purpose in a measure hitherto unknown. It became a necessity of courts, of aristocracy, of the Curia. Whether with Johann Georg I of Saxony, with Louis XIV of France, with Pope Gregory XIII, or with smaller and smallest potentates, lords and gentlemen, princely ceremony was always called for. Similarly the Catholic Church outwardly projected its ascendancy by means of splendor in music as well as in architecture, the fine arts, craftsmanship, ceremonial. No other age produced nearly such magnificent insignia, royal mantles, furnishings, monstrances, baldachins, wigs, and automatic musical instruments as the Baroque.

The tremendous unfolding of concerted sacred and secular music was possible only with the support of courts or ecclesiastical centers, both for financial reasons and because only here could its meaning achieve its full effect. For that meaning lay in pageantry, spectacle. Hence the musicians of the time felt that they stood at the absolute summit of music, which had reached so high a pinnacle that it evoked their greatest creative efforts. As early as 1593 Lasso himself had asked the significant question whether the music of his time had attained the height of perfection or whether it was about to experience a new spring. Praetorius and Schein looked upon polychoral music as not to be surpassed, the true reflection of the heavenly choirs. It is from this point of view that one should understand Bach's contrasting, in his memorial of 1730 to the Council in Leipzig, of the brilliance of the Dresden court orchestra with the low estate to which middle-class musical activity had sunk

in Leipzig.

The center of court ceremony in the Baroque era lay in the opera, that of the Church's presentation of itself in the High Mass. As the Baroque palace suitably housed the absolute monarch, so the domed Baroque church provided a fitting frame for the representation of divine majesty and its earthly delegates. The Lutheran Church followed suit at a little distance; Schering has pictured the glorious unfolding of the Lutheran service in Bach's Leipzig as a last blazing-up of the fire of Protestant self-assertion. Since in the Baroque era a rigid hierarchical order carried through in strict gradations from the highest personalities and central places down to the lowest nobility and smallest country house, questions of rank and etiquette being no mere external matters in life but considered of serious significance in the organization of status and society, and since at the same time the orderings within the middle-class ranks, a lingering echo of the departed Middle Ages, were steadily losing in importance, it is understandable that musicians more and more strove to achieve positions at court. The Italian Baroque brought forth the showy forms of music vital to court and church ceremony. Court and church requirements blended so intimately that the Baroque became without more ado the age of court art and aristocratic cultivation of music and the aristocratic spirit set its stamp upon this music. And the longer this went on the more did musicians themselves feel at home only in the atmosphere of courts. Monteverdi worked in the service of the Dukes of Mantua and the Doges of Venice. Lully was director of music to Louis XIV. Schütz sought the posts of court director in Dresden and Copenhagen, as Bach was to do a hundred years later from Leipzig. The Roman opera was fostered by the Cardinals Barberini, who promoted French opera as well. Opera, indeed, became the scarcely veiled allegory of absolute sovereignty, which it served. Almost every published work was dedicated to a patron, a Maecenas, a spiritual or a worldly lord, ruler, gentleman. Operas, cantatas, instrumental concertos and every sort of secular music were commissioned by them, every sort of church music by princes of the church. Without such commissions neither Bach's Brandenburg Concertos nor Cesti's *Pomo d'oro,* neither Lully's ballets nor

Benevoli's Salzburg Mass would have seen the light. If in the
Renaissance period the cultivation of music by a high-ranking
citizenry was responsible for musical creativity—even the courts
of the period bore this burgher-like stamp, and the prince was
the first among his subjects—in the Baroque the emphasis shifted
heavily toward the side of court and church aristocracy, and here
the personality of the ruler or dignitary assumed a central position.

With this came specialization among professional musicians.
The Renaissance no longer distinguished between *musicus* and
cantor (at least not in practice), as the Middle Ages had done. The
musician was composer, director of music, singer, instrumentalist,
all in one, and the composer possessed a fundamental mastery of
all species of music. In the Baroque, production and reproduction
gradually moved apart. The more accomplished coloratura singing
became, the more brilliant instrumental performance, the greater
the need for the professional virtuoso singer and player. This need
brought forth the great prima donnas and castratos from Vittoria
Archilei (end of 16th c.) to Farinelli (Carlo Broschi, 1705–1782)
and the traveling instrumental virtuosos from Carlo Farina (early
17th c.) to Vivaldi. Of many Baroque composers it is no longer
known that they appeared as performers (for example, Monteverdi,
Schütz) aside from their activity as directors of music and *maestri
al cembalo*. Others were at the same time virtuosos, like Lully,
Corelli, Bach. Opera performances lay in the hands of either court
orchestras and highly-paid virtuosos or commercial producers who
engaged professional artists or specially set-up traveling opera
companies. The composers themselves frequently specialized in
certain fields. In Palestrina an almost exclusive limitation to church
music is already indicative, while Lasso cultivated every sort of
secular and sacred composition, though liturgical church music
shifted to a peripheral position in the process. Lully was almost
exclusively an opera and ballet composer, like Cavalli, Cesti, and
many others; Corelli concentrated principally on chamber music,
Vivaldi on concertos. Bach and Handel once again embraced the
whole field. Every musician in the court orchestra had need to
study but a single instrument—"nur ein einziges instrument zu
excolieren," as Bach writes in his memorial, so that he could do

something really well—"was Treffliches und Excellentes"; of the ordinary (common) middle-class musician it was required that, though badly paid, he should be able to play right off all sorts of music from everywhere—"allerhand Arten von Musik, sie komme nun aus Italian oder Frankreich, England oder Polen sofort extempore musizieren"—in addition to which he must be his own composer, performer, copyist, teacher, etc. As a result of this Baroque attitude there entered upon the stage of history the professional musician who was nothing but a musician, needed no university study, specialized in one particular musical faculty, and carried out his duties strictly in accord with his official status as court, civil, or ecclesiastical employe or earned his living as a traveling virtuoso or impresario by satisfying the needs of the leading classes of society for ceremony or entertainment. The Classical period started out on these same assumptions and rapidly made them over into the free functioning of the modern performing artist.

To this rise of court and aristocratic musical life corresponded a decline in the old middle-class and ecclesiastical musical activity and the slow rise of an emancipated new citizenry that, based on a considerable prosperity derived from the mercantile world, depended at first on court-cultivated music, gradually became self-reliant, and by the end of the Baroque was so firmly established in the principal cities of Europe (Venice, Naples, Vienna, Paris, Leipzig, Hamburg, London, etc.) that it was able to enter the beginning of the Classic era in full possession of its heritage of court-musical culture from the Baroque.

The interrelationship of the three levels upon which music was cultivated in the Baroque has not yet been sufficiently investigated and can only be sketched here, somewhat along the following lines:

In Italy the distinctions were not too marked since, given the political weakness of the country, absolute rulership was not fully developed and the middle class did not sink so far into insignificance as, say, in France, but rather, in association with the nobility, managed early to found a commercial public musical life. In the many spiritual and secular centers of Italy—Rome,

Naples, Bologna, Florence, Venice, and others—a musical culture, stylistically as well as socially homogeneous, in the main, flourished in opera houses, churches, and "academies," these last having the character in part of exclusive clubs for the aristocracy and upper-class citizens, in part of public concerts. In the France of Louis XIII and XIV the accent fell almost entirely on court music, to such an extent that music history knows of practically no French middle-class music culture during the Baroque. In England, aristocratic and upper-class musical activity appears to have remained unified on the basis of strong national traditions; not until the House of Hanover came in early in the 18th century did there arise in England a separate court musical culture that went against tradition by taking over Italian opera. In Germany the contrasts were very marked. Catholic as well as Protestant secular and ecclesiastical courts—Vienna, Salzburg, Munich, Stuttgart, Mainz, Cologne, Münster, Fulda, Dresden as Protestant residency in the 17th century, Catholic in the 18th, Cassel, Brunswick-Wolfenbüttel, Berlin under Frederick I and Sophie Charlotte, Hanover, Celle, down to the little secular courts in Saxony and Thuringia, to Anhalt-Cöthen, to the courts of the Bohemian nobility—these blossomed on the Italian pattern, later on the French, into all the brilliance of which the Baroque was capable. Over against them stood the cities, especially those of Lutheran Germany, in which the declining culture of middle-class and church music still persisted into Bach's time. Alongside this, however, there grew up among the rising new middle class, at least in the late Baroque phase, a well-to-do cultured stratum which with the beginning of public concert life in Germany, the shifting from private to public performance of opera seria and buffa, with the coming of the new lied and *Singspiel* after 1740 entered upon its heritage from the Baroque in the same way as happened in France with *comédie-vaudeville,* with the beginnings of *opéra-comique,* and with the Concerts Spirituels. From the sociological point of view in music too the time around 1740 sets a definitive boundary-line: the court age is replaced by that of the middle class, the Baroque age by the Classic.

But the conquering course of Italian music in the Baroque

aroused and strengthened national forces elsewhere. In Paris Italian opera brought forth the national French genre of the *tragédie lyrique,* Italian instrumental music the French orchestral practices. From about 1670 on both, though deriving from Italian precedent and inconceivable without it, took on the firm character of a French musical Baroque style. Its difference from the Italian style is explained by the enduring vigor of French academicism in music, dance, and poetry having brought its own validity into the Italian forms; indirectly and directly Racine and Molière took part in French opera and French ballet just as much as did the Italians Cavalli and Lully. From the same time on France developed her specific type of harpsichord music out of the native tradition of her lute music. Thus there arose a whole complex of late-Baroque French music that exerted a decisive influence alongside the Italian on all Europe.

England's independent, nationally characteristic music in the field of viol-ensembles and the virginal during the Elizabethan era spread to the Continent through those musicians who emigrated for religious reasons. Through Sweelinck English keyboard music carried over to Scheidt and it remained influential in North Germany up to Buxtehude and Bach. From Vienna to the ducal court of Gottorp in Schleswig-Holstein, from Berlin to Stuttgart, English instrumentalists held sway at the beginning of the 17th century to such an extent that Italian instrumental music could penetrate but slowly. In the 1620s English theatrical companies performed Shakespeare at the courts of Cassel and Dresden. As late as 1629 Johann Georg I of Saxony commissioned John Price and two other English composers to produce instrumental chamber music in the English, French, and Italian styles.

In the 1670s and '80s French opera and *ouverture* came to the fore in Germany with Agostino Steffani, Johann Kaspar Horn, Johann Sigismund Kusser, and others, while French keyboard music was imported directly. But Italian music had from the end of the 16th century been increasingly infiltrating all German musical composition, undertakings, cultural centers. The extant catalogues of the former Dresden, Cassel, and Lüneburg libraries prove as much. The compilations of Friedrich Lindner and the subsequent

German collections of Kaspar Hassler, Erhard Bodenschatz, Adam
Schade (Schadaeus), etc. had brought Italy's *prima pratica* to
Germany in superabundant measure, and from the time of Hans
Leo Hassler, Schütz, Christoph Kittel, and many others, countless
German composers themselves went to Italy to study at the source.
Around 1630 the gallery of musicians' portraits in the Dresden
court chapel consisted of the two Gabrielis, Monte, Rore, Lasso,
Willaert, Alessandro Striggio, Monteverdi, Giovanni Croce, Claudio
Merulo, Alessandro Orologio, and Sweelinck, with a certain Klein
as the only German. There was danger that the German heritage
from the Reformation period might succumb to the forceful pene-
tration of foreign music; and this danger became the greater with
the glorious blossoming of the late-Baroque courts that increasingly
drew Italian and to some extent French musicians to Germany.
In consequence the 17th century in Germany became an age of
battle, continuously recognized as such from Praetorius to Quantz.
But here too, nevertheless, the national element established itself
and carried through a German Baroque in Italian forms, and later
to a certain extent in French forms—all this as the result of a
tremendous receptive process at the center of which stood the awe-
inspiring figure of Heinrich Schütz, acknowledged even by his
contemporaries as a wise judge. No matter how Italian the garb
of much German music of the middle Baroque, no *Kleines Konzert*
of Schütz, no sonata of Rosenmüller, no Krieger lied, no Froberger
keyboard suite could possibly have been composed in Italy: they
all, though in Italian dress, unmistakably speak German. This is
often true of German music in the late Baroque too, no matter
how French or Italian it may often appear; it is not necessary to
climb to the heights of Bach or Handel for evidence: every key-
board fantasy of Telemann, every cantata of Kuhnau, every aria
of Reinhard Keiser indisputably speaks German, whatever the
style in which it is written. As the writing of Campra, Destouches,
Couperin was convincingly French, that of Blow and Purcell
convincingly English, so Bach's was convincingly German.

The history of what took place between Italy and the other
countries may be summarized in the following formula: from
beginning to end of the Baroque, spirit and style, norms and forms

were fundamentally Italian; the other nations, in their resistance, their adaptation, their receptivity, came to an understanding with all this on the basis of their own heritage and carried the "Baroque" idea to its full breadth and depth; out of this analytical and creative understanding there grew in each of them a nationally characteristic Baroque music. In the late-Baroque phase a veritable "concert" of national styles went on in Europe, both in the sense of "concertizing together" and in that of "blending with each other." The conductor of this European concert—at times disputed, indeed, but in the last analysis clearly recognized—was still Italy. At the end of the Baroque the growing autonomy of these national musics battled against Italian domination, especially those of France and Germany; England's, while in the early-Baroque phase it had been influential in North Germany, was hardly known in Europe as a whole.

That this Italian domination still existed nevertheless is evident from its further history. Since 1710 Italian opera troupes had reigned in London and from 1730 on they began to overflow the German cities and, after 1750, Paris. But the types of opera they now brought with them were no longer Baroque but in part of a limiting classicistic stamp, sober, intent on enlightenment (Metastasio's opera seria), in part of a popular and naturalistic cast (the Neapolitan opera buffa) that in France came up against Rousseau's return-to-nature gospel and a citizenry on the march toward emancipation, in Germany against the already completed turn away from the Baroque in music. The reforms in opera seria from Niccolò Jommelli to Gluck, the blending of opera buffa with *Singspiel,* French *comédie-vaudeville* and *opéra-comique,* and English ballad opera rapidly led to the national, domestic, popular, anti-Baroque species of opera. Italian keyboard and chamber music quickly succumbed to the new Bohemian, Austrian, and North German instrumental music. Only in court spheres could opera seria and the Italian oratorio hold their own for another half-century, undermined as they were by the popular music culture of all countries and the breakthrough of German symphonic composition, which in one sweep from Stamitz to Haydn rose to mastery in Europe. The importance of the Italian composers in the

second half of the 18th century was a national hangover, the importance of their court music a social hangover, analogous to the style hangover of which they were the bearers. If Italy was still regarded by the historically-minded 19th century as the great nation of music—as it was by musicians like Nicolai, Lortzing, Mendelssohn, and also by Goethe—and 19th century Europe still sought in Italy "the" land of music, this was simply an echo of the great Italian period in the music of the Baroque. The Baroque itself, however, had run its course by around 1740. And with it the supremacy of Italy in the history of European music came to an end.

BIBLIOGRAPHY

This is a highly selective list, with emphasis on works in English, and preference given to those easily available in paperback editions.

Renaissance

GENERAL WORKS

Burckhardt, Jacob, *The Civilization of the Renaissance in Italy*, transl. S. G. C. Middlemore, 2 vols., New York, 1958 (paperback). Other editions also available.

Ferguson, Wallace K., *The Renaissance in Historical Thought: Five Centuries of Interpretation*, Boston, 1948.

Huizinga, Johan, *Men and Ideas: History, the Middle Ages, the Renaissance*, transl. James S. Holmes and Hans van Marle, New York, 1959 (paperback).

Mommsen, Theodor E., *Petrarch's Conception of the Dark Ages*, in *Speculum*, XVIII (1942), 226; also in his *Medieval and Renaissance Studies*, ed. Eugene F. Rice, Jr., Ithaca, N.Y., 1959, p. 106.

Michelet, Jules, *Histoire de France*, 17 vols., Paris, 1833–67.

Panofsky, Erwin, *Renaissance and Renascenses*, in *The Kenyon Review*, VI (1944), 201.

...., *Renaissance and Renascences in Western Art*, New York, 1960; 2nd ed., 1965.

WORKS ABOUT MUSIC

Abbiati, Franco, *Storia della musica*, 5 vols., Milan, 1939–46.

Ambros, A. W., *Geschichte der Musik*, 5 vols., Breslau and Leipzig, 1862–78, 1882. Completed by Hugo Leichtentritt. Vol. 5 consists of Kade's supplement of musical examples.

Arnold, Denis, *Marenzio*, New York, 1965.

...., *Monteverdi*, New York, 1963.

Besseler, Heinrich, *Die Musik des Mittelalters und der Renaissance*, Potsdam, 1931–35.

Borren, Charles van den, *Geschiedenis van de muziek in de Nederlanden*, 2 vols., Antwerp, 1948, 1951.

Bukofzer, Manfred, *Changing Aspects of Medieval and Renaissance Music*, in *The Musical Quarterly*, XLIV (1958), 1.

...., *Studies in Medieval and Renaissance Music*, New York, 1960 (also in paperback).

Dart, Thurston, *The Interpretation of Music*, New York, 1954 (also in paperback).

Donington, Robert, *The Interpretation of Early Music*, New York, 1963.

Einstein, Alfred, *The Italian Madrigal*, Princeton, 1949.

Fellowes, E. H., *The English Madrigal Composers*, Oxford, 1921; 2nd ed., 1948.

...., *William Byrd*, Oxford, 1936; 2nd ed., 1948.

Fétis, François Joseph, *Histoire générale de la musique*, 5 vols., Paris, 1869–76.

Forkel, Johann Nicolaus, *Allgemeine Geschichte der Musik*, 2 vols., Leipzig, 1788–1801.

Hughes, Dom Anselm, and Gerald Abraham, eds., *Ars Nova and the Renaissance, 1300–1540 (New Oxford History of Music*, III), New York, 1960.

Kerman, Joseph, *The Elizabethan Madrigal*, New York, 1962.

LaRue, Jan, ed., *Aspects of Medieval and Renaissance Music: A Birthday Offering to Gustave Reese*, New York, 1966.

Lowinsky, Edward E., *Music in the Culture of the Renaissance*, in *Journal of the History of Ideas*, XV (1954), 509.

...., *Secret Chromatic Art in the Netherlands Motet*, New York, 1946.

...., *Tonality and Atonality in Sixteenth-Century Music*, Berkeley, 1961.

Morley, Thomas, *A Plain and Easy Introduction to Practical Music*, ed. R. Alec Harman, New York, 1952; rev. ed., 1963.

Pirro, André, *Histoire de la musique de la fin du XIVe siècle à la fin du XVIe*, Paris, 1940.

Reese, Gustave, *Music in the Renaissance*, New York, 1954; rev. ed., 1959.

Riemann, Hugo, *Handbuch der Musikgeschichte*, 2 vols. in 5 parts, Leipzig, 1904–13.

Sachs, Curt, *The Commonwealth of Art*, New York, 1946.

...., *The History of Musical Instruments*, New York, 1940.

...., *Our Musical Heritage*, New York, 1948; rev. ed., 1955.

...., *Rhythm and Tempo: A Study in Music History*, New York, 1953.

...., *World History of the Dance*, transl. Bessie Schönberg, New York, 1937 (paperback).

Schrade, Leo, *Monteverdi, Creator of Modern Music*, New York, 1950.

...., *Renaissance: The Historical Conception of an Epoch*, in *International Society for Musical Research, Fifth Congress, Utrecht, 1952, Report*, p. 19.

Stevens, Denis, *Tudor Church Music*, New York, 1961; rev. ed., 1966.

Stevenson, Robert, *Spanish Cathedral Music in the Golden Age*, Berkeley, 1961.

Strunk, Oliver, *Source Readings in Music History*, New York, 1950 (also paperback ed., 5 vols., New York, 1965).

Baroque

GENERAL WORKS

Croce, Benedetto, *Storia della età barocca in Italia*, Bari, 1929.
Focillon, Henri, *The Life of Forms in Art*, transl. C. B. Hogan and George Kubler, New Haven, 1942; enl. ed., 1948.
Journal of Aesthetics and Art Criticism, V/2 (1946). Special issue on Baroque style.
Mâle, Émile, *L'Art religieux après le concile de Trente*, Paris, 1932.
Manierismo, barocco, rococò: concetti e termini (Accademia nazionale dei Lincei, CCCLIX, No. 52), Rome, 1962.
Ors, Eugenio d', *Du Baroque*, Paris, 1935.
Wittkower, Rudolf, *Art and Architecture in Italy, 1600 to 1750*, Baltimore, 1958.
Wölfflin, Heinrich, *Principles of Art History*, transl. M. D. Hottinger, New York, 1950 (paperback).
...., *Renaissance and Baroque*, transl. Kathrin Simon, London, 1964.

WORKS ABOUT MUSIC

Adler, Guido, *Handbuch der Musikgeschichte*, II, 2nd ed., Berlin, 1930.
Arnold, Denis, *Monteverdi*, New York, 1963.
Arnold, F. T., *The Art of Accompaniment from a Thorough-Bass as Practiced in the XVIIth and XVIIIth Centuries*, London, 1931 (also paperback ed., 2 vols., New York, 1965).
Bach, Carl Philipp Emanuel, *Essay on the True Art of Playing Keyboard Instruments*, transl. and ed. William J. Mitchell, New York, 1949.
Bukofzer, Manfred, *Allegory in Baroque Music*, in *Journal of the Warburg Institute*, III (1939–40), 1.
...., *The Baroque in Music History*, in *Journal of Aesthetics and Art Criticism*, XIV (1955), 152.
...., *Music in the Baroque Era*, New York, 1947.
Cannon, Beekman C., *Johann Mattheson*, New Haven, 1947.
Clercx, Suzanne, *Le Baroque et la musique: Essai d'esthétique musicale*, Brussels, 1948.
Dart, Thurston, *The Interpretation of Music*, New York, 1954 (also in paperback).
David, Hans T., and Arthur Mendel, eds., *The Bach Reader*, New York, 1945; rev. ed., 1966 (also in paperback).
Dent, E. J., *Alessandro Scarlatti*, New York, 1960.
Deutsch, O. E., *Handel, A Documentary Biography*, London, 1955.
Donington, Robert, *The Interpretation of Early Music*, New York, 1963.
Dufourcq, Norbert, *Jean-Sébastien Bach, le maître de l'orgue*, Paris, 1948.
...., *La Musique des origines à nos jours*, Paris, 1946; rev. ed., 1956.
Girdlestone, Cuthbert, *Jean-Philippe Rameau, His Life and Work*, New York, 1957.
Haas, Robert, *Die Musik des Barocks*, Potsdam, 1928.
Hutchings, A. J. B., *The Baroque Concerto*, New York, 1961 (also in paperback).

Kirkpatrick, Ralph, *Domenico Scarlatti*, Princeton, 1953; rev. ed., 1955.
Klenz, William, *Giovanni Maria Bononcini of Modena*, Durham, N.C., 1962.
Lang, Paul Henry, *George Frideric Handel*, New York, 1966.
Lefkowitz, Murray, *William Lawes*, London, 1960.
Mann, Alfred, *The Study of Fugue*, New Brunswick, N.J., 1958 (also in paperback).
Mellers, Wilfrid, *Francois Couperin and the French Classical Tradition*, New York, 1950.
Meyer, E. H., *English Chamber Music*, London, 1946.
Moser, H. J., *Heinrich Schütz*, transl. Carl F. Pfatteicher, St. Louis, 1959.
Newman, William S., *The Sonata in the Baroque Era*, Chapel Hill, N.C., 1959.
Pincherle, Marc, *Corelli, His Life, His Music*, transl. H. E. M. Russell, New York, 1956.
. . . ., *Vivaldi*, transl. Christopher Hatch, New York, 1957 (paperback).
Quantz, Johann Joachim, *On Playing the Flute*, transl. Edward R. Reilly, New York, 1966.
Riemann, Hugo, *Handbuch der Musikgeschichte*, II/2: *Das Generalbass-Zeitalter*, 2nd ed., Leipzig, 1922.
Sachs, Curt, *The Commonwealth of Art*, New York, 1946.
. . . ., *The History of Musical Instruments*, New York, 1940.
. . . ., *World History of the Dance*, transl. Bessie Schönberg, New York, 1937 (paperback).
Schrade, Leo, *Monteverdi, Creator of Modern Music*, New York, 1950.
Stevens, Denis, *Thomas Tomkins*, New York, 1957.
Vecchi, Giuseppe, *Classicismo e barocco nella musica del seicento in Italia*, in *Il Mito del classicismo nel seicento*, Messina & Florence, n.d.
Walker, D. P., *Musical Humanism in the 16th and Early 17th Centuries*, in *The Music Review*, II (1941), 1, 111, 220, 288; III (1942), 55.
Westrup, Sir Jack, *Purcell*, New York, 1949 (also in paperback).
Ursprung, Otto, *Die katholische Kirchenmusik*, Potsdam, 1931.

INDEX

Index